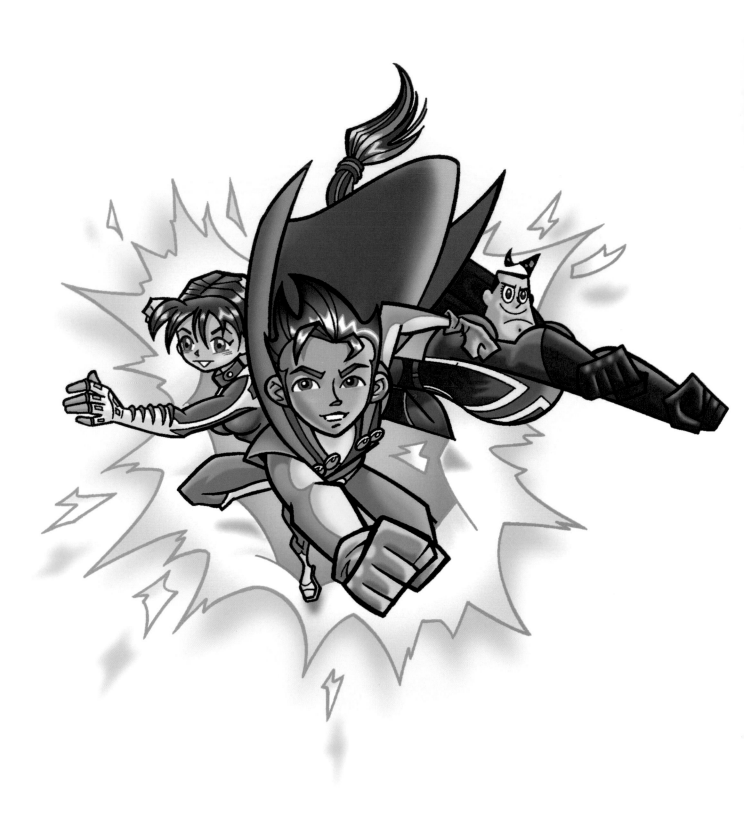

# CREATING SUPERHEROES

## & COMIC BOOK CHARACTERS

ARTWORK> **JIM HANSEN**
COLORIST> **JOHN BURNS**

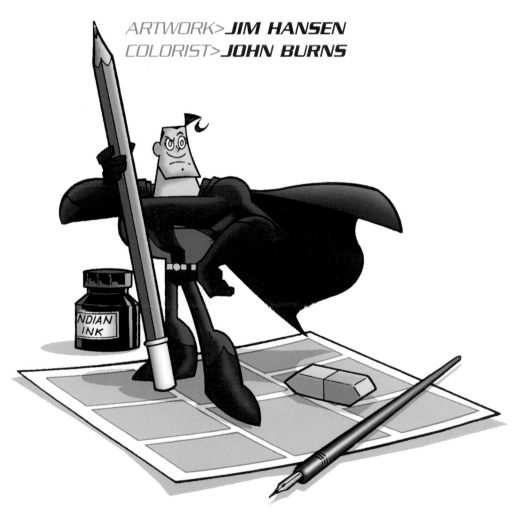

Capella

This edition published 2005
for Bookmart Limited
Registered Number 2372865
Trading as Bookmart Limited
Blaby Road, Wigston,
Leicester LE18 4SE

ISBN 1-84193-267-1

Printed in China

Artwork & text>
Jim Hansen

Colorist>
John Burns

Cover & book design>
Steve Flight

# CONTENTS

# INTRODUCTION

**Y**ou've pulled this book off the shelf and given it a quick flip through. Three different styles, mmm, slightly intriguing? Well, the variety of comic book art nowadays allows an amazing range of artistic styles to be incorporated into this much-undervalued medium. The three I've chosen to demonstrate here are my personal favourites.

The first section is obviously humorous. This is the sort of style one might find on Cartoon Network. Over the last few years, cartoons, especially in animation, have been rejuvenated. Traditional boundaries have long been abandoned with artists expressing new and delightful "extreme" styles. You may be an aspiring cartoonist with little or no experience, or well established but fancy expanding your artistic range. Hopefully this book may help. Once you see and understand the simplicity of the building blocks, your imagination can be fully unleashed to create your own characters in your own style.

Like every other "how to draw" book, there are basic rules to follow. This helps to get you going but these rules aren't cast in stone and as you develop your own skills, drawing your characters will become second nature and one or two stages will be come irrelevant.

As you'll see, our first "stylized" hero is anatomically incorrect. He has a body, head, and four limbs but they're greatly exaggerated. In developing him I played around, giving him large shoulders with even larger forearms, and small thighs with bigger calves, until he developed into the magnificent figure you see depicted here. The idea is just to have fun and to develop a truly humorous cartoon superhero.

In the second section we move onto the very popular animation style one sees on many children's TV programs, featuring many well-known and established superheroes: caped crusaders and chaps that can fly faster than a speeding bullet. Many other animation series have adapted this exciting style for the development of their own characters, as its clean, graphic style looks and works beautifully for animation. Looks pretty great in comics and graphic novels too.

Thirdly we come to the ever popular, and rightly so, manga style. "Manga" translates literally as "irresponsible pictures" and became extremely popular in the 1960s as Japanese comics began to infiltrate and influence western comic culture. Comic artists all over the world have been so inspired by this delightful style that it now has its own description of "pseudo manga." The beauty of manga is that it can be adapted to a variety of styles. Certain characteristics denote it's manga, separating it from more traditional western styles, e.g. large liquid eyes, and an almost non-existent nose.

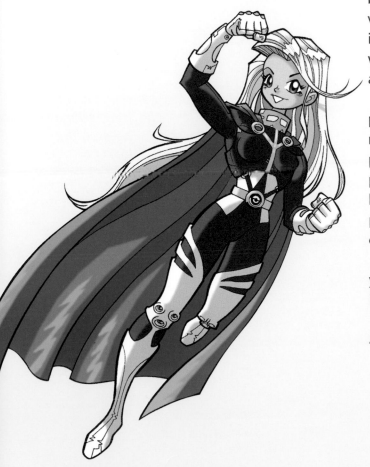

We then proceed hopefully to explain the principles of comic composition, touching on the materials you need to assist in creating professional art: the all-important value of perspective, and foreshortening, which is the knack of drawing the body or figure in perspective. Then we move on to page composition, inking, and finally coloring.

I certainly hope this book helps you to develop your comic artistic skills as it's been good fun illustrating the three different styles.

*So, with a freshly sharpened 2B, go to it!*

# TOOLS of the TRADE

To start with, you need the tools of the trade plus a good working environment. Somewhere with excellent natural light (north facing is the best), and put a blue daylight bulb in your desk lamp for night work: you may well have many of those as you try to meet deadlines when you turn professional!

**Pencils**: Start light to get the rough shape—an HB is ideal **Detail**: Move to a 2B.

**Sharpener**: Unless you use a mechanical pencil—0.3 and 0.5 are best.

**Erasers**: Art gum or smooth kneaded. Heck! Have both.

**Ink**: Any good brand will do.

INDIAN INK

**Pens**: Simple dip pen and nib, plus experiment with the wide variety of felt tips and roller-balls on the market.

*Felt tip & ball point*

**Ruler**: Indispensable.

**Set square or triangle**: You're going to have to draw right angles.

**Opaque white**: Boy, do I use loads of this stuff! A must for covering errors in inking.

**French curves**: Essential for those smooth curved lines.

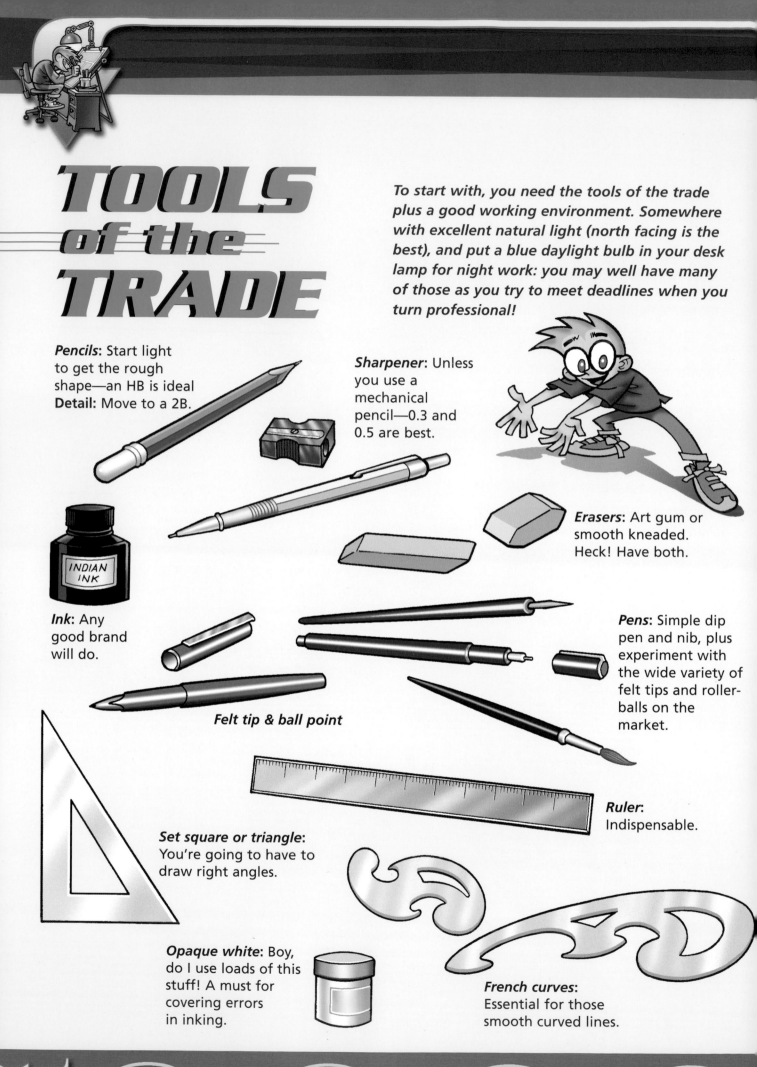

THERE ARE VARIOUS OTHER BITS AND PIECES THAT I HAVEN'T INCLUDED HERE. AS YOU DEVELOP, YOU'LL FIND VARIOUS TOOLS THAT WILL HELP YOUR STYLE OF ART. THE HUMBLE HAIRDRYER IS ONE OF MY BEST FRIENDS. IT REALLY SPEEDS UP INK-DRYING TIME WHEN YOU WANT TO GET A MOVE ON. DON'T FORGET AN OLD RAG OR KITCHEN ROLL TO CLEAN YOUR NIBS AND RULER.

**Stencil**: This little bit of plastic has just about replaced my compass, but I still need one for those really big circles.

**Light box**: Very handy if you want to retrace your pencil line for a cleaner look.

**Illustration paper**: Very important. I like A3 bristol board the best because it's very smooth.

**Desk lamp**: Sadly the sun can set before you've finished for the day, so get that daylight bulb!

**Drawing board**: You've got to have something to rest your paper on.

**And finally**: Don't forget a beverage of your choice to keep you going.

# BASIC CONSTRUCTION

*You're not going to believe this, but to start with, you don't need an awful lot to construct your comic characters. Just juggle a few geometrical shapes: squares, spheres, cylinders, circles, triangles, and the odd cone in the right order and hey presto! Miraculously a new superhero is born. The world and mankind are saved yet again ...*

IT REALLY HELPS WHEN YOU DRAW THESE SHAPES TO THINK OF THEM AS SOLID OBJECTS.

... OVER THE NEXT FEW PAGES YOU WILL SEE WHY A COLLECTION OF GEOMETRICAL SHAPES IS THE KEY TO COMIC ART.

LET'S START WITH A COLLECTION OF
CUBES, CIRCLES, SQUARES ETC., FLOATING
AROUND LIKE SO MUCH SPACE DEBRIS...

ALL YOU HAVE TO DO IS
ASSEMBLE THEM IN THE
CORRECT SEQUENCE...

AND RIGHT BEFORE
YOUR PENCIL TIP...

WITH A TWITCH OF THE EYELIDS
AND A JERK OF A FOOT,
SUDDENLY THE CHEST HEAVES
AND LO AND BEHOLD, YES, YOU
HAVE CREATED A LIVING BEING!!!

WELL...NOT QUITE,
BUT YOU GET THE
PICTURE.

# RIGHT! LET'S START

Grab your sharpened HB and let's bring a few characters to life. You're about to experience the same euphoric feeling that the very misunderstood Dr. Frankenstein felt when he flicked on the power switch.

# CARTOON STYLE

We'll start with a bit of fun. Nothing too complicated—in fact nothing is too complicated in this book as simplicity is what we're after. A bit of humorous cartooning should always cheer us up on a rainy day.

BEFORE YOU START TO DETAIL THE WHOLE BODY, LET'S PUT A FACE ON OUR COMIC HERO. IT ONLY TAKES 3 TO 4 STEPS AND OUR CHISELLED-JAW SUPERHERO WILL BE COMPLETE.

## <STRAIGHT ON>

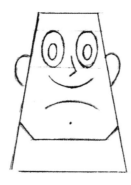

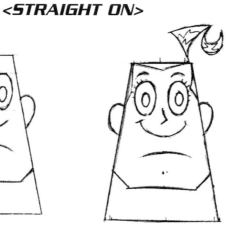

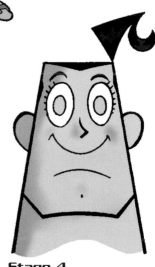

**Stage 1**
Draw an oblong shaping the jaw.

**Stage 2**
Add the eyes, nose, mouth, and ears.

**Stage 3**
Fill in the essential details.

**Stage 4**
And finally ink and color it.

## <SIDE ON>

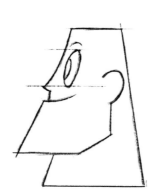

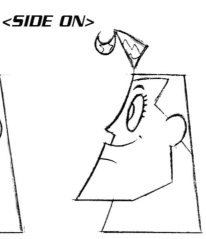

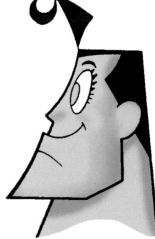

**Stage 1**
Draw an oblong shaping the jaw.

**Stage 2**
Add the eyes, nose, mouth, and ears.

**Stage 3**
Fill in the essential details.

**Stage 4**
And finally ink and color it.

SEE? ABSOLUTELY NOTHING TO IT! GIVE YOURSELF A PAT ON THE BACK.

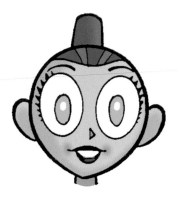

AS YOU'VE SEEN, THE MALE IS MOSTLY CONSTRUCTED OF SHARP ANGULAR LINES. BY CONTRAST HIS LOVELY SIDEKICK IS ALL SOFT CURVES ...

## <STRAIGHT ON>

  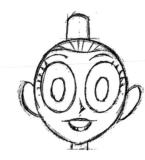

**Stage 1**
Start with a circle.
Add the lower jaw.

**Stage 2**
Then eyes, nose,
mouth, and ears.

**Stage 3**
Now the details.

**Stage 4**
Ink and color.

## <SIDE ON>

 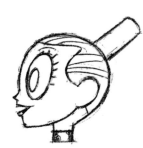 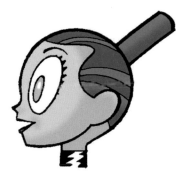

**Stage 1**
Draw an oblong
shaping the jaw.

**Stage 2**
Then eyes, nose,
mouth, and ears.

**Stage 3**
Fill in the essential
details.

**Stage 4**
And finally ink
and color it.

AGAIN, PRETTY SIMPLE. AND YOU
DIDN'T THINK GEOMETRY WAS FUN ...

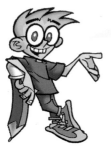

THE PROCEDURE IS THE SAME AS BEFORE. AGAIN, REMEMBER TO THINK OF YOUR SQUARES AND CIRCLES AS SOLID OBJECTS.

OF COURSE, WE WON'T ALWAYS BE DRAWING FROM JUST TWO ANGLES. HERE WE TACKLE OUR COUPLE, VIEWING THEM AT A THREE-QUARTER ANGLE, PLUS LOOKING DOWN ON THEM, THEN UP...

NOTICE HOW THE GUIDELINES FOR HER EYES FOLLOWS THE CURVE OF THE CIRCLE "BALL."

**Stage 1**

**Stage 2**

**Stage 3**

**Stage 4**

**Stage 1**

**Stage 2**

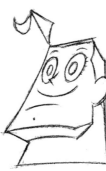

**Stage 3**

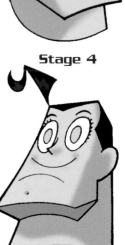

**Stage 4**

**Stage 1**

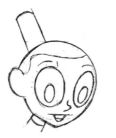

**Stage 2**

**Stage 3**

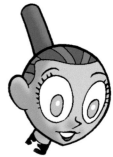

**Stage 4**

**Stage 1**

**Stage 2**

**Stage 3**

**Stage 4**

THE FACE AND ITS EXPRESSIONS ARE THE MAIN FOCUS OF OUR ATTENTION. GIVING YOUR CHARACTERS EMOTION REALLY BRINGS THEM ALIVE.

HERE ARE JUST A FEW. YOU TRY SOME.

**Happy**

**Intense**

**Shouting**

**Apologetic**

**Tearful**

**Tired**

**Laughing**

**Angry**

**Startled**

**Suspicious**

**Shocked**

**Flirtatious**

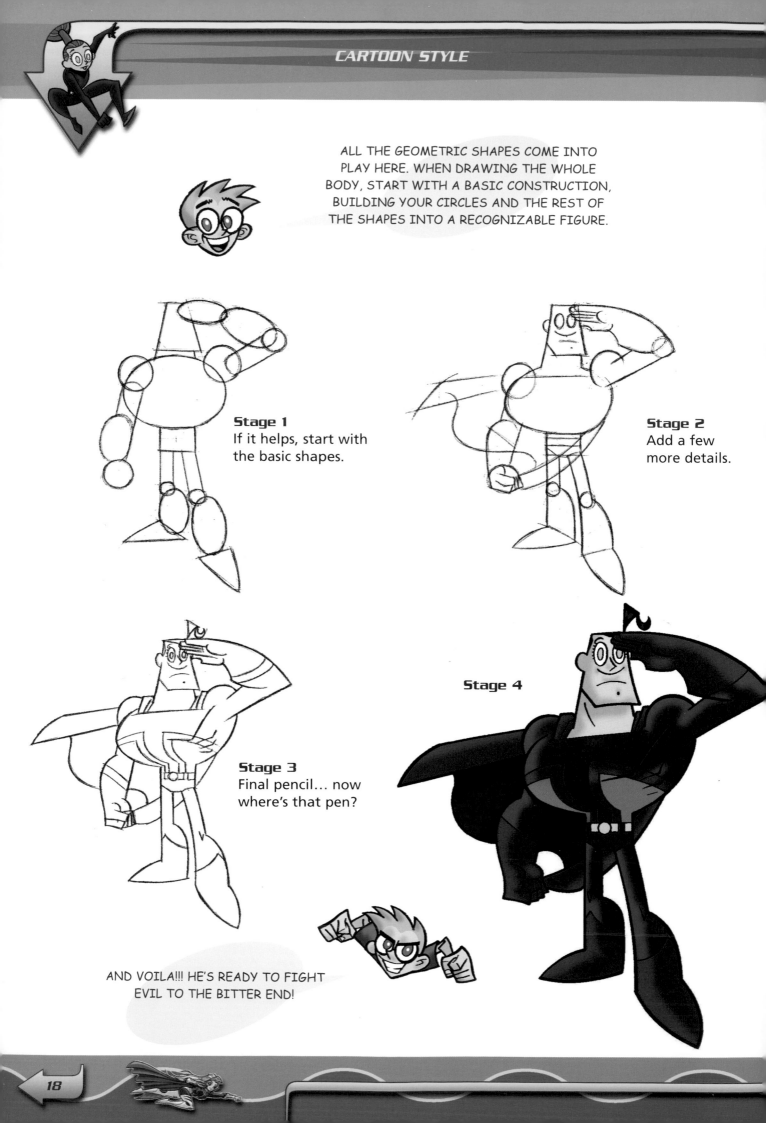

ALL THE GEOMETRIC SHAPES COME INTO PLAY HERE. WHEN DRAWING THE WHOLE BODY, START WITH A BASIC CONSTRUCTION, BUILDING YOUR CIRCLES AND THE REST OF THE SHAPES INTO A RECOGNIZABLE FIGURE.

**Stage 1**
If it helps, start with the basic shapes.

**Stage 2**
Add a few more details.

**Stage 3**
Final pencil… now where's that pen?

**Stage 4**

AND VOILA!!! HE'S READY TO FIGHT EVIL TO THE BITTER END!

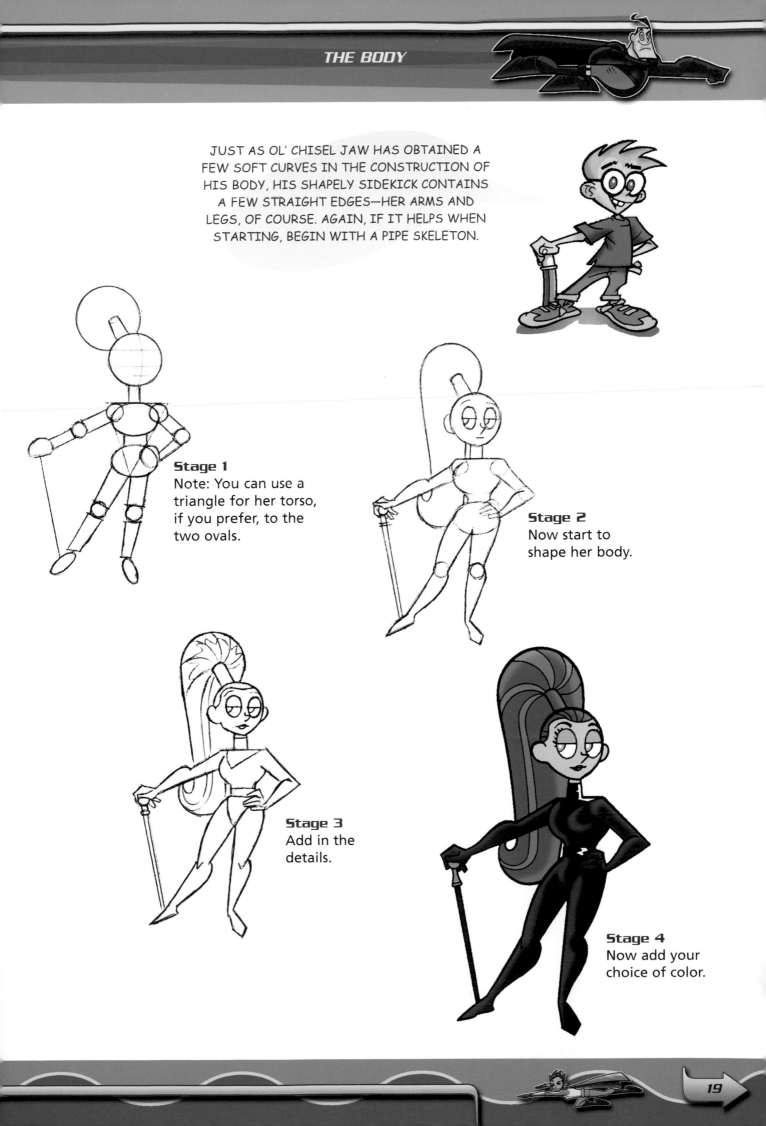

JUST AS OL' CHISEL JAW HAS OBTAINED A FEW SOFT CURVES IN THE CONSTRUCTION OF HIS BODY, HIS SHAPELY SIDEKICK CONTAINS A FEW STRAIGHT EDGES—HER ARMS AND LEGS, OF COURSE. AGAIN, IF IT HELPS WHEN STARTING, BEGIN WITH A PIPE SKELETON.

**Stage 1**
Note: You can use a triangle for her torso, if you prefer, to the two ovals.

**Stage 2**
Now start to shape her body.

**Stage 3**
Add in the details.

**Stage 4**
Now add your choice of color.

RIGHT, WE'VE MASTERED THE STATIC HERO POSE.
NOW LET'S GIVE HIM A BIT OF MOVEMENT.

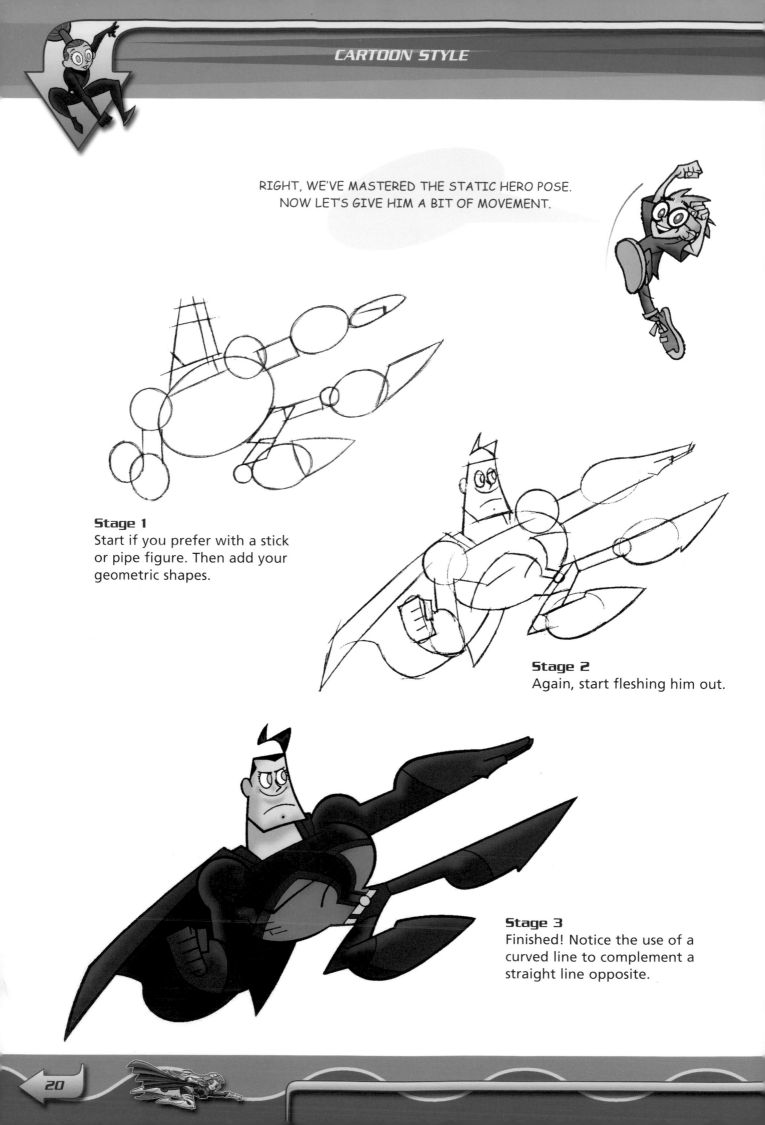

**Stage 1**
Start if you prefer with a stick
or pipe figure. Then add your
geometric shapes.

**Stage 2**
Again, start fleshing him out.

**Stage 3**
Finished! Notice the use of a
curved line to complement a
straight line opposite.

AS YOU SEE, THIS IS A THREE-QUARTER ANGLE, PLUS OUR VIEWPOINT IS FROM ABOVE.

**Stage 1**
As mentioned before, if it helps, start with a pipe figure!

**Stage 2**
This is an example of foreshortening, which will be covered in detail on page 121. So don't panic, all will be explained.

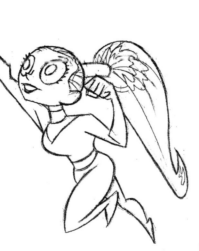

**Stage 3**
The finished pencil illustration.

**Stage 4**
Bet you're dying to start inking and coloring.

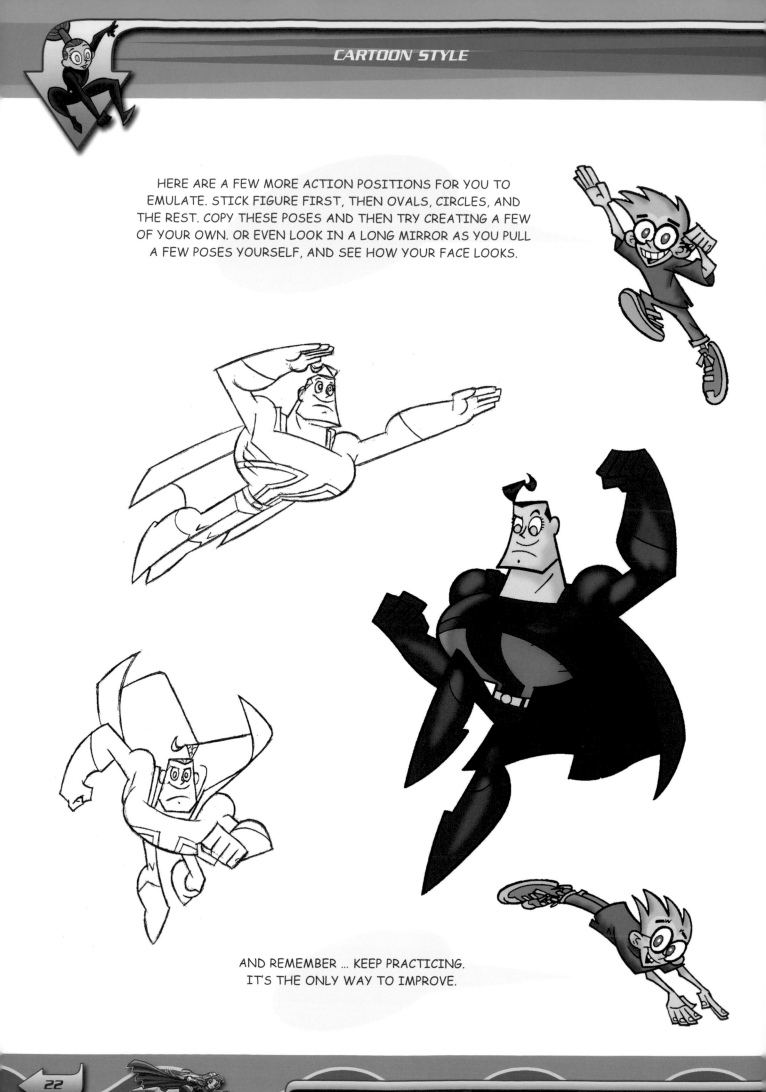

HERE ARE A FEW MORE ACTION POSITIONS FOR YOU TO EMULATE. STICK FIGURE FIRST, THEN OVALS, CIRCLES, AND THE REST. COPY THESE POSES AND THEN TRY CREATING A FEW OF YOUR OWN. OR EVEN LOOK IN A LONG MIRROR AS YOU PULL A FEW POSES YOURSELF, AND SEE HOW YOUR FACE LOOKS.

AND REMEMBER ... KEEP PRACTICING. IT'S THE ONLY WAY TO IMPROVE.

NOW A FEW ACTION SHOTS OF OUR HEROINE IN A COUPLE OF THE POSES. YOU'LL NOTICE SOME FORESHORTENING IS USED. THIS WILL BE EXPLAINED IN DETAIL LATER (AGAIN, SEE PAGE 121) AS ALL THREE STYLES USE IT A LOT.

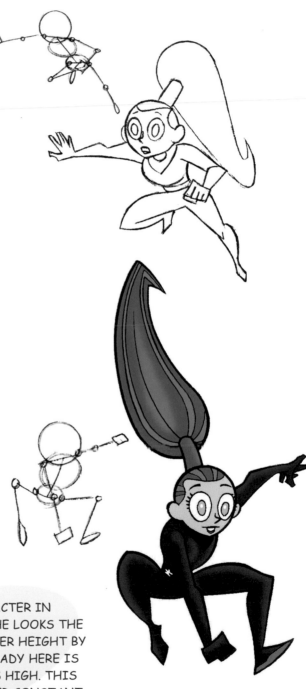

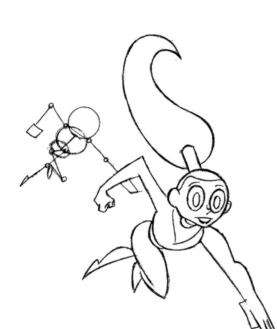

TO KEEP YOUR CHARACTER IN PROPORTION (SO THAT SHE LOOKS THE RIGHT SIZE), WORK OUT HER HEIGHT BY HEAD SIZE. OUR LITTLE LADY HERE IS FOUR AND A HALF HEADS HIGH. THIS SHOULD HELP YOU KEEP HER CONSTANT.

EXPERIMENT WITH THESE EXAMPLES.
PEAR, BANANA, ROUND, AND SQUARE.

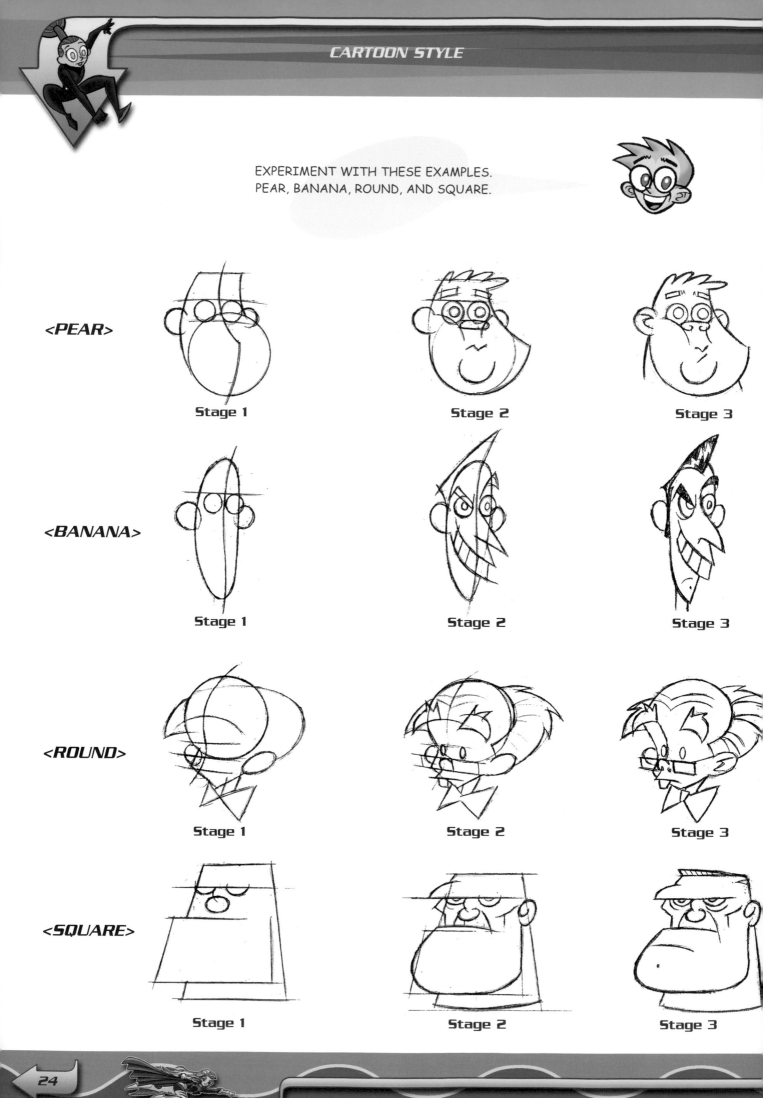

**<PEAR>**

Stage 1          Stage 2          Stage 3

**<BANANA>**

Stage 1          Stage 2          Stage 3

**<ROUND>**

Stage 1          Stage 2          Stage 3

**<SQUARE>**

Stage 1          Stage 2          Stage 3

TRADITION SEEMS TO DICTATE THE SHAPE OF THE HEAD OF THE CHARACTER. VILLAINS ARE USUALLY THICK SET AND SQUARE, OR LONG AND THIN. THERE IS ABSOLUTELY NO END AS TO HOW YOU CAN PLAY AROUND WITH FACES. EYES, NOSES, MOUTHS, EYEBROWS, AND EARS IN THE CARTOON WORLD CAN ALL BE GROSSLY MANIPULATED. TRY TO WORK OUT THE BUILD-UP TO THE FOUR CHARACTERS ON THE RIGHT.

**Stage 4**

**Stage 5**

**Stage 4**

**Stage 5**

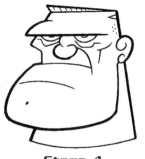

**Stage 4**

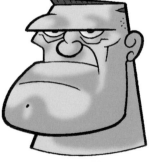

**Stage 5**

**Stage 4**

**Stage 5**

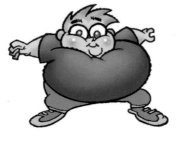

ALSO TRY OUR RATHER
GENEROUSLY GIRTHED SIDEKICK.
NOT AN AWFUL LOT OF SHARP,
ANGULAR LINES IN HIM.

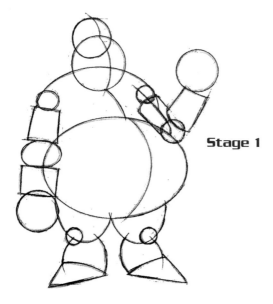

**Stage 1**

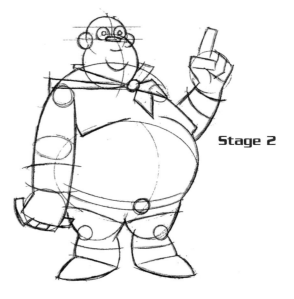

**Stage 2**

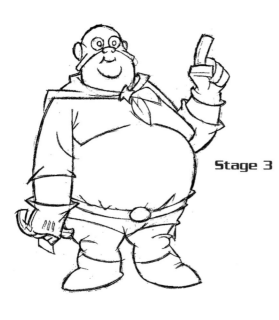

**Stage 3**

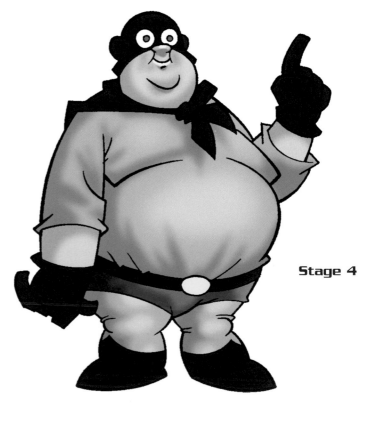

**Stage 4**

NOW FOR THE TALL, THIN VILLAIN. HE'S GOT SHARP, VERY POINTY FEATURES, SO THERE ARE A FEW TRIANGLES THROWN IN HERE. YOU'LL NOTICE THAT BY ADDING A CENTRAL LINE TO THE FACE AND TORSO, YOU'LL GIVE THEM THE SUGGESTION OF FULLNESS, RATHER THAN SIMPLY BEING FLAT SHAPES.

NOTE THE HIPS. THE RIGHT LIFTS A LITTLE AS HE SHIFTS HIS WEIGHT ONTO THE RIGHT LEG. AS HIS CHEST IS PUFFED OUT, DO THE SAME WITH HIS BEHIND TO BALANCE HIS STANCE.

**Stage 1**

**Stage 2**

**Stage 3**

WELL, US SHORT GUYS HAVE TO STICK TOGETHER. REMEMBER, PUTTING A CENTRAL LINE DIVIDING THE FACE MAKES IT APPEAR A ROUND, RATHER THAN A FLAT CIRCLE. AND IT HELPS IMMENSELY WITH THE POSITIONING OF THE EYES, NOSE, AND MOUTH.

**Stage 1**

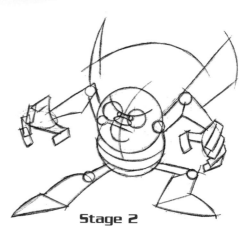

**Stage 2**

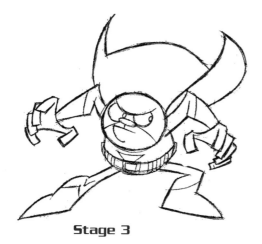

**Stage 3**

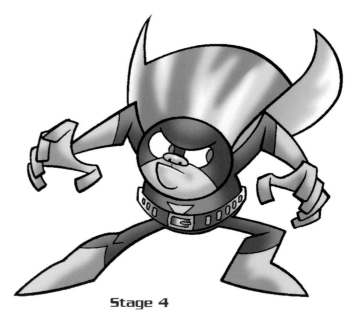

**Stage 4**

NOTE THE HANDS ON THIS PARTICULAR GUY. THEY'RE SQUARER, WITH BLUNTED ENDS— RATHER LIKE FISHSTICKS! I THINK THIS COMPLEMENTS THE ROUNDNESS OF HIS BODY AS A COUNTERBALANCE.

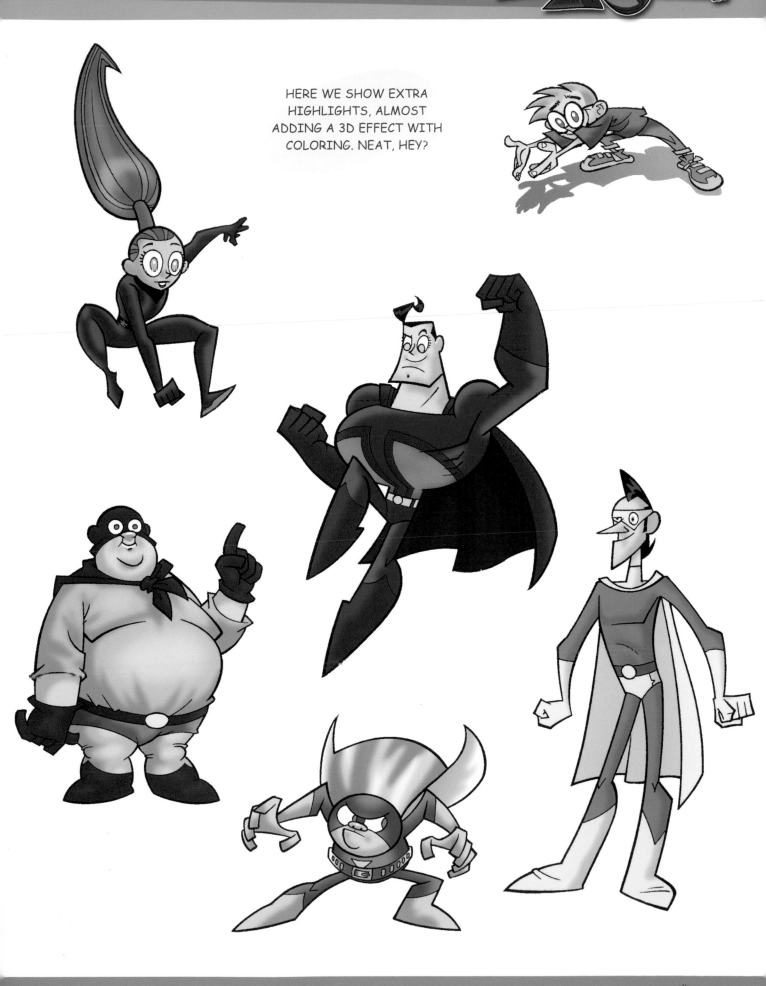

HERE WE SHOW EXTRA
HIGHLIGHTS, ALMOST
ADDING A 3D EFFECT WITH
COLORING. NEAT, HEY?

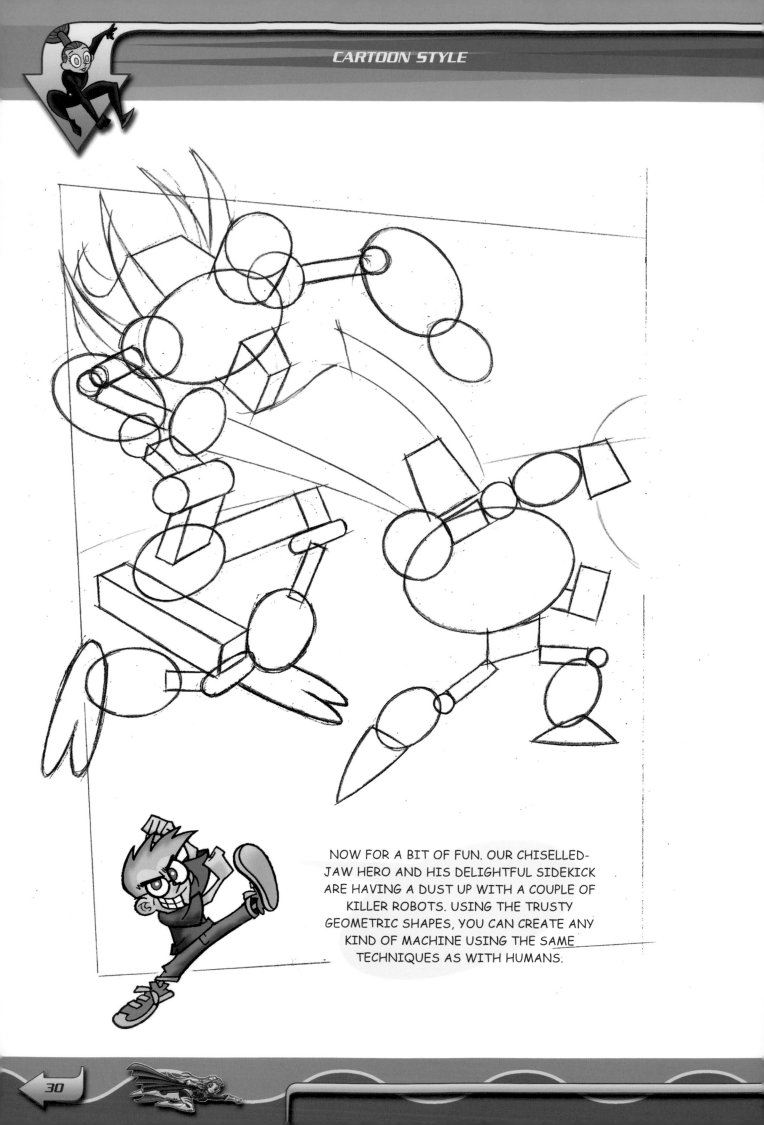

NOW FOR A BIT OF FUN. OUR CHISELLED-JAW HERO AND HIS DELIGHTFUL SIDEKICK ARE HAVING A DUST UP WITH A COUPLE OF KILLER ROBOTS. USING THE TRUSTY GEOMETRIC SHAPES, YOU CAN CREATE ANY KIND OF MACHINE USING THE SAME TECHNIQUES AS WITH HUMANS.

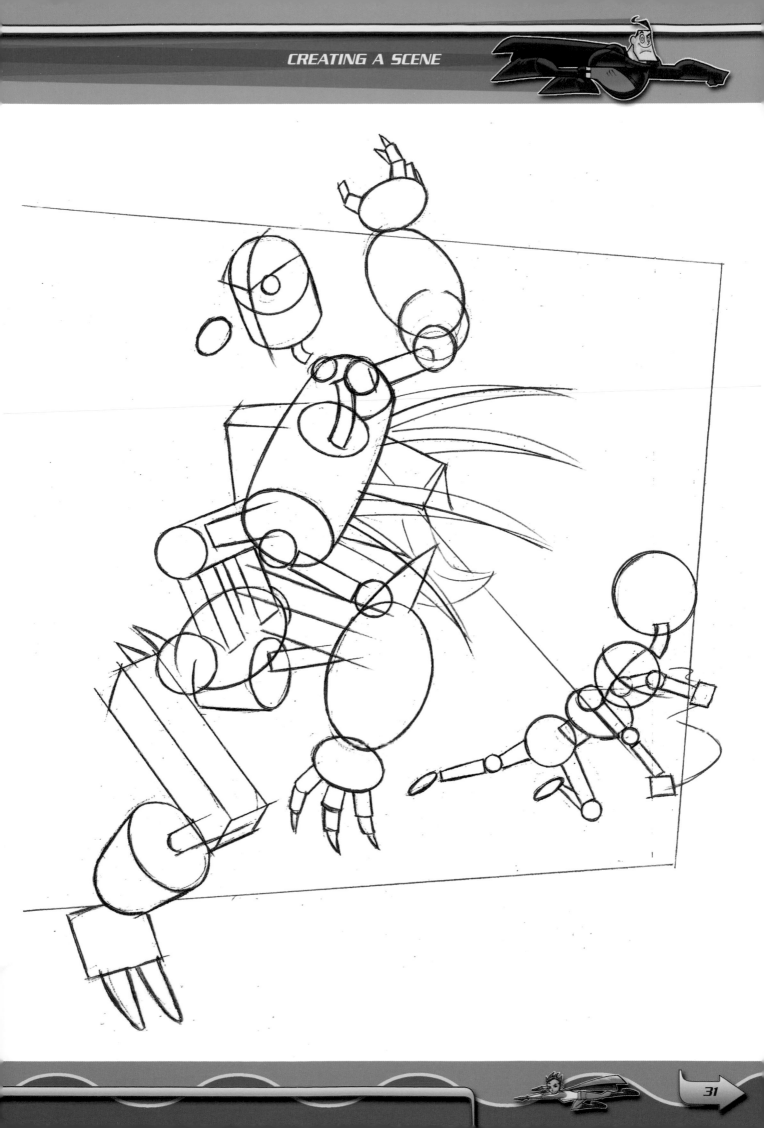

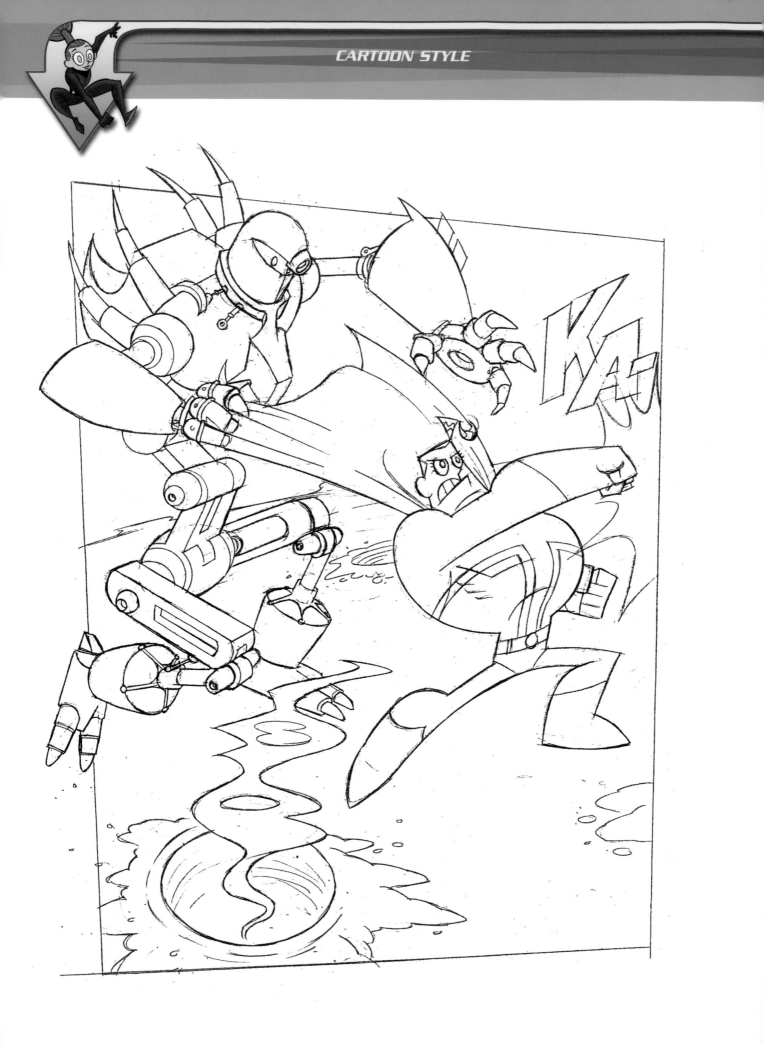

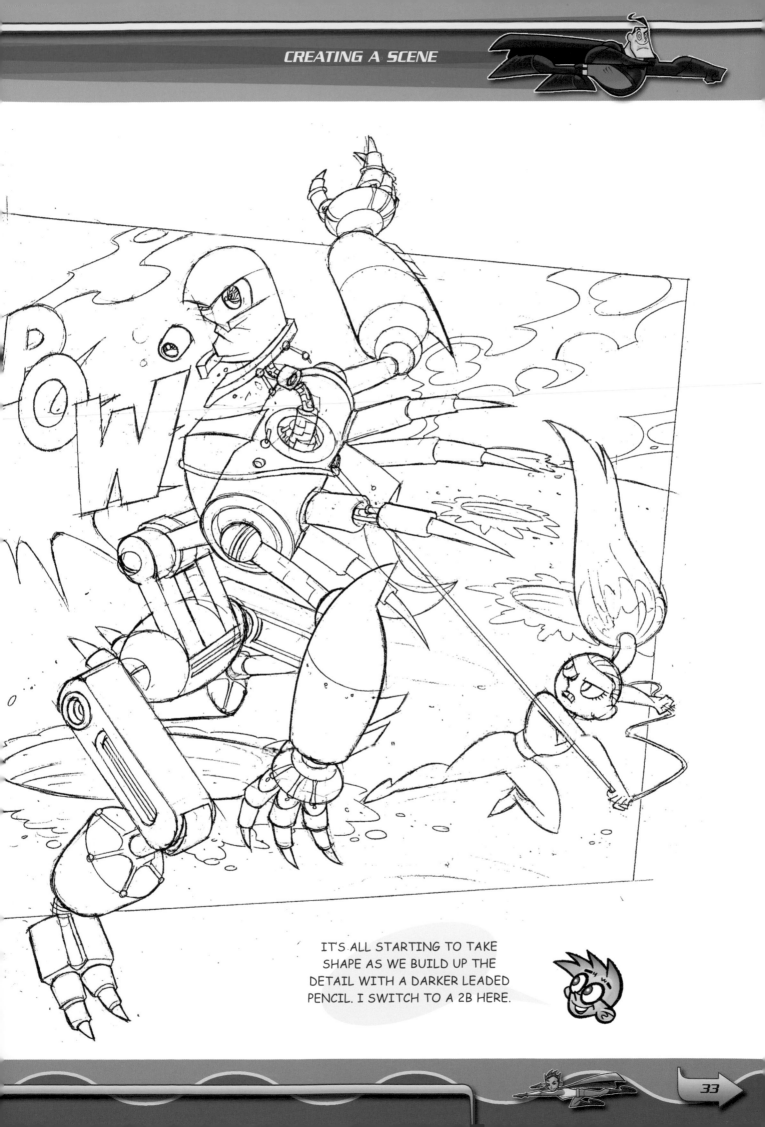

IT'S ALL STARTING TO TAKE
SHAPE AS WE BUILD UP THE
DETAIL WITH A DARKER LEADED
PENCIL. I SWITCH TO A 2B HERE.

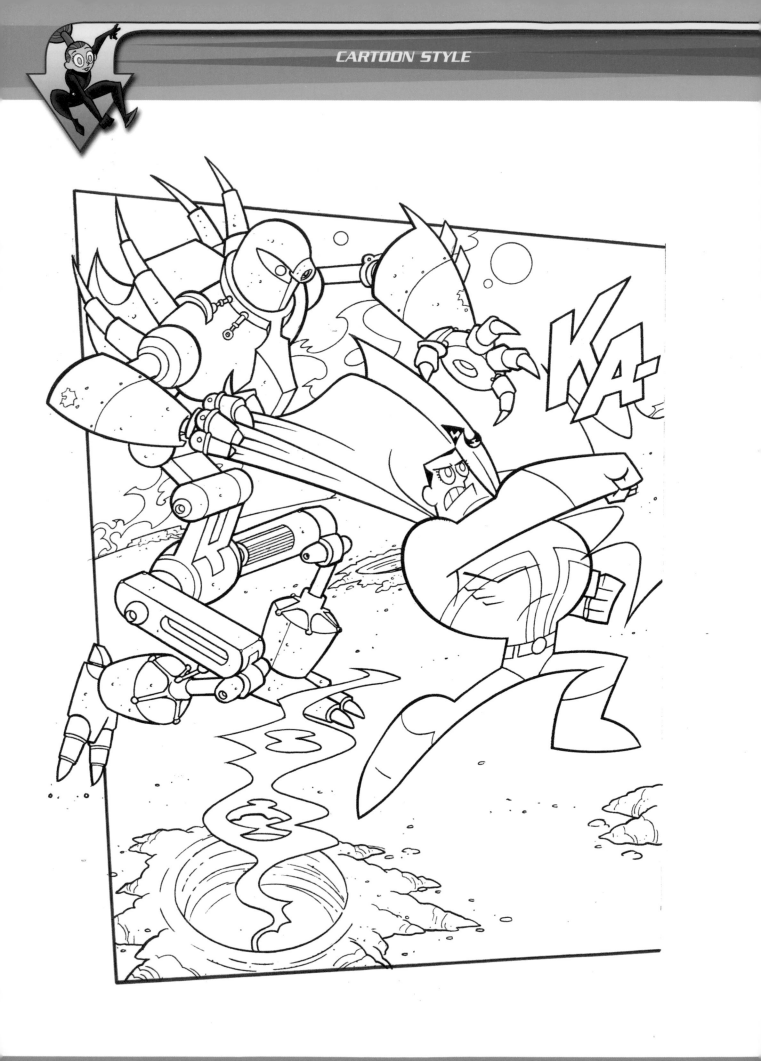

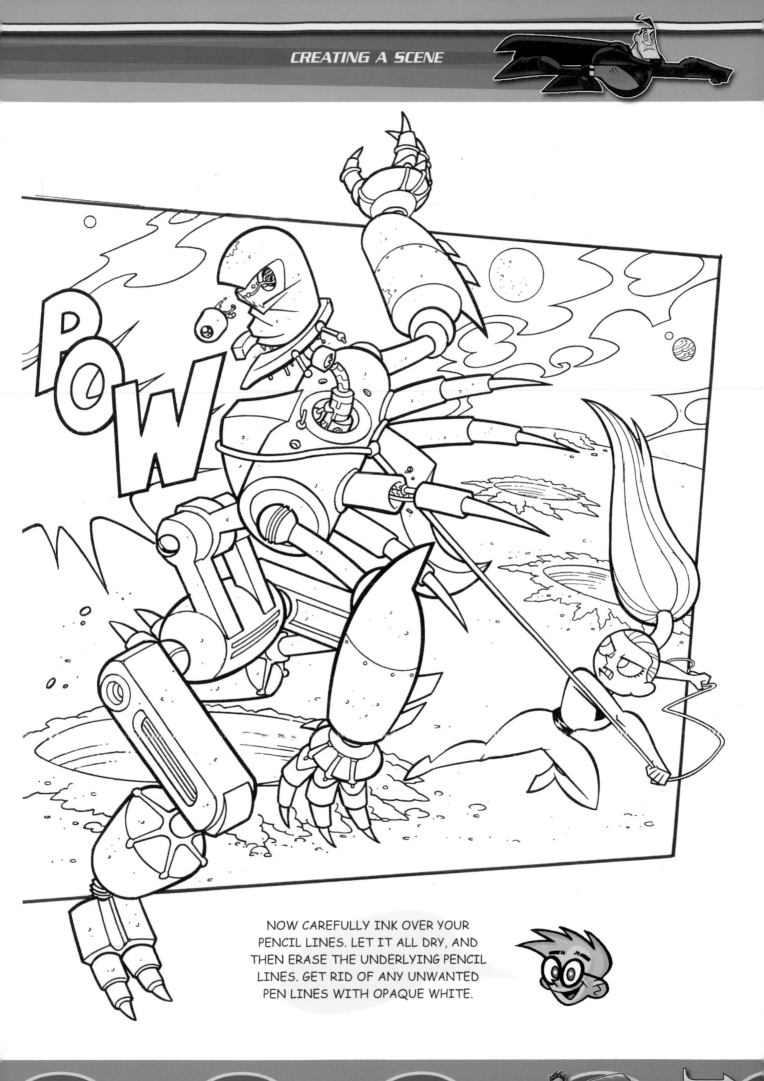

NOW CAREFULLY INK OVER YOUR
PENCIL LINES. LET IT ALL DRY, AND
THEN ERASE THE UNDERLYING PENCIL
LINES. GET RID OF ANY UNWANTED
PEN LINES WITH OPAQUE WHITE.

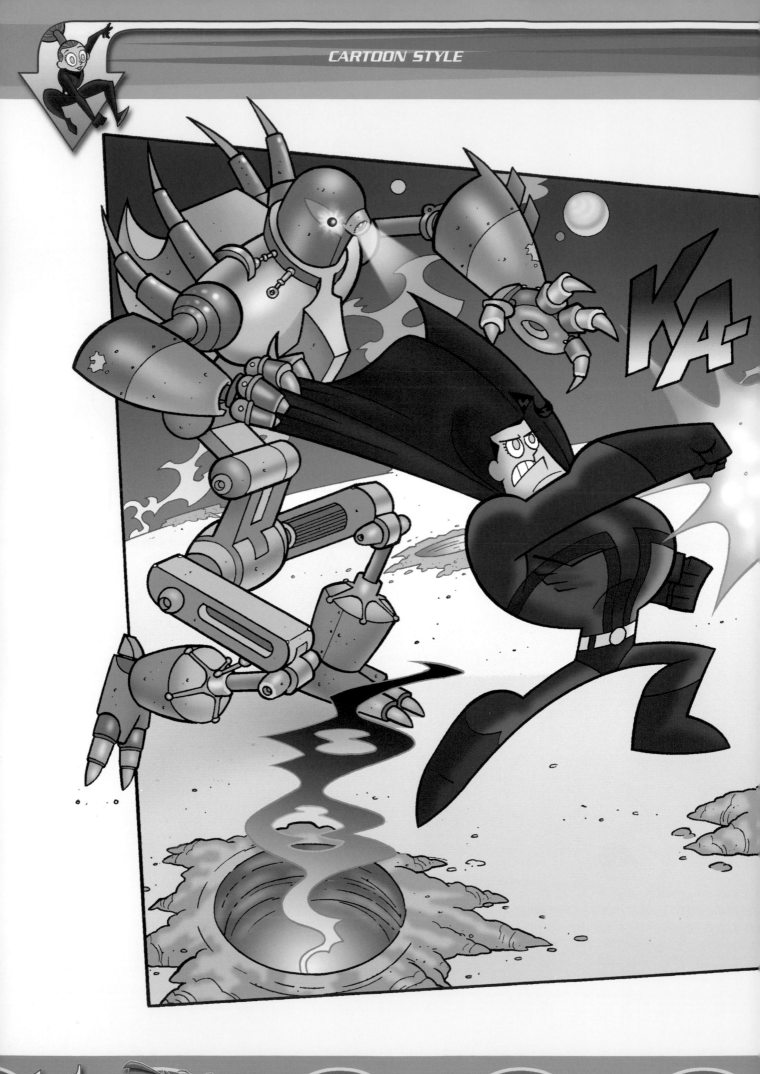

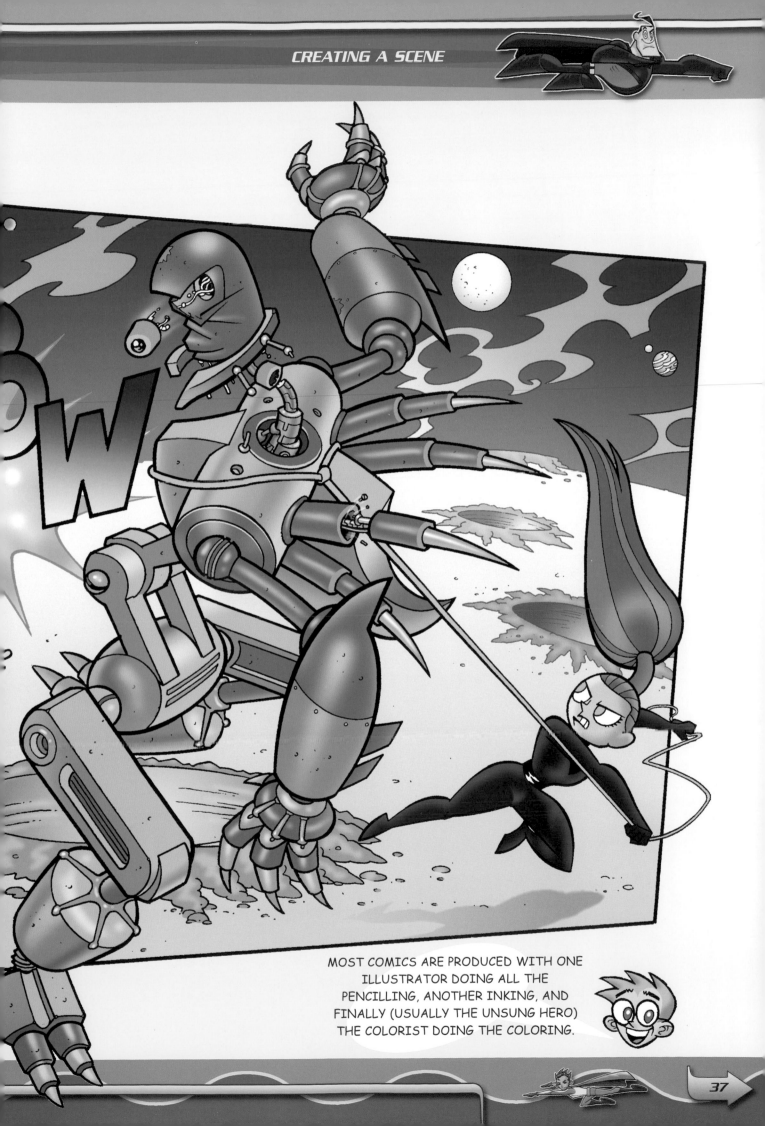

MOST COMICS ARE PRODUCED WITH ONE
ILLUSTRATOR DOING ALL THE
PENCILLING, ANOTHER INKING, AND
FINALLY (USUALLY THE UNSUNG HERO)
THE COLORIST DOING THE COLORING.

# SCREEN HEROES
## TEEN SUPERHERO

*Here we're going to tackle the slick, stylized action heroes you'll find animated on many children's TV programs. This is my personal favorite as I love the sharp-edged, angular graphic look.*

THE STRUCTURE FOR THIS STYLE IS BASICALLY THE SAME AS FOR THE BIG-JAWED HERO, BUT A BIT MORE "MANNEQUINISH": THE TORSO PARTICULARLY AS IT USES A "BALL AND SOCKET" JOINT. YOU'LL SEE WHAT I MEAN IF YOU LOOK AT THE WOODEN MANNEQUINS OF THE HUMAN FIGURE FOUND IN MOST ART MATERIAL SHOPS.

SO, WITHOUT FURTHER ADO, GET YOUR CIRCLES, OVALS, SQUARES, AND THE REST READY.

FOR THIS POPULAR COMIC AND ANIMATED STYLE, IT'S BEST, AS EVER, TO START WITH THE HUMBLE BUT IMPORTANT STICK FIGURE. DON'T TRY TO DRAW THE COMPLETE FIGURE ALL AT ONCE. SPEND AS LONG AS YOU CHOOSE DOODLING WITH STICK FIGURES. YOUR TIME WON'T BE WASTED.

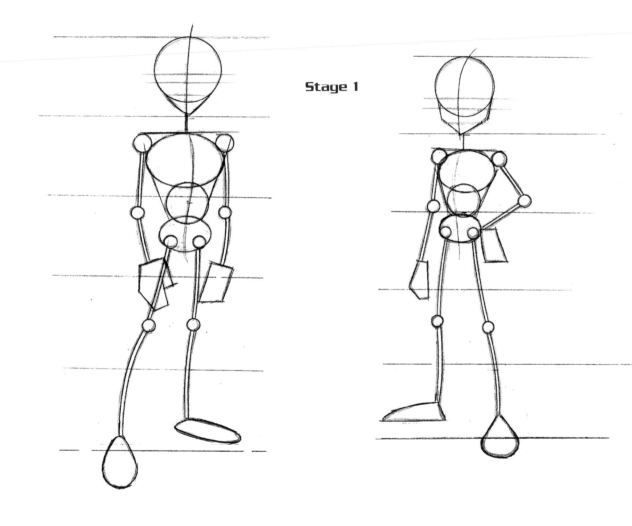

**Stage 1**

PRACTICE DRAWING YOUR FIGURES IN MANY DIFFERENT POSITIONS. WALKING, RUNNING, FLYING ETC. IT ALL HELPS!

IF YOU'VE SKIPPED THE FIRST CHAPTER BECAUSE THIS IS MORE YOUR STYLE, DON'T WORRY, I WON'T BE OFFENDED. WE START THE SAME ANYWAY, WITH A STICK OR PIPE FIGURE.

KEEP PRACTICING. IT BUILDS SELF-CONFIDENCE, WHICH IS A BIG FACTOR FOR THE BUDDING ARTIST.

### Stage 2

Visualize the upper and lower limbs as ball and socket joints (see below) which enables them to rotate in any natural position.

OVALS, CIRCLES, CYLINDERS, AND SQUARES ARE ALL USED TO CONSTRUCT A MANNEQUIN.

THE HEAD RESTING IN THE NECK SOCKET ENABLES IT TO ALLOW NATURAL MOVEMENT.

THE LEGS ARE MORE RESTRICTED BUT ALSO TURN AND LIFT IN THE BALL AND SOCKET.

THE CHEST FITS ON THE UPPER ABDOMEN (BALL) ENABLING YOU TO DRAW THE TORSO IN A NATURAL STANCE.

FOR THIS STYLE, THE "STICK FIGURE" AND MANNEQUIN IS THE KEY TO GETTING IT RIGHT.

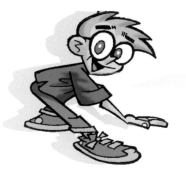

YOUR AVERAGE TEEN SUPERHERO
IS ROUGHLY FIVE HEADS TALL.
THE MALE IS SOMEWHAT WIRY
WITH THINNISH ARMS AND
LEGS, AND RATHER BIG FEET!

**Stage 3**
You may find the
fleshing-out part rather
trickier than it looks.
Persist! The more you
work at it, the easier
it will become.

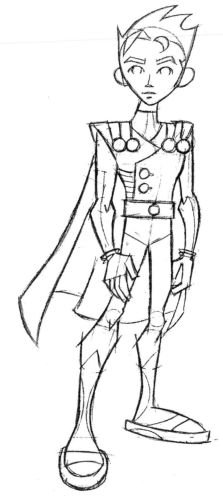

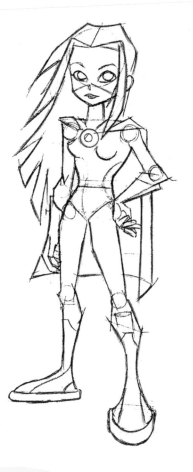

THE FEMALE, OF COURSE, IS CURVIER,
ALTHOUGH HER ARMS AND LEGS ARE
ALMOST AS ANGULAR AS THE MALE'S. HER
FEET, TOO, ARE RATHER LARGE IN
PROPORTION TO HER SIZE. EVEN SO, SHE
STILL LOOKS PRETTY CUTE TO ME!

A TASTER OF WHAT WE'RE GOING
TO GET AT THE INK STAGE. THIS, OF
COURSE, IS AN ART FORM IN
ITSELF. MORE ON THIS SUBJECT AT
A LATER STAGE (SEE PAGE 139).

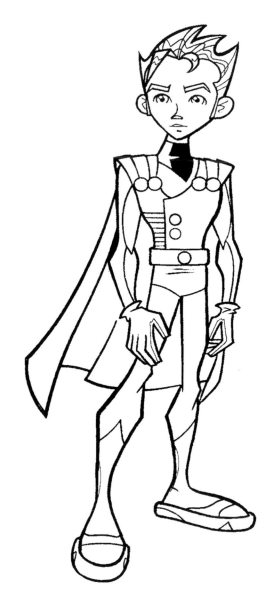

**Stage 4**

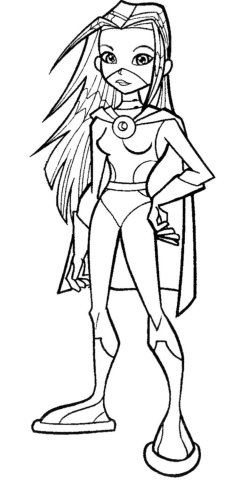

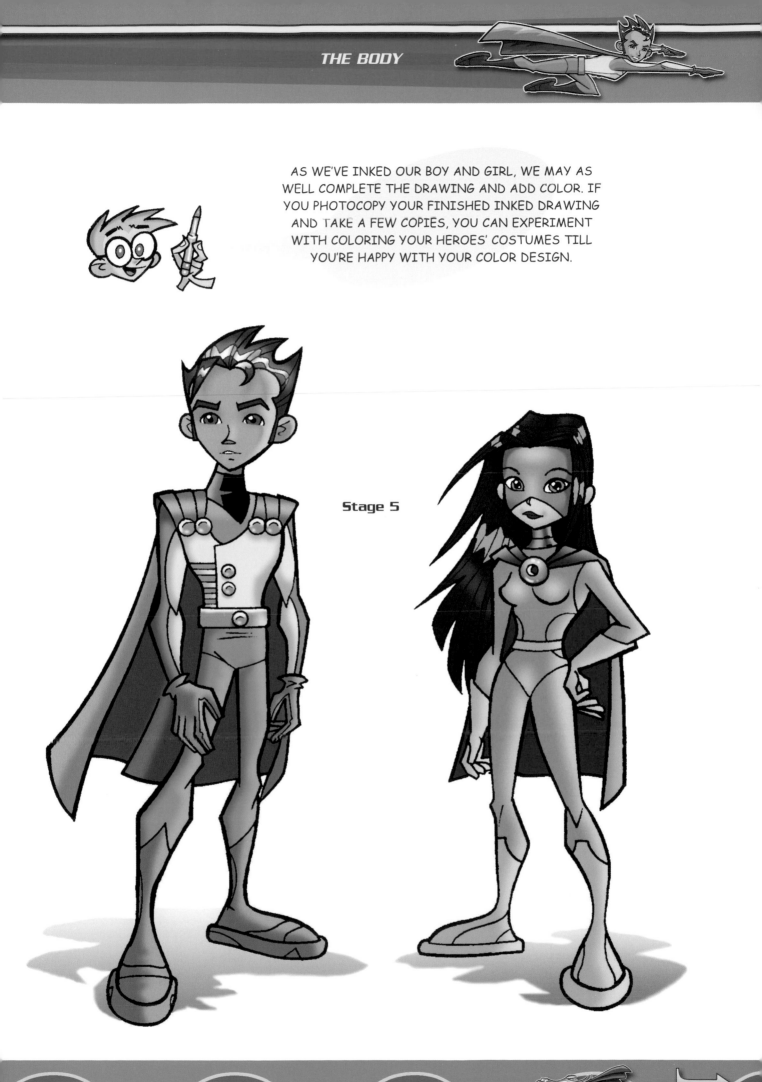

AS WE'VE INKED OUR BOY AND GIRL, WE MAY AS WELL COMPLETE THE DRAWING AND ADD COLOR. IF YOU PHOTOCOPY YOUR FINISHED INKED DRAWING AND TAKE A FEW COPIES, YOU CAN EXPERIMENT WITH COLORING YOUR HEROES' COSTUMES TILL YOU'RE HAPPY WITH YOUR COLOR DESIGN.

Stage 5

ONCE WE HAVE OUR BASIC FIGURE CONSTRUCTION, I USUALLY START TO FILL IN THE DETAIL OF THE HEAD BEFORE DOING THE SAME TO THE REST OF THE BODY.

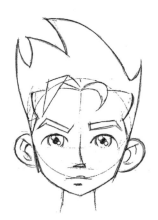

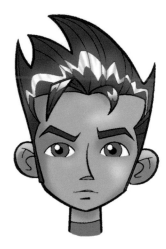

**Stage 1**  **Stage 2**  **Stage 3**

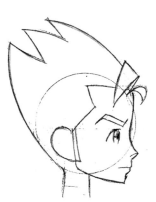

**Stage 1**  **Stage 2**  **Stage 3**

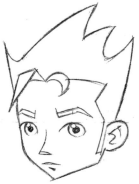

**Stage 1**  **Stage 2**  **Stage 3**

WE FOLLOW THE SAME SEQUENCE FOR THE FEMALE AS WE DID WITH THE MALE. START WITH A CIRCLE, THEN SKETCH IN THE LOWER JAW. A FEW LINES DENOTE THE EYE, NOSE, AND MOUTH LEVEL. THEN START TO ADD IN THE DETAILS.

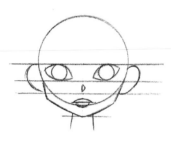

**Stage 1**

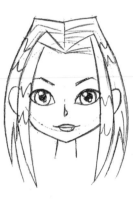

**Stage 2**

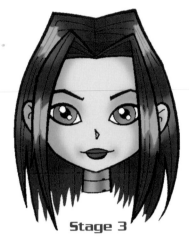

**Stage 3**

**Stage 1**

**Stage 2**

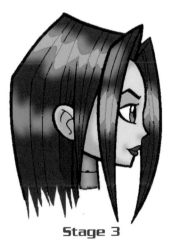

**Stage 3**

**Stage 1**

**Stage 2**

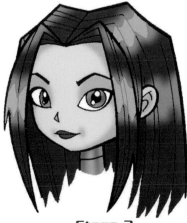

**Stage 3**

NOW LET'S TILT THE CHIN UP AND DOWN.
GETTING THE ANGLE TO LOOK CORRECT CAN BE A
LITTLE TRICKY, BUT IT HELPS TO TRY TO SEE THE
HEAD AS A BALL, WITH THE CENTER LINE AND
THE EYES, NOSE, AND MOUTH LINE DRAWN ON.

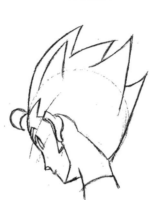

**Stage 1**

**Stage 2**

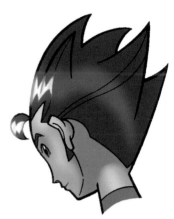

**Stage 3**

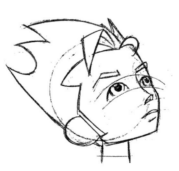

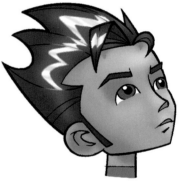

**Stage 1**

**Stage 2**

**Stage 3**

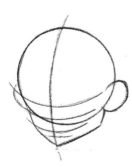

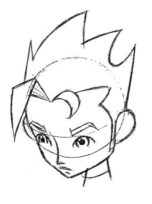

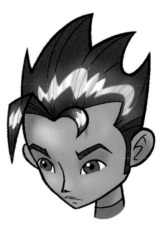

**Stage 1**

**Stage 2**

**Stage 3**

THE SAME PRINCIPLES APPLY TO OUR YOUNG
LADY. REMEMBER HER HAIR LINE. IT STAYS
IN THE SAME PLACE ON HER HEAD AS SHE
MOVES HER HEAD UP OR DOWN. THE BACK
VIEW YOU JUST HAVE TO GUESS AT A BIT.

**Stage 1**          **Stage 2**          **Stage 3**

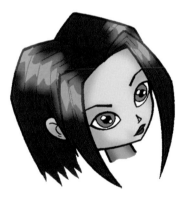

**Stage 1**          **Stage 2**          **Stage 3**

**Stage 1**          **Stage 2**          **Stage 3**

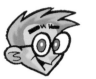

TRY THESE. ALWAYS EXPERIMENT AND PLAY AROUND WITH HEAD SHAPES, EYES, NOSES ETC. ...

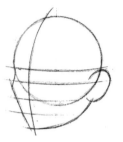

**Stage 1**

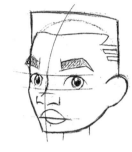

**Stage 2**

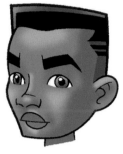

**Stage 3**

**Stage 1**

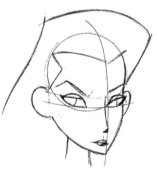

**Stage 2**

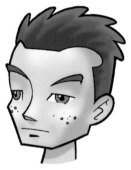

**Stage 3**

**Stage 1**

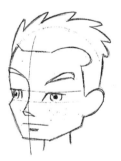

**Stage 2**

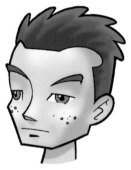

**Stage 3**

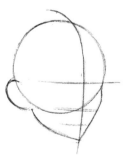

**Stage 1**

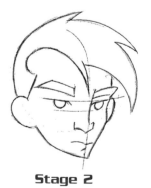

**Stage 2**

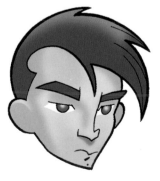

**Stage 3**

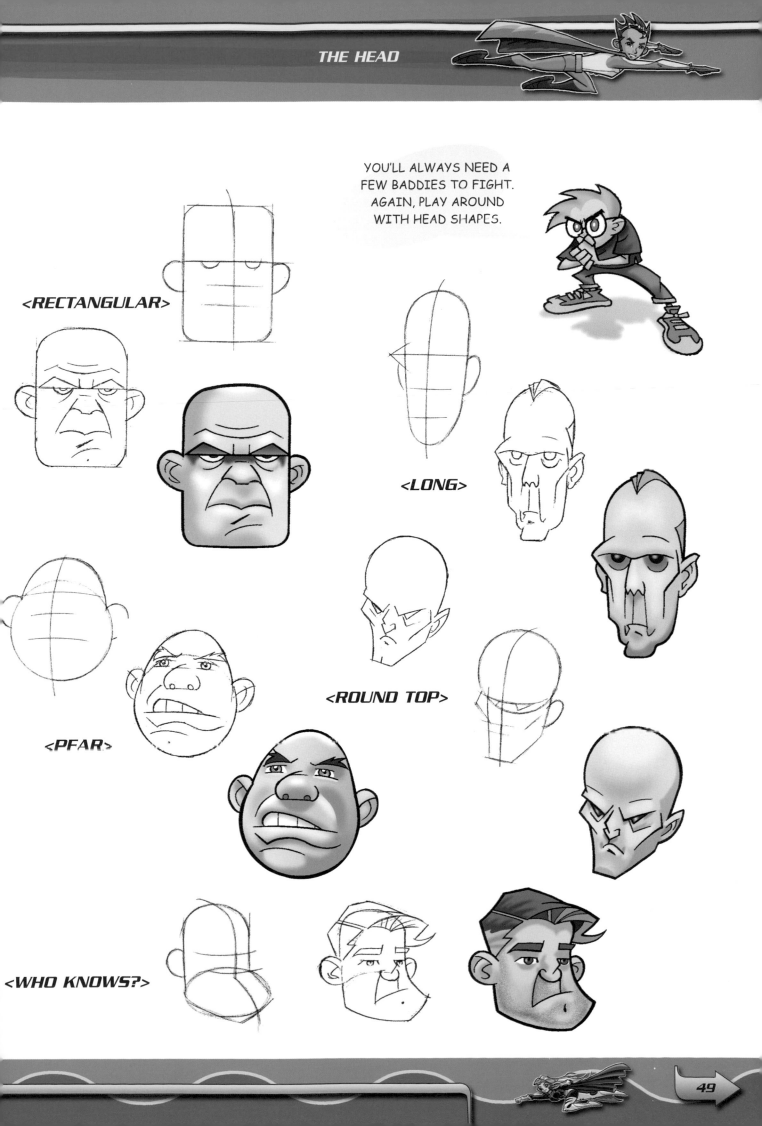

YOU'LL ALWAYS NEED A FEW BADDIES TO FIGHT. AGAIN, PLAY AROUND WITH HEAD SHAPES.

<RECTANGULAR>

<LONG>

<PEAR>

<ROUND TOP>

<WHO KNOWS?>

WE NOW FOLLOW THE SAME PROCEDURE AS AT THE START OF THIS CHAPTER. YOU'LL ALSO NOTICE SOME SLIGHT PERSPECTIVE HERE. HIS LEFT FOOT IS A BIT FARTHER AWAY FROM US THAN THE RIGHT; THEREFORE HE IS IN A THREE-QUARTER ANGLE TO US, NOT STRAIGHT ON. PERSPECTIVE RULES WOULD MEAN THAT THE GUIDELINES AT HIS SHOULDERS, HIPS, KNEES, AND FEET WOULD MEET AT THE SAME POINT EVENTUALLY, AND IF YOU CAN'T SEE THIS AS BEING THE CASE, YOU MAY WANT TO ADJUST THE LINES A LITTLE.

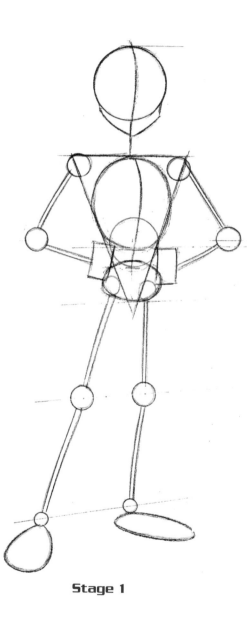

**Stage 1**

**Stage 2**

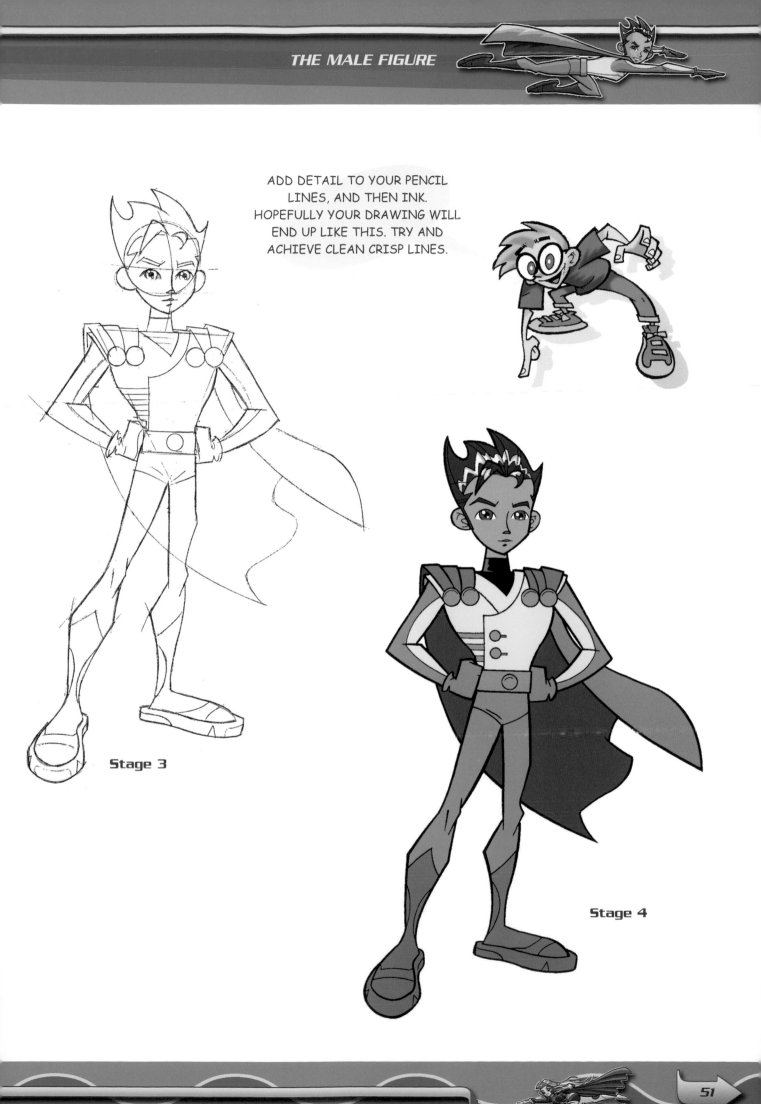

ADD DETAIL TO YOUR PENCIL
LINES, AND THEN INK.
HOPEFULLY YOUR DRAWING WILL
END UP LIKE THIS. TRY AND
ACHIEVE CLEAN CRISP LINES.

**Stage 3**

**Stage 4**

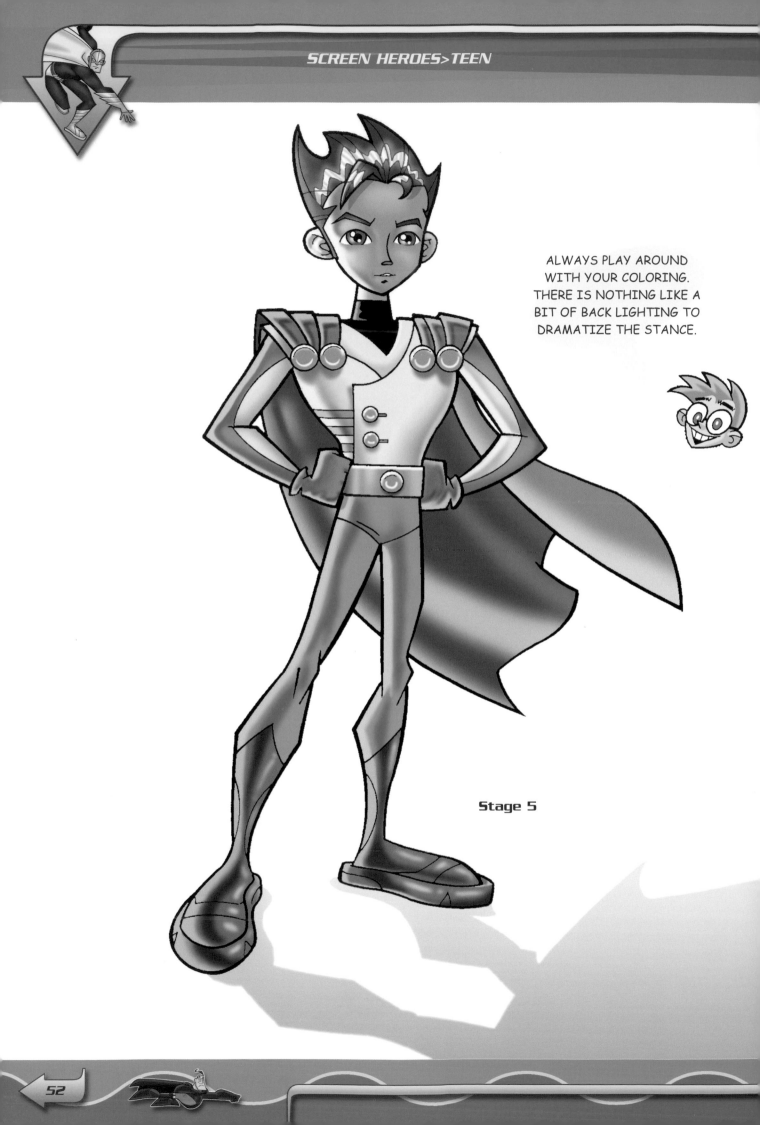

ALWAYS PLAY AROUND
WITH YOUR COLORING.
THERE IS NOTHING LIKE A
BIT OF BACK LIGHTING TO
DRAMATIZE THE STANCE.

**Stage 5**

ALTHOUGH OUR FEISTY YOUNG LADY
IS CONSTRUCTED IN THE SAME WAY,
WE OBVIOUSLY CHANGE THE BODY
SLIGHTLY BY GIVING HER A SMALLER
WAIST AND HIGH, BROADER HIPS.

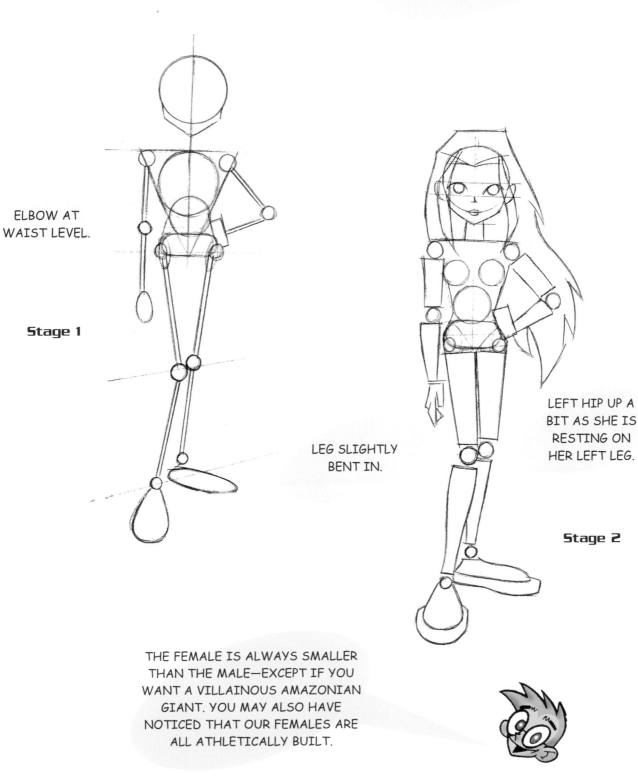

ELBOW AT
WAIST LEVEL.

**Stage 1**

LEG SLIGHTLY
BENT IN.

LEFT HIP UP A
BIT AS SHE IS
RESTING ON
HER LEFT LEG.

**Stage 2**

THE FEMALE IS ALWAYS SMALLER
THAN THE MALE—EXCEPT IF YOU
WANT A VILLAINOUS AMAZONIAN
GIANT. YOU MAY ALSO HAVE
NOTICED THAT OUR FEMALES ARE
ALL ATHLETICALLY BUILT.

FOLLOW THE SAME PROCEDURE AS WITH THE MALE. CLEAN PENCIL LINES AND CLEAN INKING.

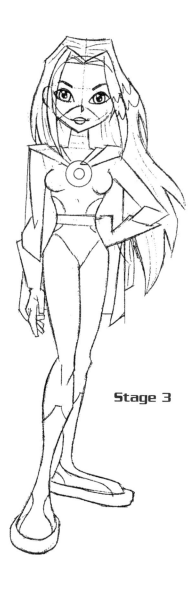

**Stage 3**

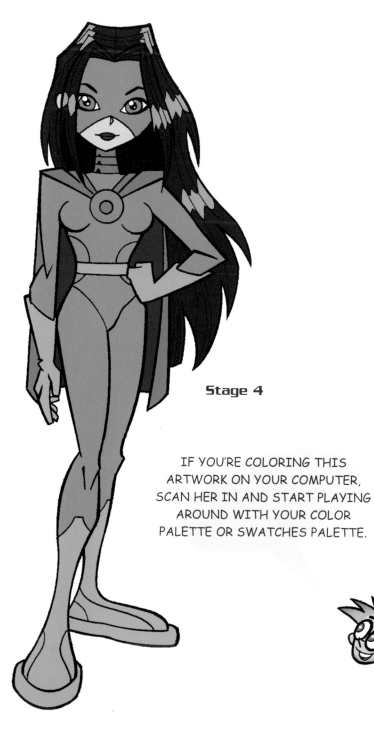

**Stage 4**

IF YOU'RE COLORING THIS ARTWORK ON YOUR COMPUTER, SCAN HER IN AND START PLAYING AROUND WITH YOUR COLOR PALETTE OR SWATCHES PALETTE.

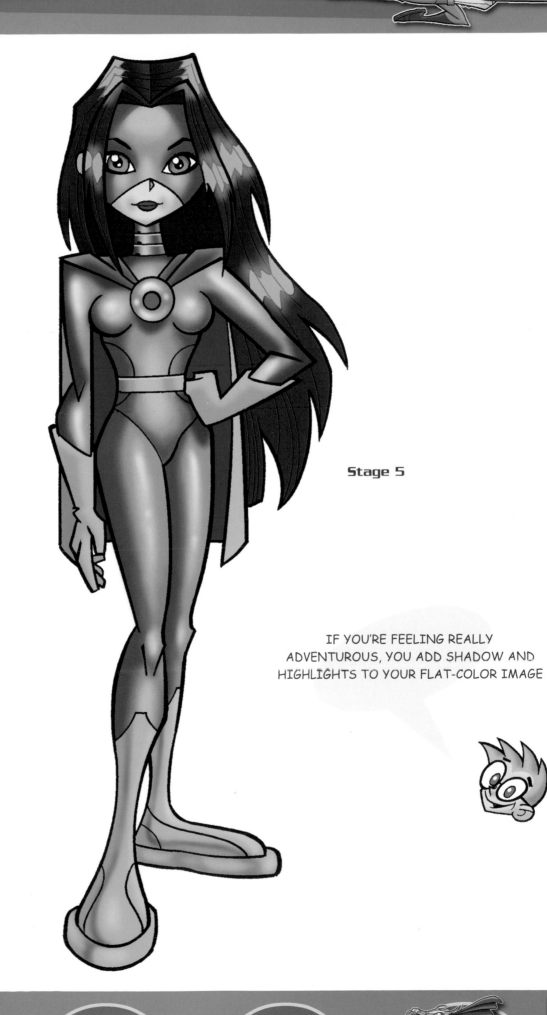

**Stage 5**

IF YOU'RE FEELING REALLY
ADVENTUROUS, YOU ADD SHADOW AND
HIGHLIGHTS TO YOUR FLAT-COLOR IMAGE

Stage 2

Stage 1

Stage 1

Stage 2

Stage 3

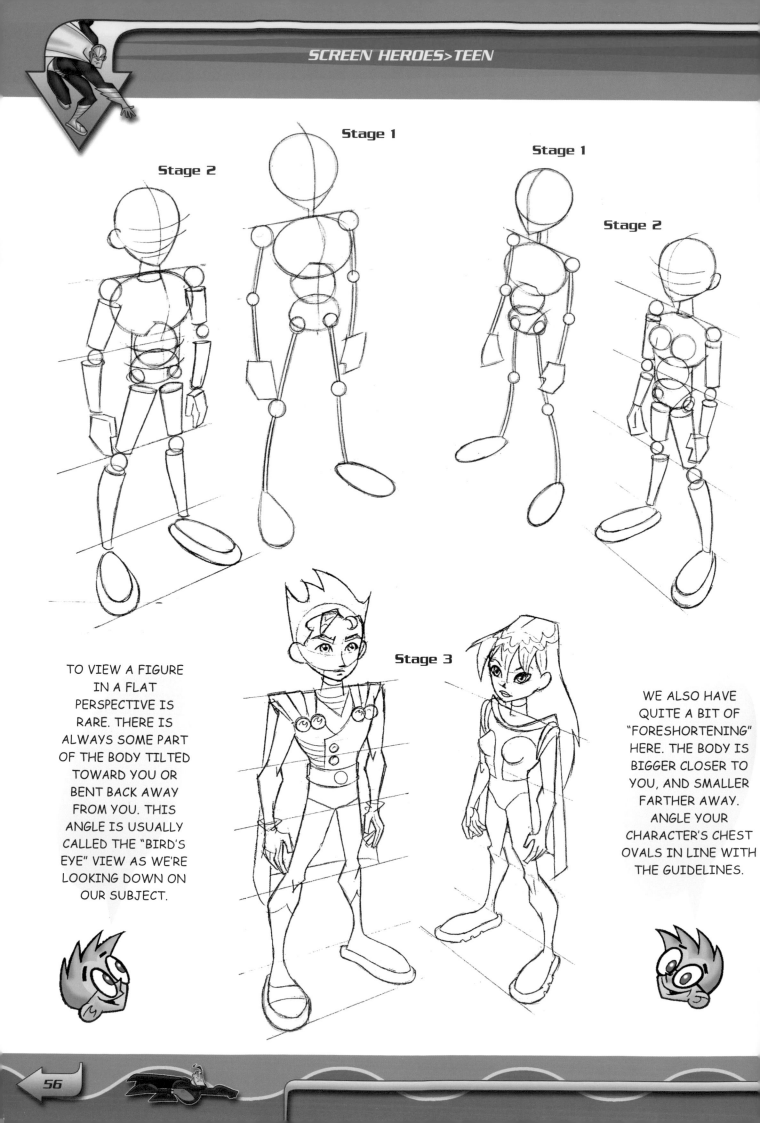

TO VIEW A FIGURE IN A FLAT PERSPECTIVE IS RARE. THERE IS ALWAYS SOME PART OF THE BODY TILTED TOWARD YOU OR BENT BACK AWAY FROM YOU. THIS ANGLE IS USUALLY CALLED THE "BIRD'S EYE" VIEW AS WE'RE LOOKING DOWN ON OUR SUBJECT.

WE ALSO HAVE QUITE A BIT OF "FORESHORTENING" HERE. THE BODY IS BIGGER CLOSER TO YOU, AND SMALLER FARTHER AWAY. ANGLE YOUR CHARACTER'S CHEST OVALS IN LINE WITH THE GUIDELINES.

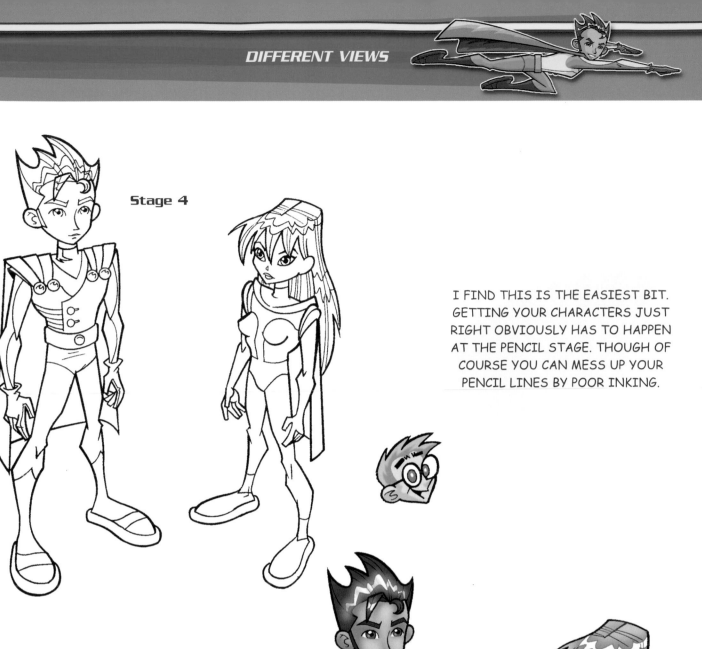

**Stage 4**

I FIND THIS IS THE EASIEST BIT. GETTING YOUR CHARACTERS JUST RIGHT OBVIOUSLY HAS TO HAPPEN AT THE PENCIL STAGE. THOUGH OF COURSE YOU CAN MESS UP YOUR PENCIL LINES BY POOR INKING.

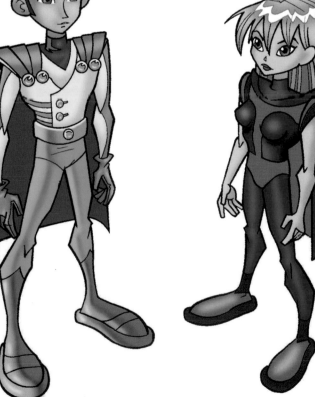

**Stage 5**

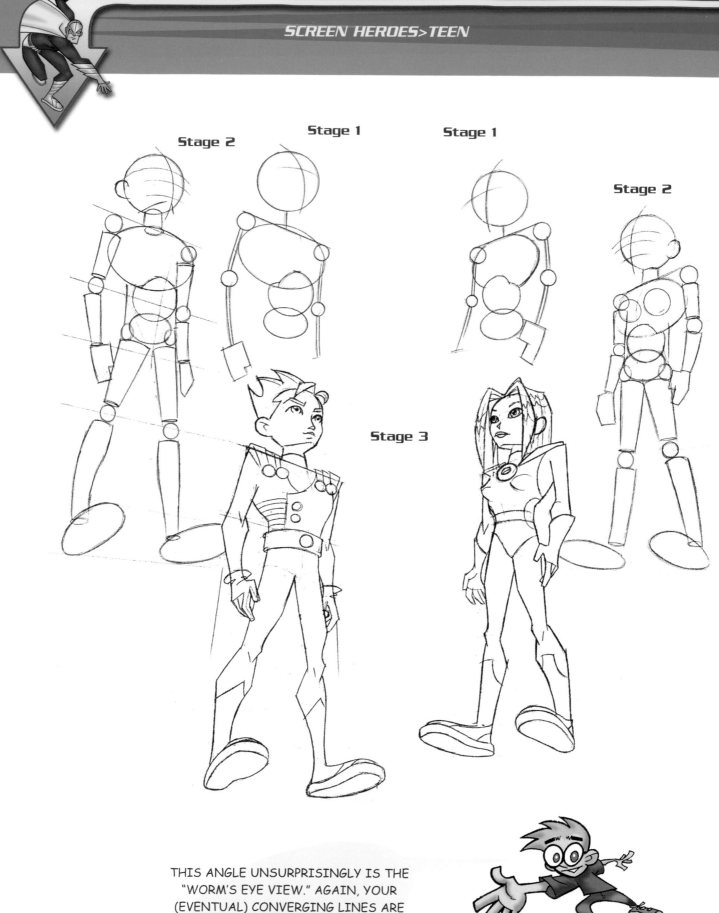

**Stage 2**

**Stage 1**

**Stage 1**

**Stage 2**

**Stage 3**

THIS ANGLE UNSURPRISINGLY IS THE "WORM'S EYE VIEW." AGAIN, YOUR (EVENTUAL) CONVERGING LINES ARE THE PERFECT GUIDE TO KEEPING YOUR DRAWING IN PERSPECTIVE.

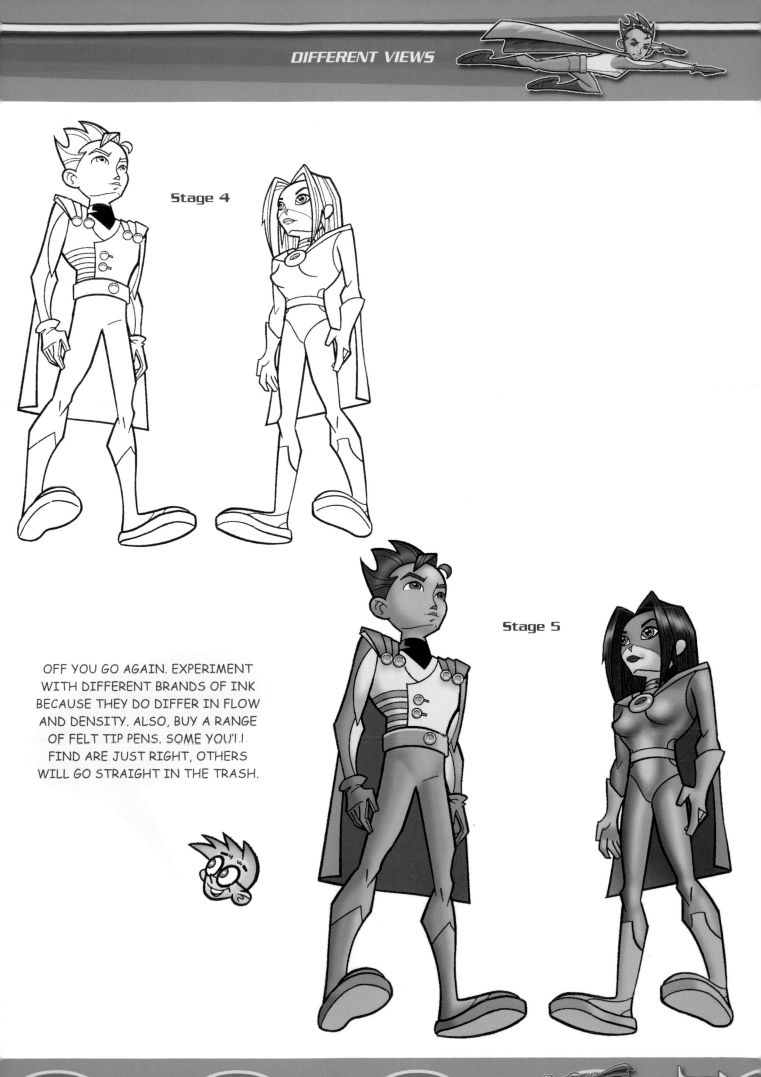

Stage 4

Stage 5

OFF YOU GO AGAIN. EXPERIMENT WITH DIFFERENT BRANDS OF INK BECAUSE THEY DO DIFFER IN FLOW AND DENSITY. ALSO, BUY A RANGE OF FELT TIP PENS. SOME YOU'LL FIND ARE JUST RIGHT, OTHERS WILL GO STRAIGHT IN THE TRASH.

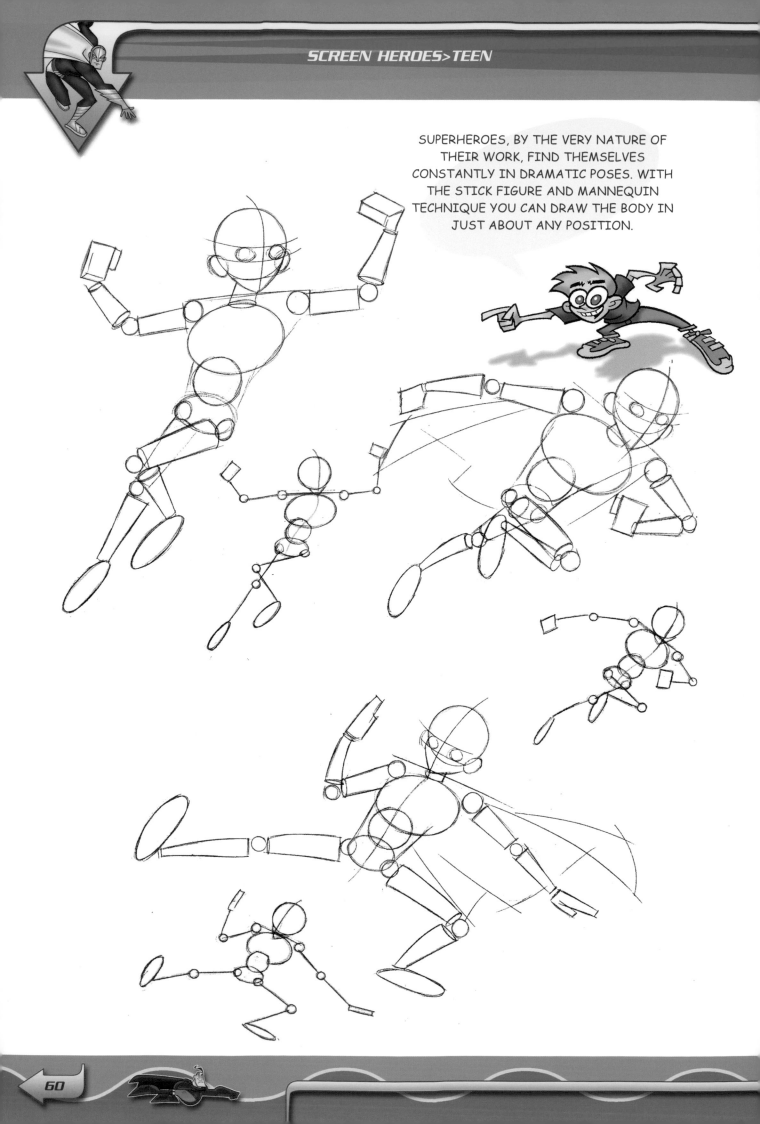

SUPERHEROES, BY THE VERY NATURE OF THEIR WORK, FIND THEMSELVES CONSTANTLY IN DRAMATIC POSES. WITH THE STICK FIGURE AND MANNEQUIN TECHNIQUE YOU CAN DRAW THE BODY IN JUST ABOUT ANY POSITION.

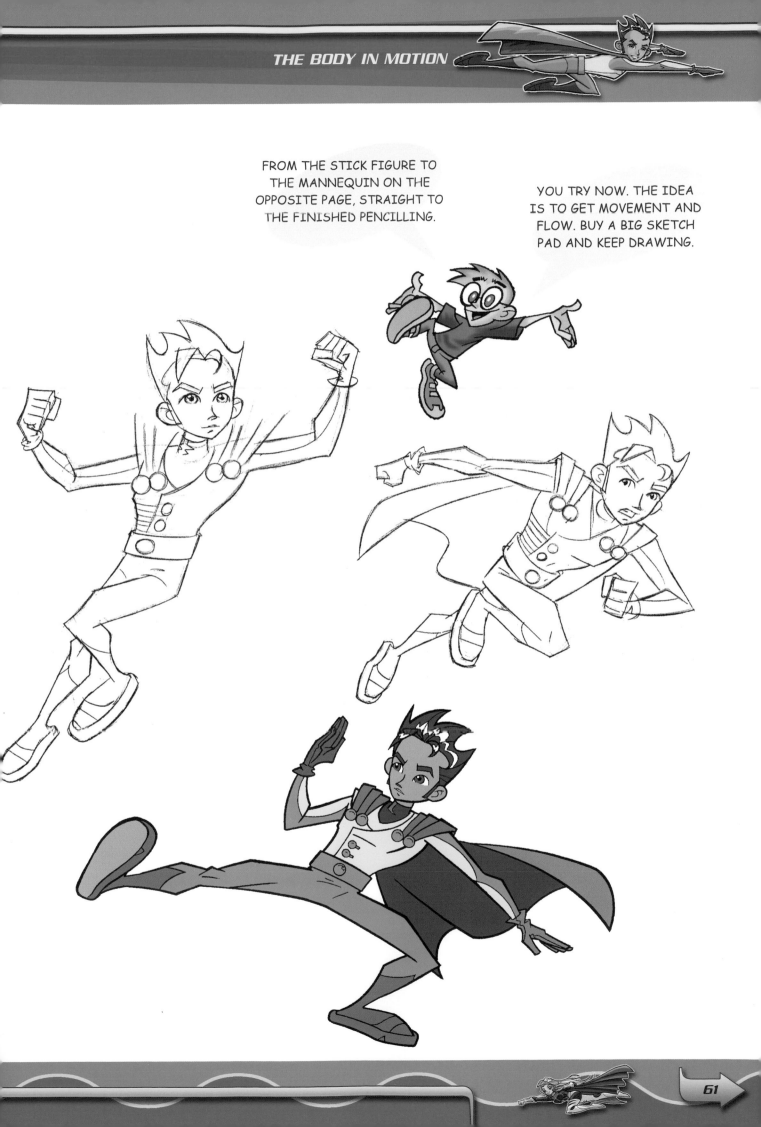

FROM THE STICK FIGURE TO THE MANNEQUIN ON THE OPPOSITE PAGE, STRAIGHT TO THE FINISHED PENCILLING.

YOU TRY NOW. THE IDEA IS TO GET MOVEMENT AND FLOW. BUY A BIG SKETCH PAD AND KEEP DRAWING.

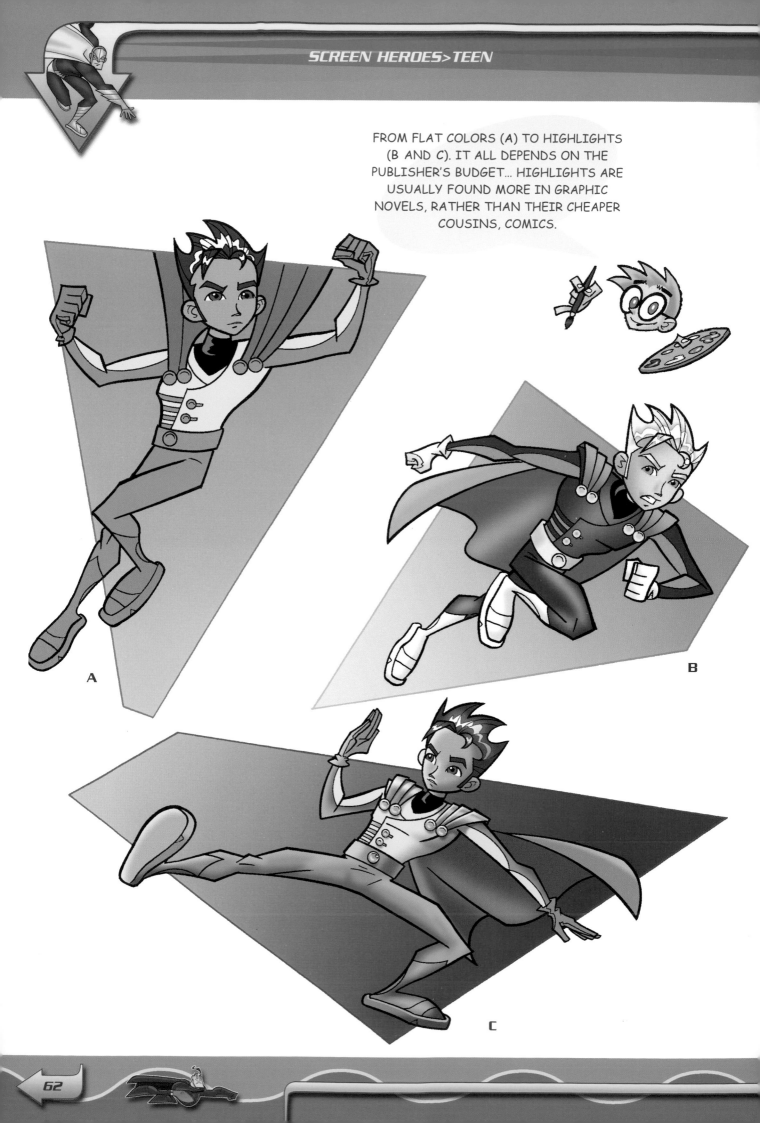

FROM FLAT COLORS (A) TO HIGHLIGHTS (B AND C). IT ALL DEPENDS ON THE PUBLISHER'S BUDGET... HIGHLIGHTS ARE USUALLY FOUND MORE IN GRAPHIC NOVELS, RATHER THAN THEIR CHEAPER COUSINS, COMICS.

A

B

C

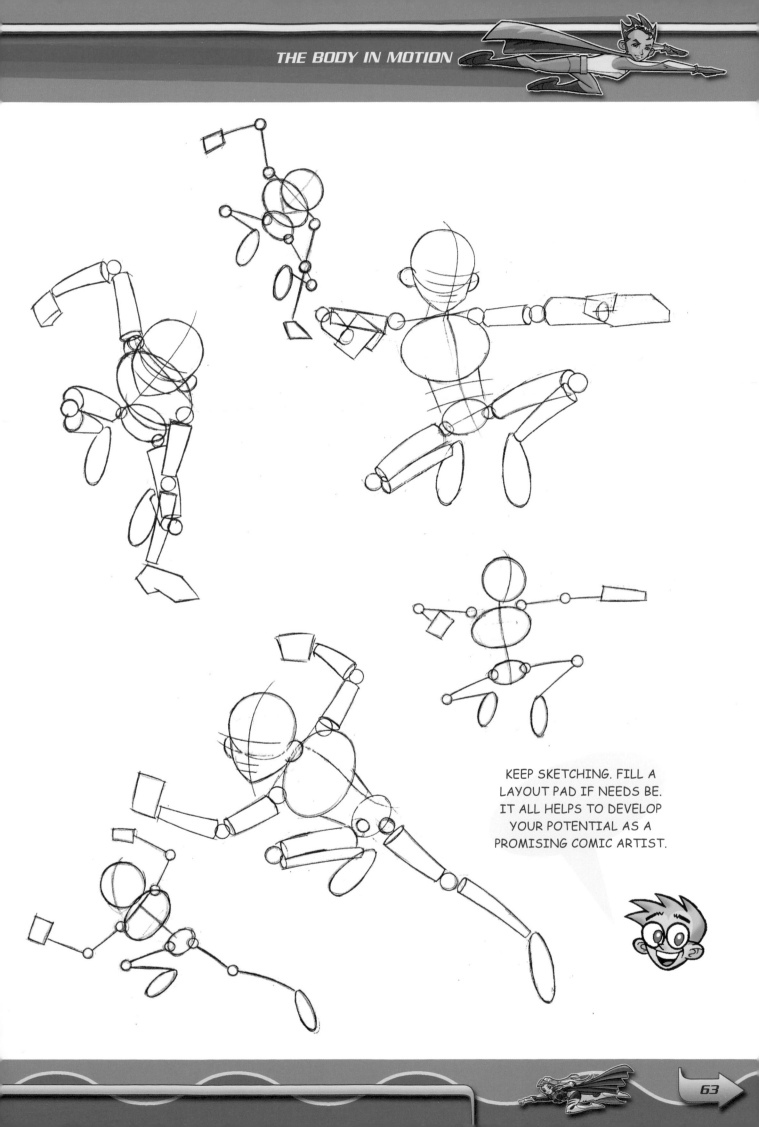

KEEP SKETCHING. FILL A
LAYOUT PAD IF NEEDS BE.
IT ALL HELPS TO DEVELOP
YOUR POTENTIAL AS A
PROMISING COMIC ARTIST.

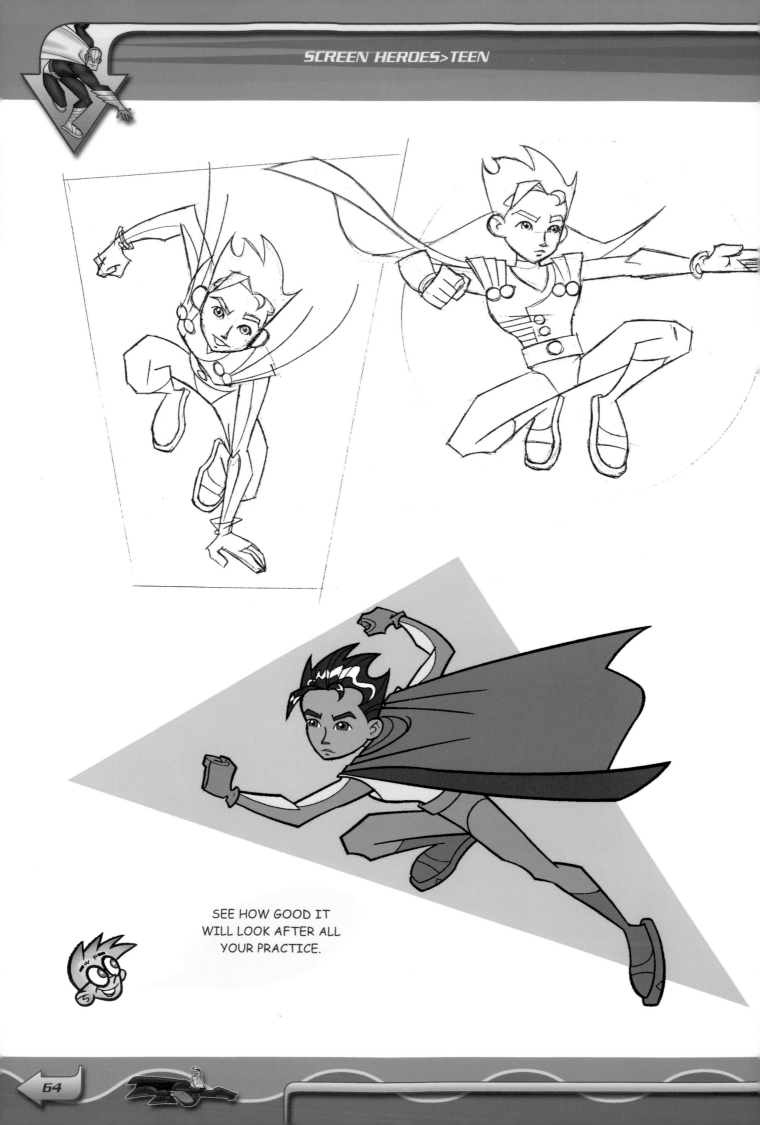

SEE HOW GOOD IT
WILL LOOK AFTER ALL
YOUR PRACTICE.

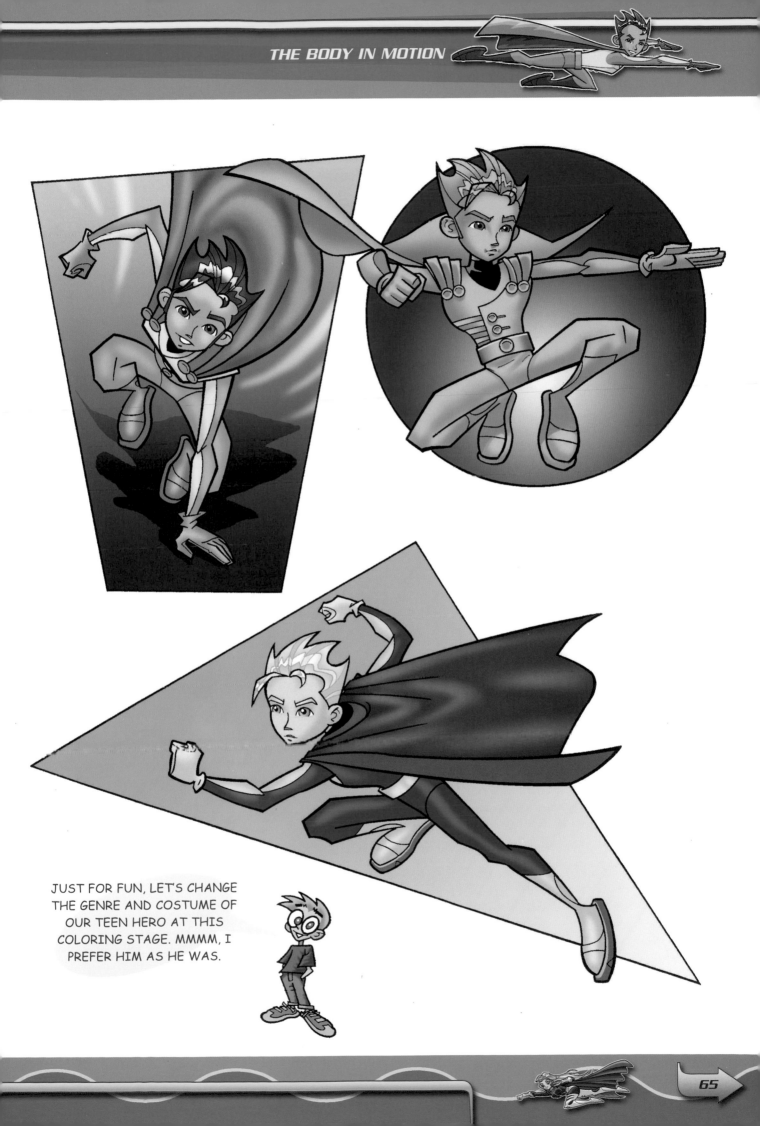

JUST FOR FUN, LET'S CHANGE THE GENRE AND COSTUME OF OUR TEEN HERO AT THIS COLORING STAGE. MMMM, I PREFER HIM AS HE WAS.

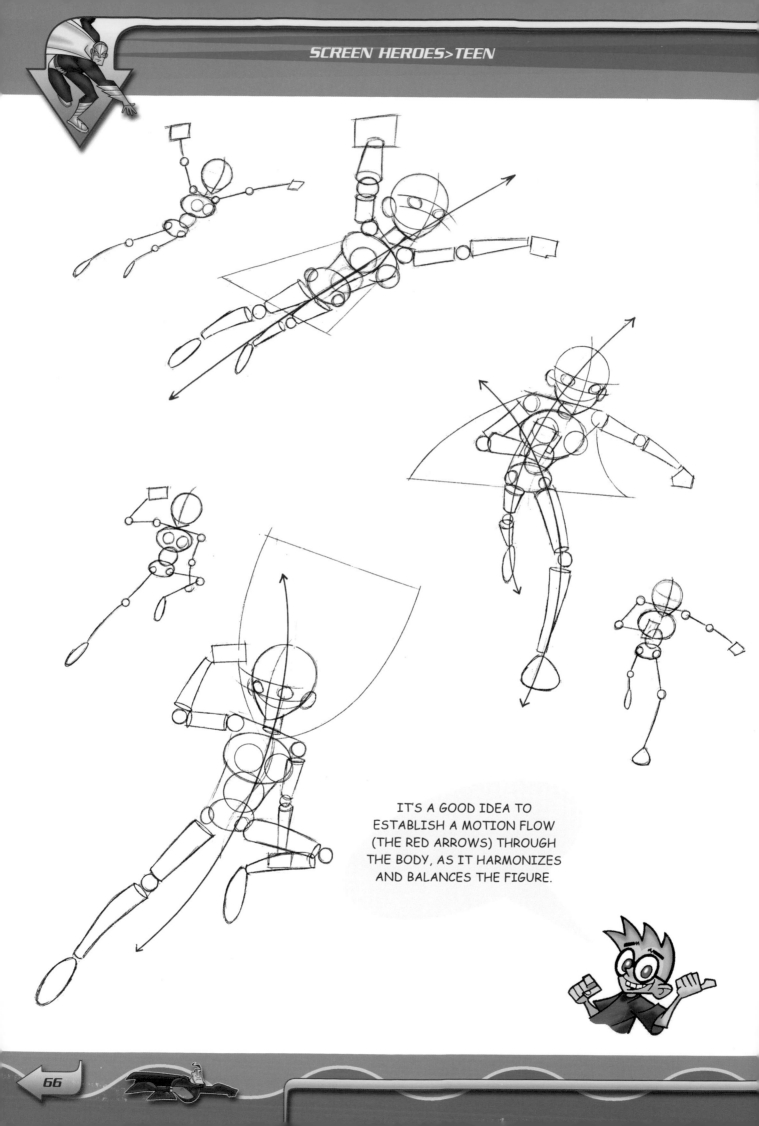

IT'S A GOOD IDEA TO
ESTABLISH A MOTION FLOW
(THE RED ARROWS) THROUGH
THE BODY, AS IT HARMONIZES
AND BALANCES THE FIGURE.

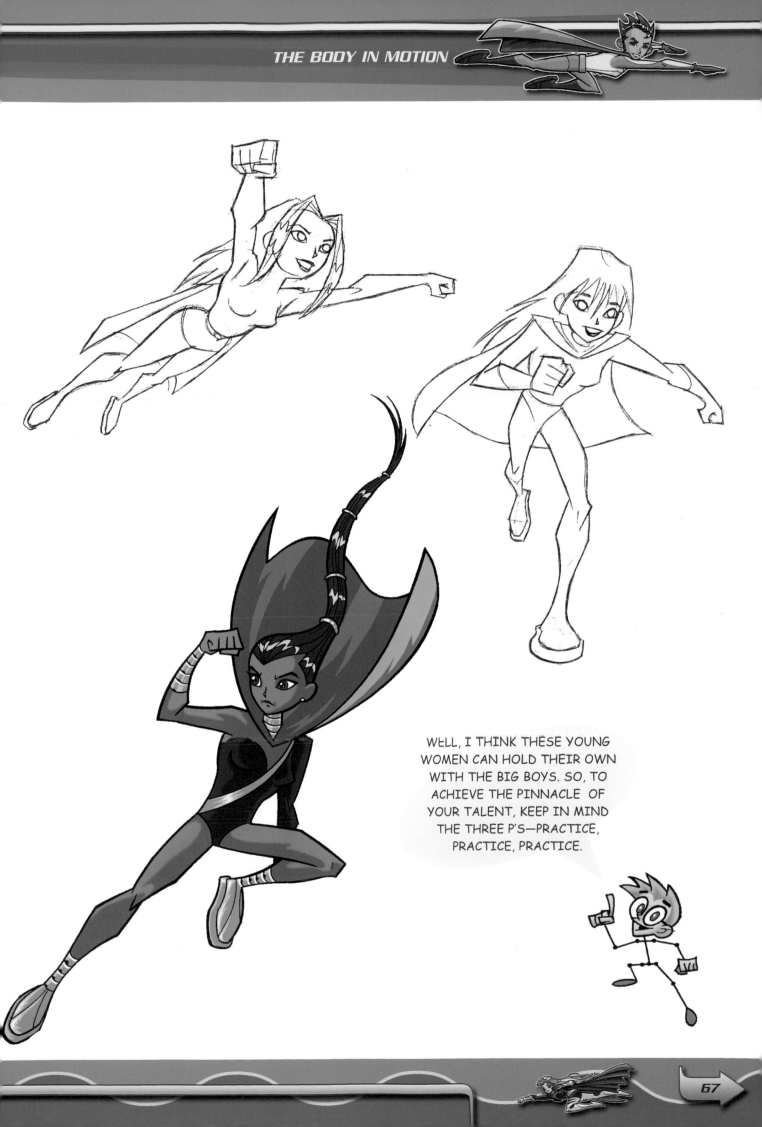

WELL, I THINK THESE YOUNG
WOMEN CAN HOLD THEIR OWN
WITH THE BIG BOYS. SO, TO
ACHIEVE THE PINNACLE OF
YOUR TALENT, KEEP IN MIND
THE THREE P'S—PRACTICE,
PRACTICE, PRACTICE.

NOW I THINK IT'S TIME FOR THE ADULTS TO STRUT THEIR STUFF. WE'LL HAVE A GO AT THE FELLOWS OUR TEEN HEROES USUALLY HAVE TO PLAY SECOND FIDDLE TO. HUH! WHO WANTS TO BE JUST A SIDEKICK? BUT I GUESS OUR TEEN HEROES WILL GROW UP TO HAVE SIDEKICKS OF THEIR OWN...

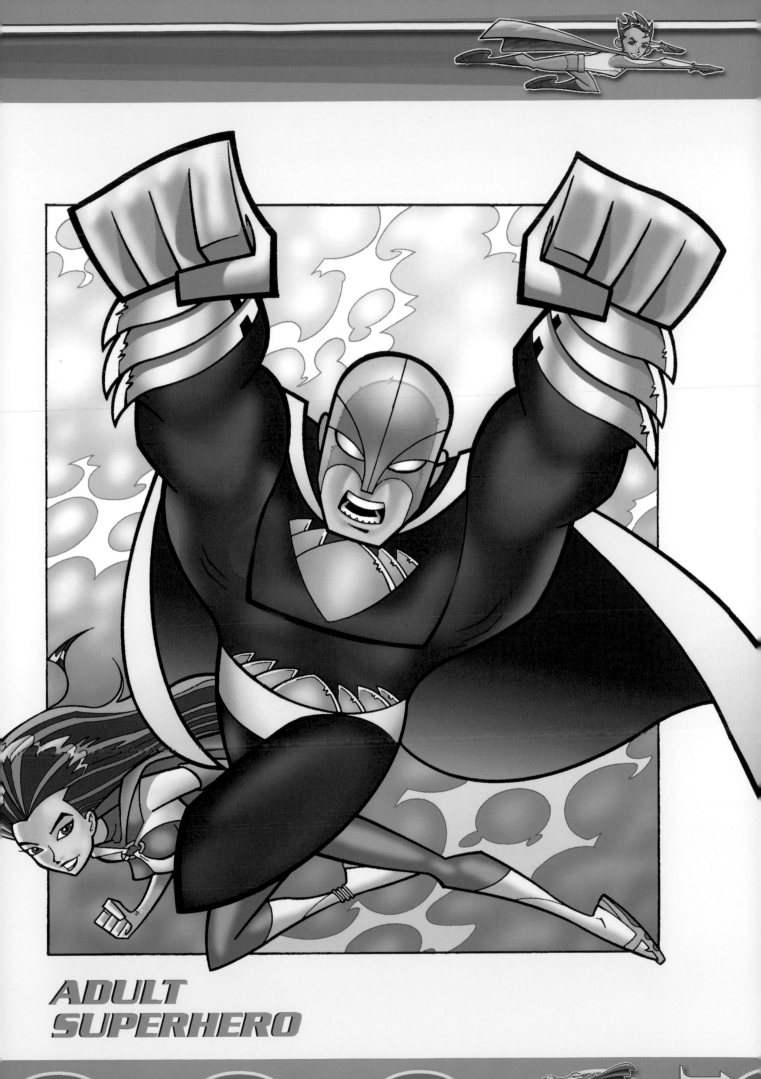

ADULT
SUPERHERO

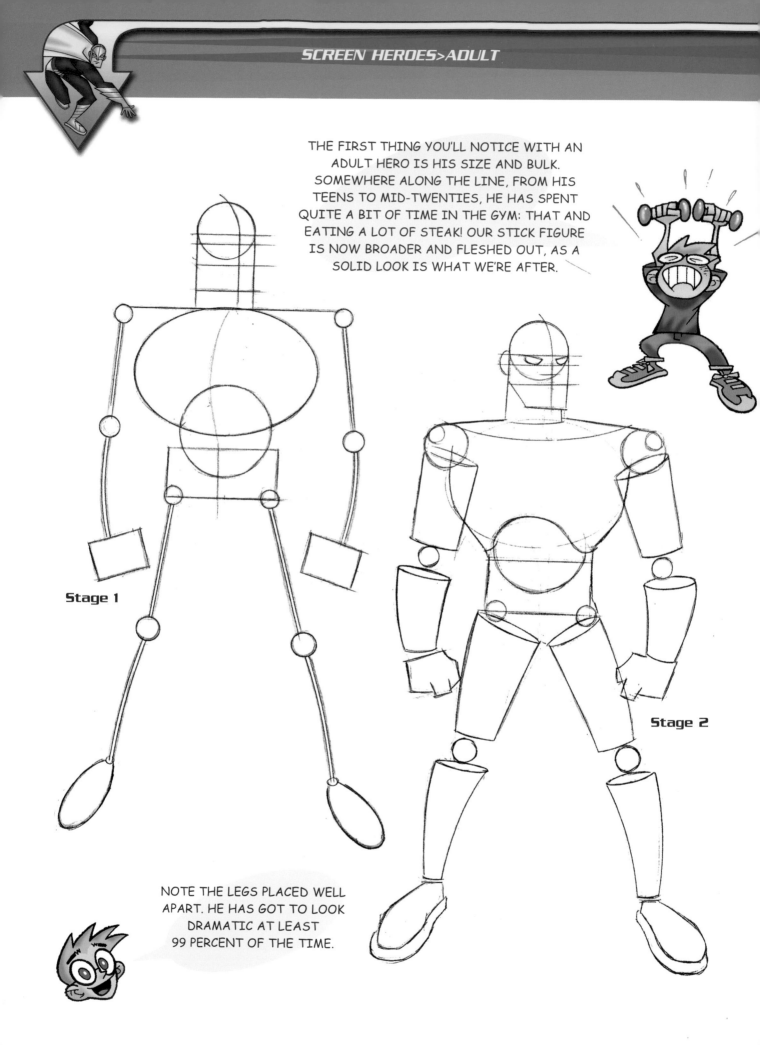

THE FIRST THING YOU'LL NOTICE WITH AN ADULT HERO IS HIS SIZE AND BULK. SOMEWHERE ALONG THE LINE, FROM HIS TEENS TO MID-TWENTIES, HE HAS SPENT QUITE A BIT OF TIME IN THE GYM: THAT AND EATING A LOT OF STEAK! OUR STICK FIGURE IS NOW BROADER AND FLESHED OUT, AS A SOLID LOOK IS WHAT WE'RE AFTER.

**Stage 1**

**Stage 2**

NOTE THE LEGS PLACED WELL APART. HE HAS GOT TO LOOK DRAMATIC AT LEAST 99 PERCENT OF THE TIME.

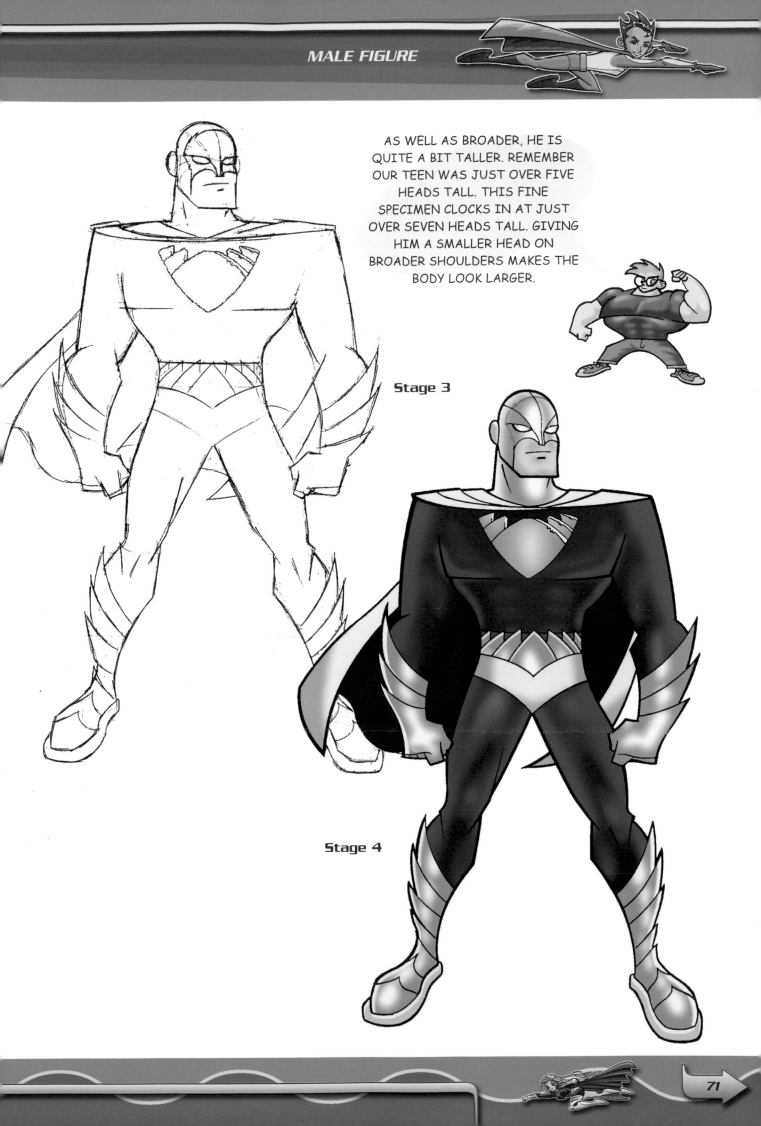

AS WELL AS BROADER, HE IS QUITE A BIT TALLER. REMEMBER OUR TEEN WAS JUST OVER FIVE HEADS TALL. THIS FINE SPECIMEN CLOCKS IN AT JUST OVER SEVEN HEADS TALL. GIVING HIM A SMALLER HEAD ON BROADER SHOULDERS MAKES THE BODY LOOK LARGER.

Stage 3

Stage 4

THE ADULT FEMALE, LIKE THE MALE, IS OF COURSE TALLER AND SLIGHTLY CURVIER THAN HER TEEN COUNTERPART. THOUGH SHE CERTAINLY HASN'T DEVELOPED THE MUSCLE BULK OF THE MALE, SHE SHOULD STILL LOOK A PRETTY TOUGH OPPONENT. SHE IS MORE LIKELY TO BE PETITE AND FAST, USING INTELLIGENCE RATHER THAN BRUTE STRENGTH. NOTE THE SMALLER EYES AND HEAD THAN THE TEEN FEMALE.

**Stage 1**

**Stage 2**

HER EYES ARE SLIGHTLY NARROWER AND SHARPER EDGED TOO.

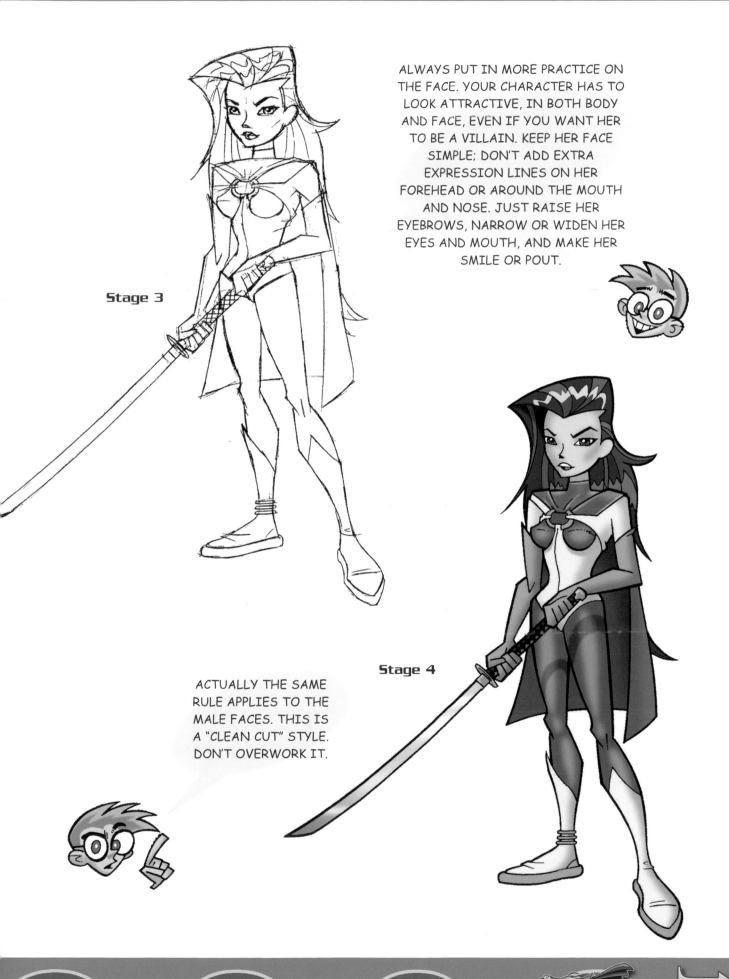

**Stage 3**

ALWAYS PUT IN MORE PRACTICE ON THE FACE. YOUR CHARACTER HAS TO LOOK ATTRACTIVE, IN BOTH BODY AND FACE, EVEN IF YOU WANT HER TO BE A VILLAIN. KEEP HER FACE SIMPLE; DON'T ADD EXTRA EXPRESSION LINES ON HER FOREHEAD OR AROUND THE MOUTH AND NOSE. JUST RAISE HER EYEBROWS, NARROW OR WIDEN HER EYES AND MOUTH, AND MAKE HER SMILE OR POUT.

**Stage 4**

ACTUALLY THE SAME RULE APPLIES TO THE MALE FACES. THIS IS A "CLEAN CUT" STYLE. DON'T OVERWORK IT.

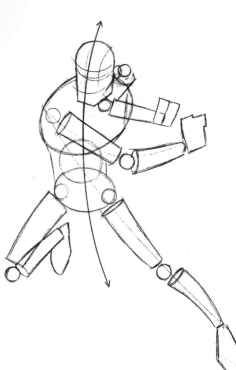

HERE ARE A COUPLE OF SAMPLES OF OUR HERO STARTING TO THROW HIS WEIGHT AROUND. ALWAYS REMEMBER TO "DRAW THROUGH" I.E. EVEN WHEN SOME PART OF THE BODY IS HIDDEN BY ANOTHER PART, MAKE SURE YOU STILL DRAW THE BIT UNDERNEATH. THIS WAY YOU'LL KNOW HIS LIMBS ARE CORRECTLY PLACED.

TRY TO GET IN THE HABIT OF DRAWING IN THE CENTER LINE FIRST. IT'LL GIVE YOU THE CURVE AND FLOW THAT YOU WANT YOUR FIGURE TO HAVE.

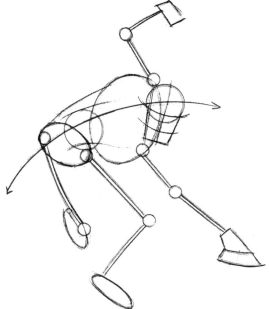

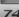

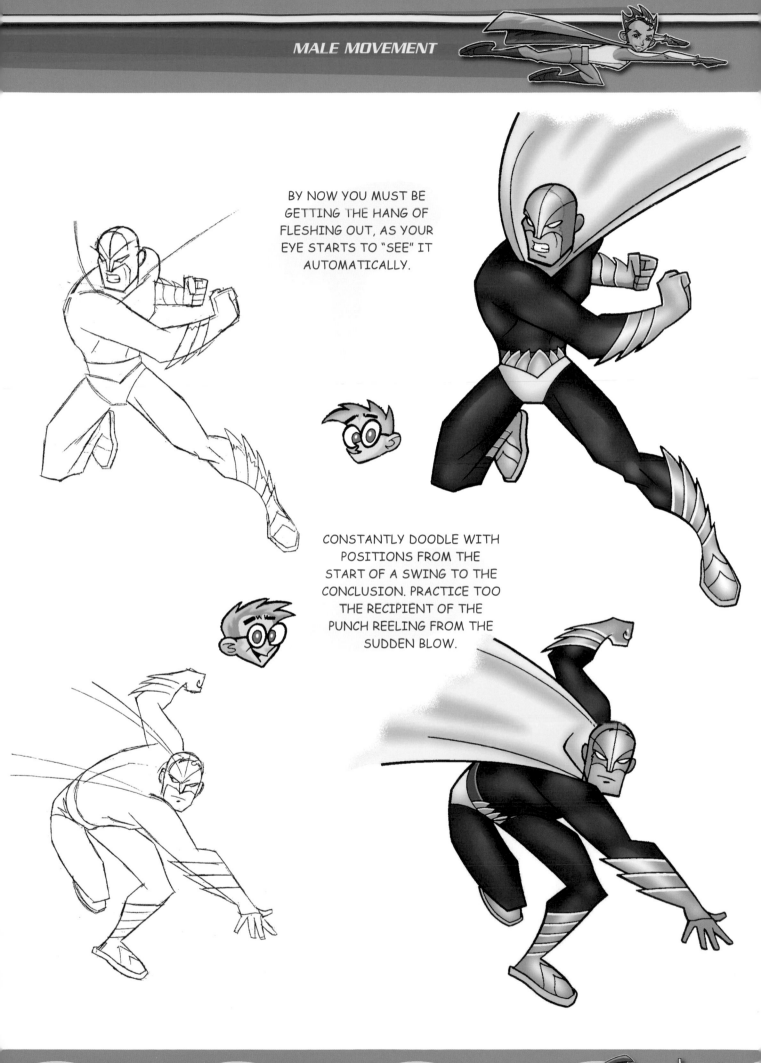

BY NOW YOU MUST BE GETTING THE HANG OF FLESHING OUT, AS YOUR EYE STARTS TO "SEE" IT AUTOMATICALLY.

CONSTANTLY DOODLE WITH POSITIONS FROM THE START OF A SWING TO THE CONCLUSION. PRACTICE TOO THE RECIPIENT OF THE PUNCH REELING FROM THE SUDDEN BLOW.

A POSE SHOULD ALWAYS HAVE A CERTAIN RHYTHM TO IT. AGAIN, USE A MOTION FLOW LINE TO ESTABLISH THE DYNAMICS OF YOUR FIGURE.

STARTING TO GET THE HANG OF IT? DON'T FORGET TO DRAW THROUGH AS THE ILLUSTRATION ABOVE DEMONSTRATES.

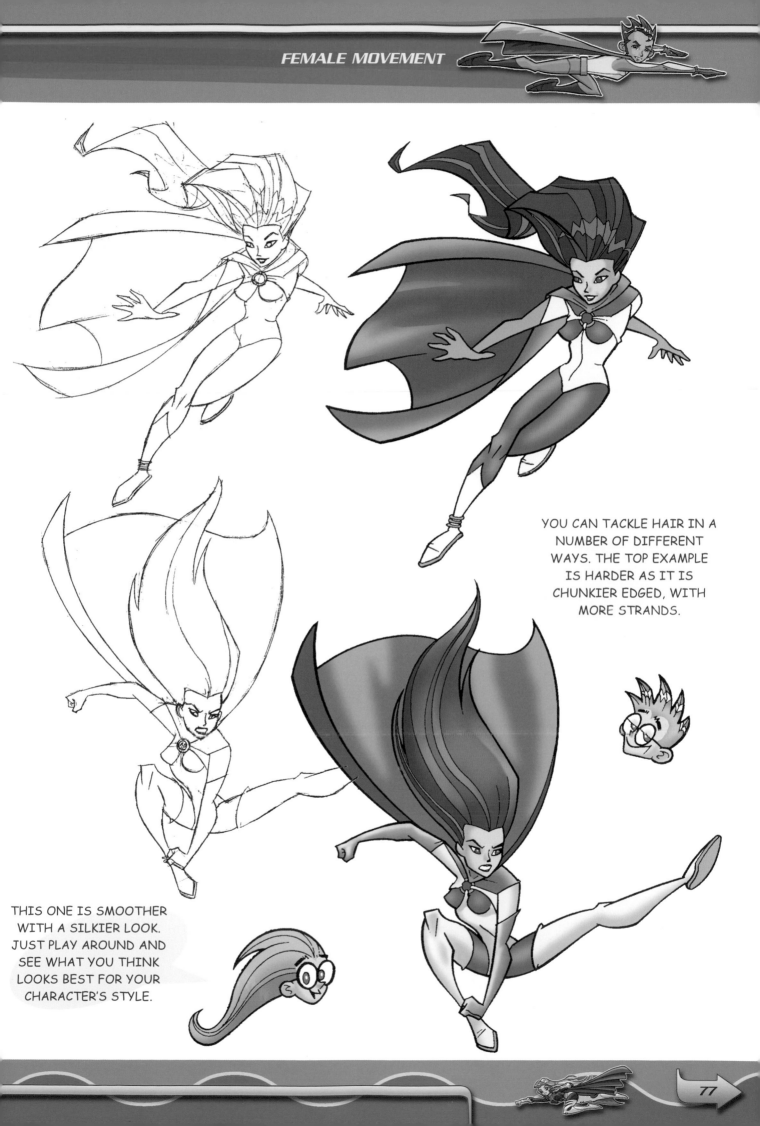

YOU CAN TACKLE HAIR IN A NUMBER OF DIFFERENT WAYS. THE TOP EXAMPLE IS HARDER AS IT IS CHUNKIER EDGED, WITH MORE STRANDS.

THIS ONE IS SMOOTHER WITH A SILKIER LOOK. JUST PLAY AROUND AND SEE WHAT YOU THINK LOOKS BEST FOR YOUR CHARACTER'S STYLE.

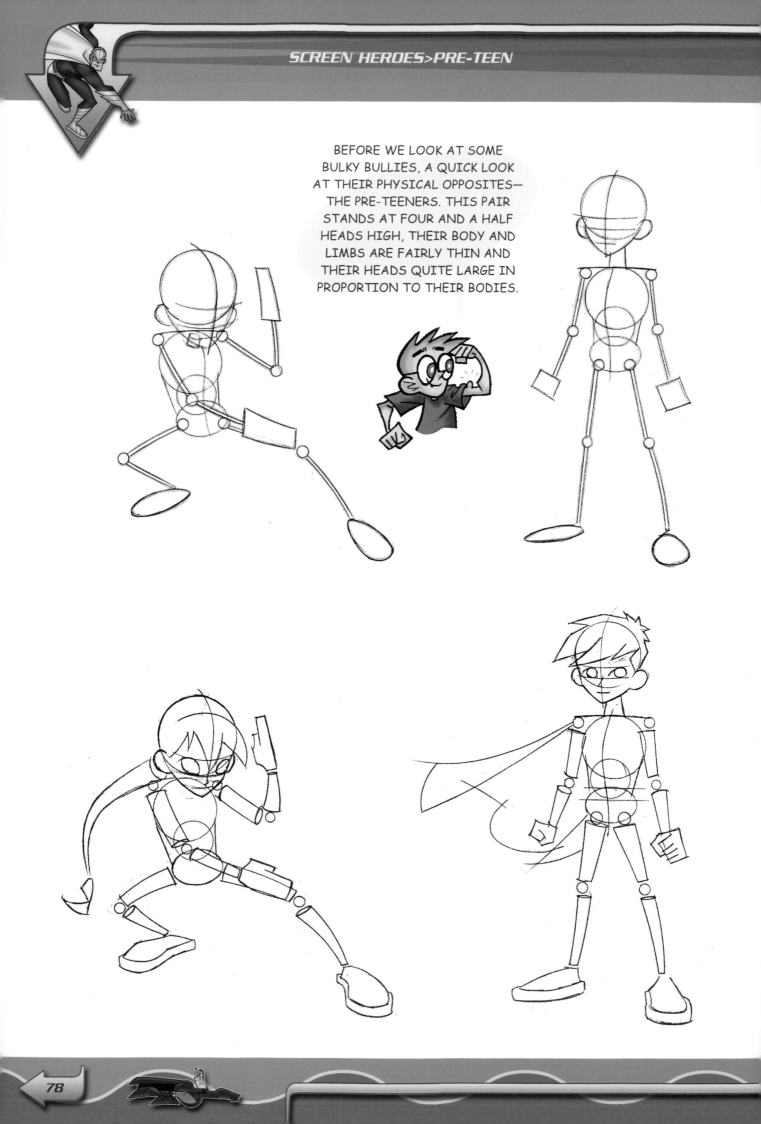

BEFORE WE LOOK AT SOME
BULKY BULLIES, A QUICK LOOK
AT THEIR PHYSICAL OPPOSITES—
THE PRE-TEENERS. THIS PAIR
STANDS AT FOUR AND A HALF
HEADS HIGH, THEIR BODY AND
LIMBS ARE FAIRLY THIN AND
THEIR HEADS QUITE LARGE IN
PROPORTION TO THEIR BODIES.

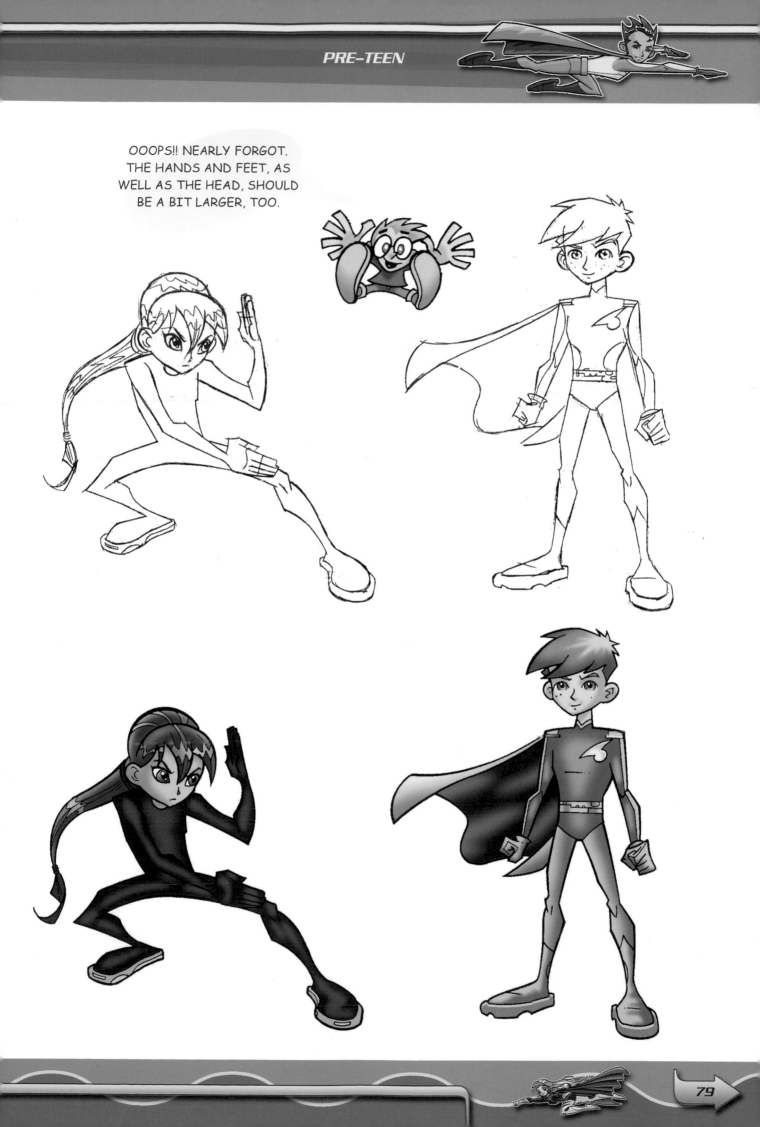

OOOPS!! NEARLY FORGOT.
THE HANDS AND FEET, AS
WELL AS THE HEAD, SHOULD
BE A BIT LARGER, TOO.

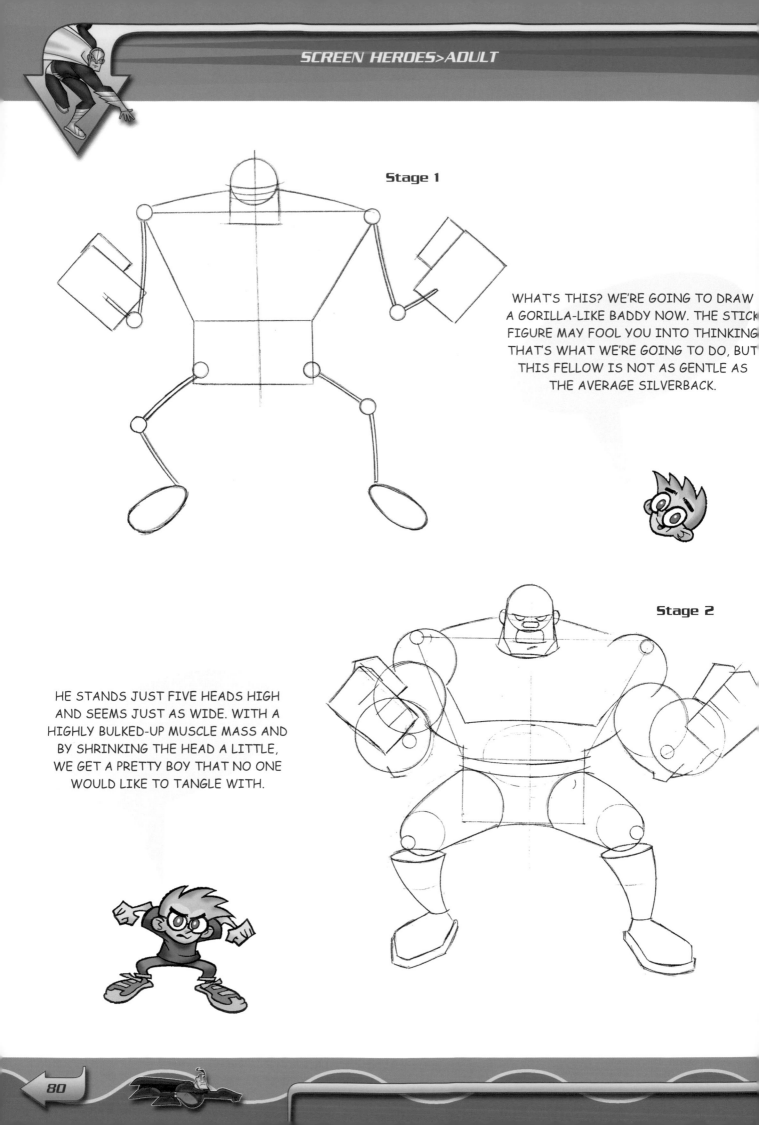

**Stage 1**

WHAT'S THIS? WE'RE GOING TO DRAW A GORILLA-LIKE BADDY NOW. THE STICK FIGURE MAY FOOL YOU INTO THINKING THAT'S WHAT WE'RE GOING TO DO, BUT THIS FELLOW IS NOT AS GENTLE AS THE AVERAGE SILVERBACK.

**Stage 2**

HE STANDS JUST FIVE HEADS HIGH AND SEEMS JUST AS WIDE. WITH A HIGHLY BULKED-UP MUSCLE MASS AND BY SHRINKING THE HEAD A LITTLE, WE GET A PRETTY BOY THAT NO ONE WOULD LIKE TO TANGLE WITH.

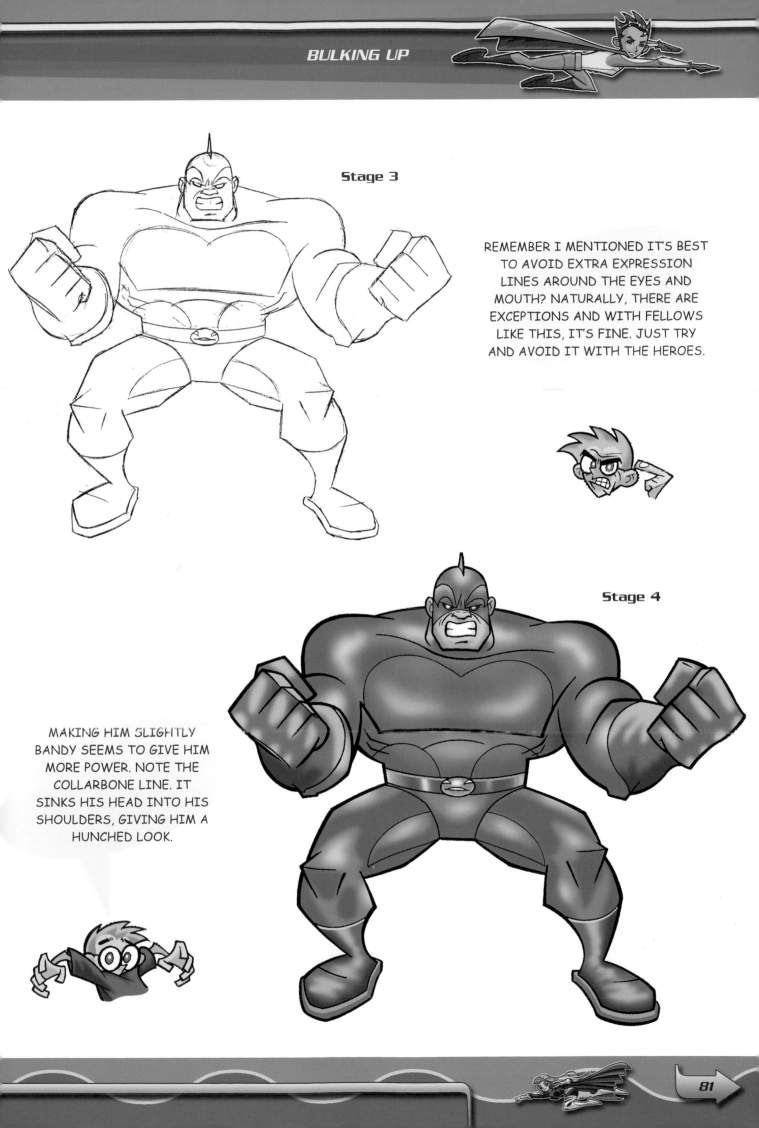

**Stage 3**

REMEMBER I MENTIONED IT'S BEST TO AVOID EXTRA EXPRESSION LINES AROUND THE EYES AND MOUTH? NATURALLY, THERE ARE EXCEPTIONS AND WITH FELLOWS LIKE THIS, IT'S FINE. JUST TRY AND AVOID IT WITH THE HEROES.

**Stage 4**

MAKING HIM SLIGHTLY BANDY SEEMS TO GIVE HIM MORE POWER. NOTE THE COLLARBONE LINE. IT SINKS HIS HEAD INTO HIS SHOULDERS, GIVING HIM A HUNCHED LOOK.

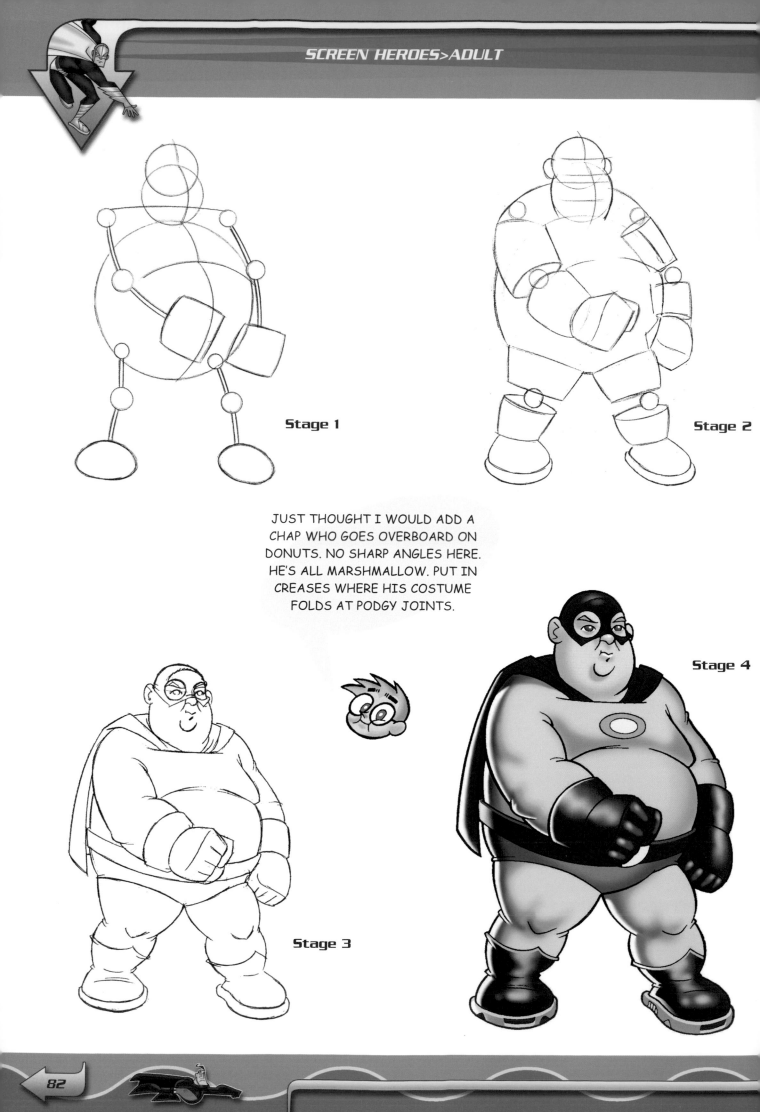

Stage 1

Stage 2

JUST THOUGHT I WOULD ADD A
CHAP WHO GOES OVERBOARD ON
DONUTS. NO SHARP ANGLES HERE.
HE'S ALL MARSHMALLOW. PUT IN
CREASES WHERE HIS COSTUME
FOLDS AT PODGY JOINTS.

Stage 4

Stage 3

HANDS CAN BE TRICKY. THEY'RE PROBABLY THE MOST VERSATILE PART OF THE BODY. AS THIS CHAPTER IS "STYLIZED" THE HANDS AREN'T ANATOMICALLY CORRECT BUT STILL SHOULD BE ACCURATE THOUGH. ASK A FRIEND TO "HAND POSE" FOR YOU. BUILD A LIBRARY OF SKETCHED HANDS IN VARIOUS POSITIONS.

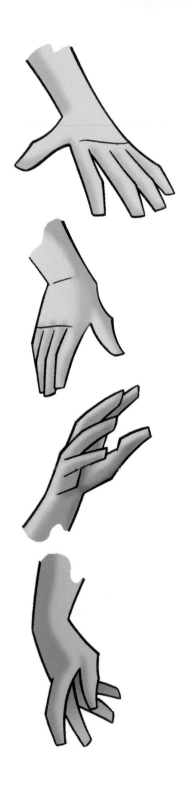

A KNUCKLE LINE RATHER THAN INDIVIDUAL BUMPS.

IN THIS STYLE, MALE AND FEMALE HANDS ARE VERY SIMILAR. JUST DRAW FEMALE HANDS AND WRISTS SLIGHTLY MORE FINELY.

WHERE WOULD A SUPERHERO BE WITHOUT A CAPE? IT DOES A LOT MORE THAN JUST FLAP IN THE BREEZE. IN FACT, IT CAN HAVE A LIFE OF ITS OWN AND CAN CERTAINLY HELP TO DRAMATIZE YOUR DRAWING. YOU HAVE TO USE YOUR IMAGINATION A FAIR BIT.

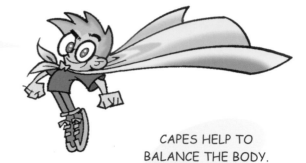

CAPES HELP TO BALANCE THE BODY.

TRY DRAWING U-SHAPED FOLDS AROUND THE NECK.

PLACE MATERIAL OVER OBJECTS AND OBSERVE HOW IT DRAPES.

DON'T *GO* MAD ON THE NUMBER OF FOLDS.

AN EXAMPLE OF USING THE CAPE FOR A FULL DRAMATIC EFFECT. IT SEEMS TO ENHANCE OUR TEEN HERO, GIVING HIM A SUPERNATURAL POWER (WHICH HE PROBABLY HAS ANYWAY)—HECK, HE IS FLYING.

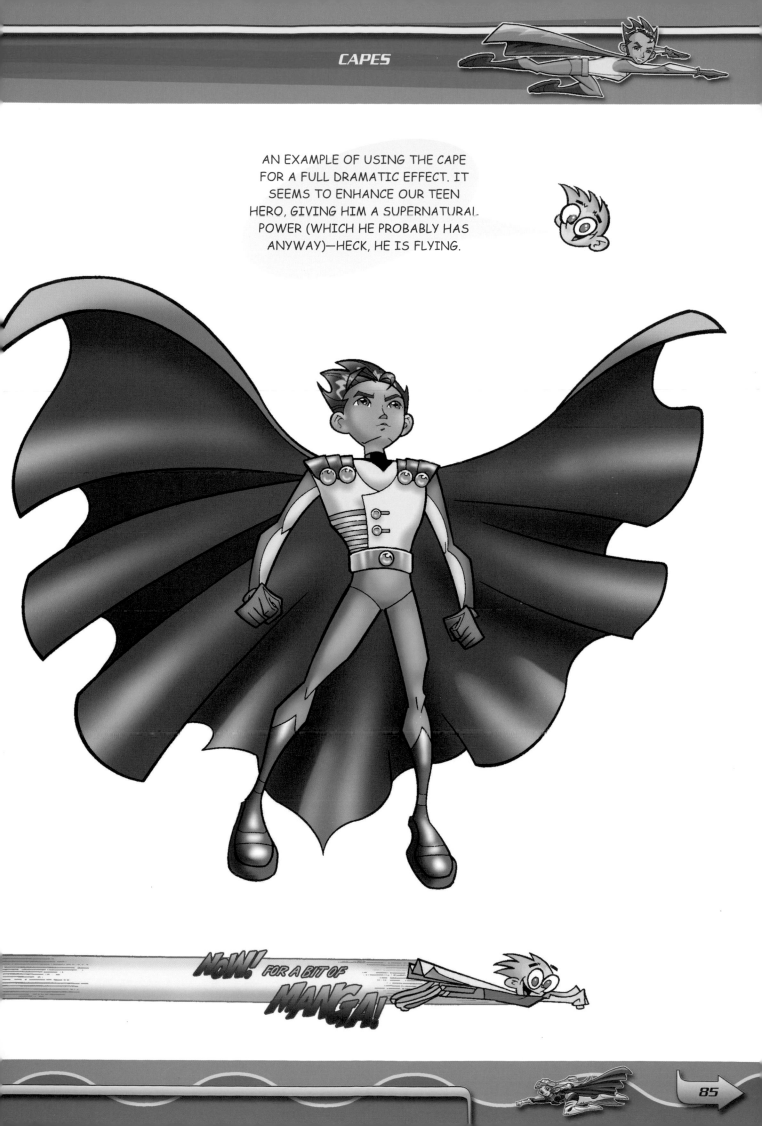

NOW! FOR A BIT OF MANGA!

# MANGA STYLE

The first examples of manga art, some say, were found on Chinese temple walls, depicting Shaolin monks practicing martial arts. Whether or not this is true, it is the rise in popularity of Japanese comic art and graphic novels, plus the exposure provided by TV and films, which has helped to promote this art form. The style has embraced a wide range of admirers, for it's been adapted to suit different tastes and ages. From young children's animated TV programs, to the slightly more adult themes of teenage romance and also the sometimes violent adult market; in Japanese culture, comic art is accepted as a genuine art form. Manga artists and writers are respected in Japan as much as best-selling authors and fine artists. In Japan, it is not unusual to see businesspeople reading manga on the train to and from work.

In the West, however, comic art is still somewhat sniffed at, though less so in Continental Europe. The French, in particular, produce beautiful comic art. Though manga incorporates many different themes it does differ slightly from western comics, as few of their characters are superheroes. Most manga story lines deal with unusual or abnormal situations into which your average citizen is unknowingly thrust. However, here we have manga superheroes and I think they work pretty well.

The key to good manga art is simplicity in the way the characters are drawn. The pen line is clean and smooth. Do not over-work your drawing: adding lots of shadow and defining every muscle, hair, and wrinkle is unnecessary and simply doesn't work with this style.

   Once you have mastered the basics of developing the way I build my characters, experiment with developing your own style. Manga characters can be sweet, pretty little things or big, mean, and ugly. The key to creating fine artwork is practice, practice, and more practice. No line is a wasted line, as with every sweep of your pencil you are improving.

**Stage 1**

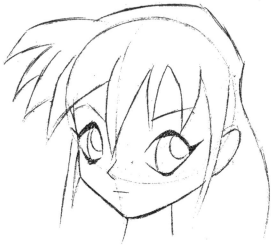

**Stage 2**

WE'LL BEGIN WITH THE HEAD, AS IT'S USUALLY THE PART OF THE BODY ON WHICH OUR EYES FOCUS FIRST. THERE'S NOT A LOT TO CONSTRUCTING THE HEAD AS IT'S SIMPLY A CIRCLE WITH A JAW LINE ADDED. PENCIL IN YOUR EYE LEVEL, WITH THE TOP OF THE EYE ABOUT HALFWAY DOWN. THEN ADD THE NOSE AND MOUTH LEVEL.

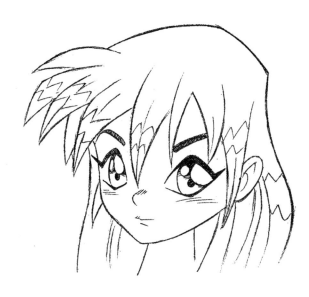

**Stage 3**

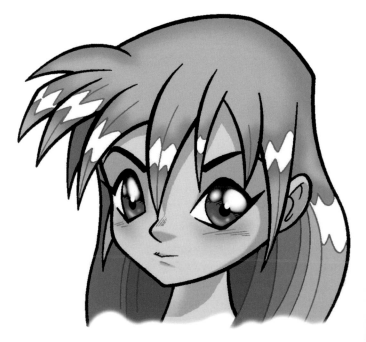

**Stage 4**

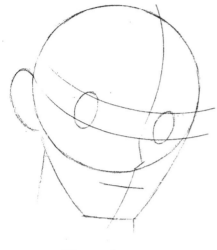

**Stage 1**

THE MALE HEAD IS CONSTRUCTED IN JUST THE SAME WAY AS THE FEMALE'S, BUT WITH A SQUARE JAW LINE THAT IS SLIGHTLY LONGER (RATHER THAN THE FEMALE "V" SHAPE). HE DOESN'T ALWAYS HAVE AN ANGULAR JAW: AS YOU WORK YOUR WAY THROUGH THIS CHAPTER, YOU'LL NOTICE I OFTEN CHANGE THE SHAPE OF MY CHARACTERS' FACIAL FEATURES. YOU DON'T WANT ALL YOUR HEROES LOOKING THE SAME, SO THEY ALL NEED DIFFERENT CHARACTERISTICS.

**Stage 2**

HIS EYES, OF COURSE, AREN'T AS BIG AS THE FEMALE'S AND THERE ARE NO THICK LINES TO DEPICT EYELASHES.

HIS HAIR IS USUALLY SPIKY AND SOMEWHAT WAYWARD. WITH A STEADY HAND, INK OVER THE PENCIL LINES, WHICH YOU THEN ERASE ONCE THE INK IS DRY. NOW ALL WE NEED IS COLOR.

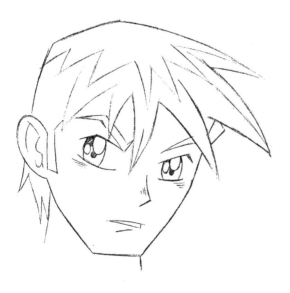

**Stage 3**

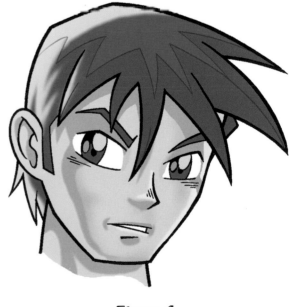

**Stage 4**

AS THE HEAD IS, I FEEL, THE MOST IMPORTANT PART OF THE BODY IN TERMS OF EXPRESSION, YOU SHOULD SPEND A FAIR TIME PRACTICING THE ANGLES FROM WHICH IT CAN BE VIEWED: LOOKING UP, HEAD DOWN, THREE-QUARTER ANGLE, SIDE ANGLE, EVEN FROM THE BACK. IN MANGA, THE HEAD SAYS IT ALL ABOUT YOUR CHARACTER.

**Looking Up**

**¾ Angle**

**Side On**

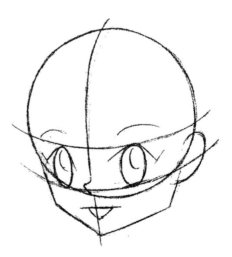

**Head Slightly Down**

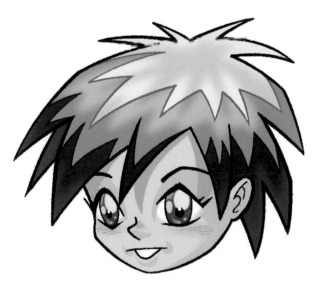
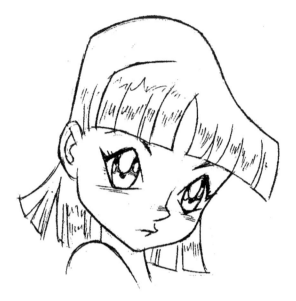
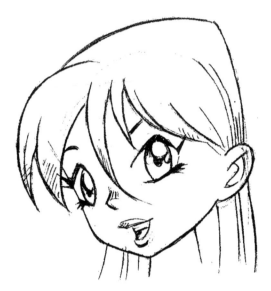
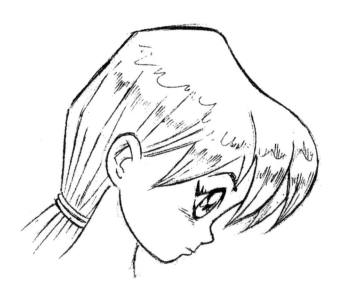

SO HERE ARE THOSE LINES OPPOSITE WORKED-UP READY FOR INKING. EACH HEAD HAS BEEN TREATED SLIGHTLY DIFFERENTLY WHEN DRAWING IN THE SHAPE OF THE HEAD AND THE EYES. THE HAIR, OF COURSE, REALLY DIFFERENTIATES YOUR CHARACTERS FROM ONE ANOTHER AND YOU CAN HAVE GREAT FUN PLAYING AT HAIR DESIGN. THE HIGHLIGHTS YOU GIVE HAIR CAN VARY, TOO. BUT WHETHER YOU CHOOSE SHARP EDGED OR EXTREMELY SOFT— YOU'RE IN CONTROL.

YOU SHOULD BE GETTING THE HANG OF IT BY NOW, AND GETTING PRETTY GOOD AT QUICK CIRCLES. THEY DON'T HAVE TO BE PERFECTLY ROUND, THOUGH YOU'LL BE SURPRISED AT HOW ACCURATE YOU START TO BECOME THE MORE YOU DRAW. AS MENTIONED EARLIER, THE MALE'S EYES ARE NOT ONLY SMALLER THAN THE FEMALE'S, BUT NARROWER TOO. THIS GIVES HIM MORE OF A "STEELY" LOOK, AND NOT SO MUCH THE "BAMBI" DOE-EYED LOOK THAT SHE HAS.

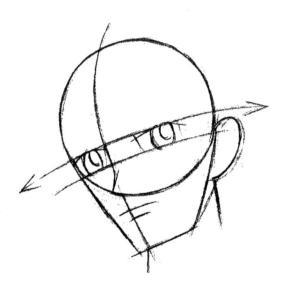

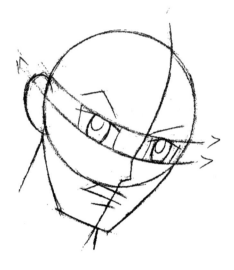

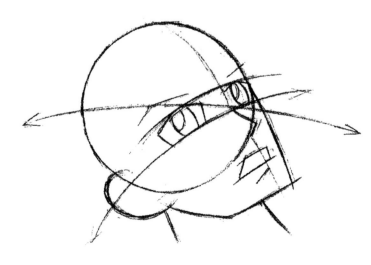

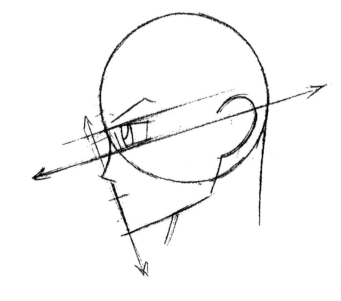

THE HAIR, JAW LINE, AND EVEN THE EYEBROWS ARE ALL USED WHEN DESIGNING DIFFERENT CHARACTERS. YOU CAN EVEN TRY EXPERIMENTING WITH FACIAL HAIR, ALTHOUGH A HERO IS USUALLY CLEAN SHAVEN. IT'S THE VILLAIN WHO GETS THE MOUSTACHE, GOATEE, OR FULL RASPUTIN GROWTH. AS WITH THE FEMALE, HAIR HIGHLIGHTS DIFFER DEPENDING ON THE "LOOK" YOU ARE TRYING TO ACHIEVE. NEVER BE AFRAID TO EXPERIMENT.

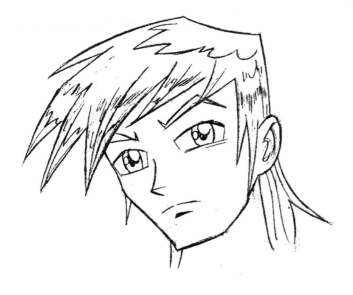

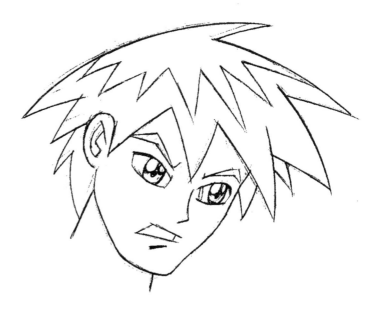

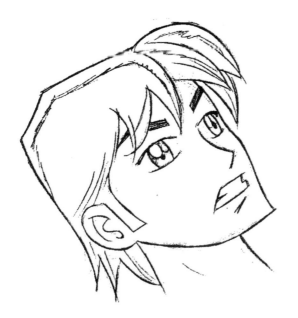

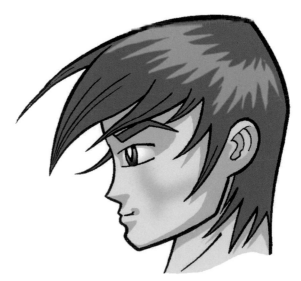

THE HUMAN BODY IS THE MOST IMPORTANT FACTOR IN A STORY. YOU LOOK AT THE FACE, THEN THE REST OF THE BODY. AS THIS BOOK IS ABOUT SUPER BEINGS, TRADITION DICTATES THAT OUR HEROES WILL BE IN THEIR YOUNGISH TEENS TO EARLY TWENTIES, DEFINITELY ATHLETIC AND SLIM, AND EXCEPTIONALLY GOOD LOOKING.

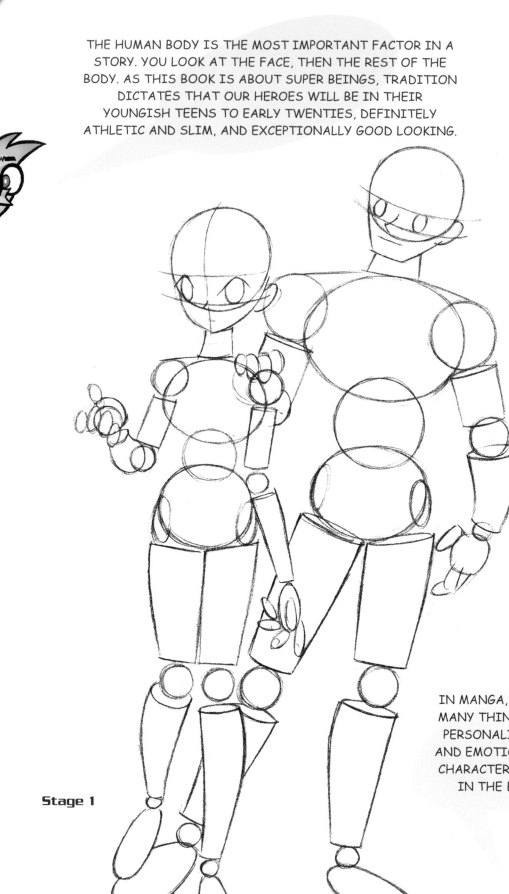

Stage 1

IN MANGA, THE BODY CAN SAY MANY THINGS TO THE READER. PERSONALITY, DISPOSITION, AND EMOTIONAL STATE OF THE CHARACTER ARE ALL CONVEYED IN THE BODY LANGUAGE.

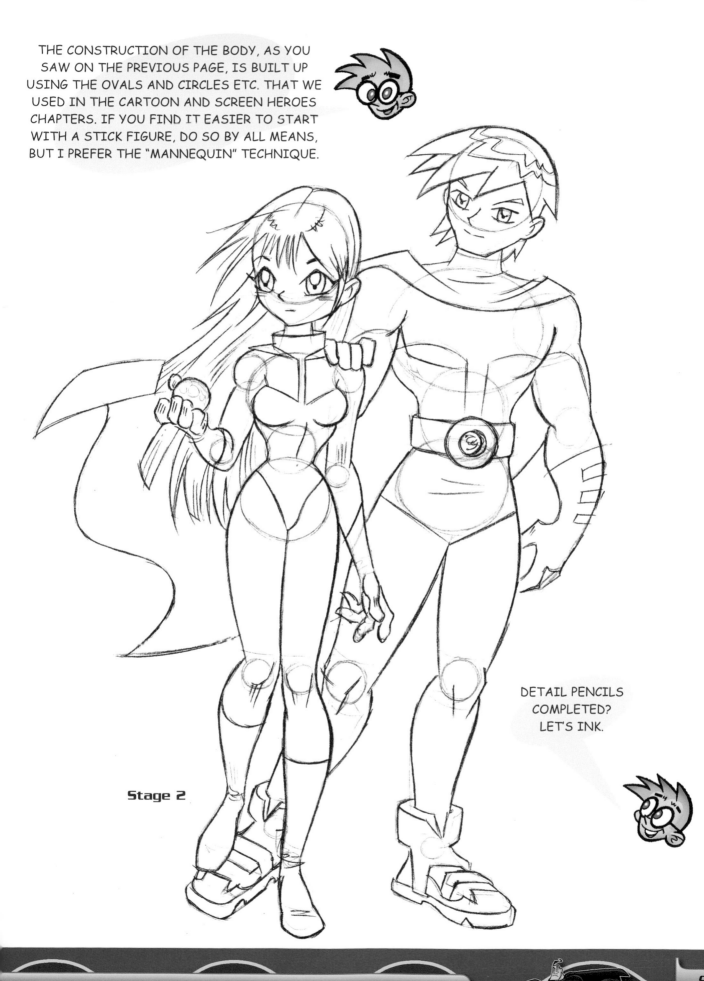

THE CONSTRUCTION OF THE BODY, AS YOU SAW ON THE PREVIOUS PAGE, IS BUILT UP USING THE OVALS AND CIRCLES ETC. THAT WE USED IN THE CARTOON AND SCREEN HEROES CHAPTERS. IF YOU FIND IT EASIER TO START WITH A STICK FIGURE, DO SO BY ALL MEANS, BUT I PREFER THE "MANNEQUIN" TECHNIQUE.

Stage 2

DETAIL PENCILS COMPLETED? LET'S INK.

SOMETIMES IT ALMOST SEEMS A SHAME TO ERASE YOUR PENCIL LINES AS THEY HAVE A FLUENCY THAT CAN BE LOST AT THIS STAGE, ESPECIALLY WHEN YOU'RE STILL LEARNING. THIS IS WHY INKING IS VERY IMPORTANT, AND IS SOMETHING WE'LL TACKLE LATER (SEE PAGE 139).

**Stage 3**

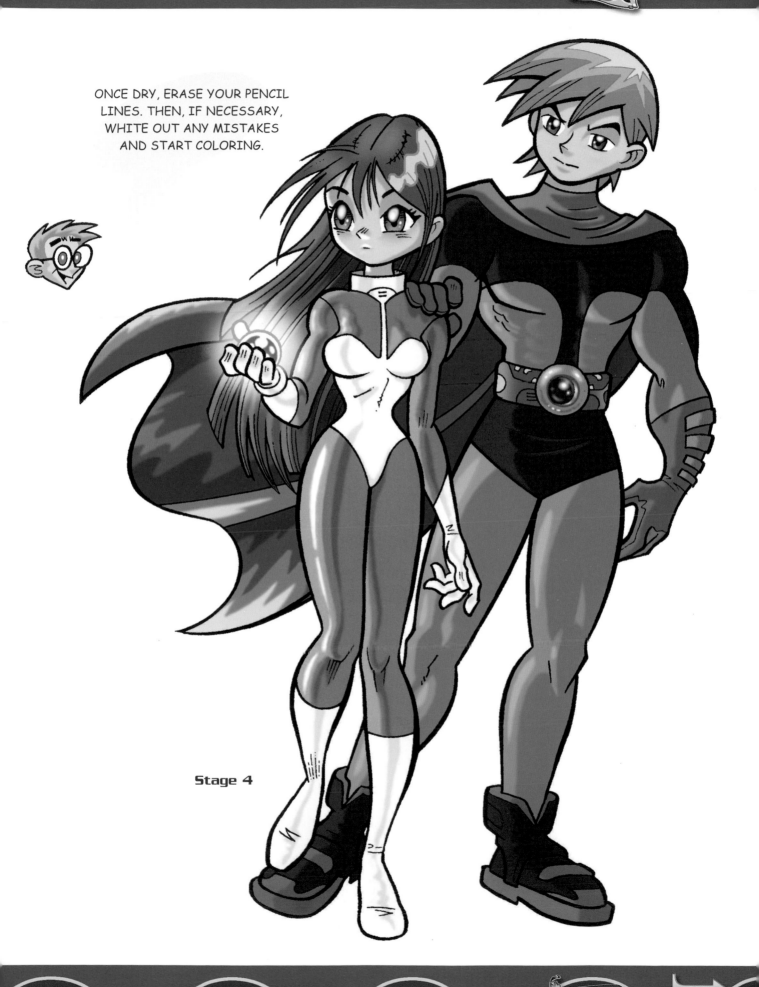

ONCE DRY, ERASE YOUR PENCIL
LINES. THEN, IF NECESSARY,
WHITE OUT ANY MISTAKES
AND START COLORING.

Stage 4

WITH THIS STYLE OF MANGA DRAWING, I RARELY USE SHARP EDGES. NOT A TRIANGLE, SQUARE, OR OBLONG APPEARS: CIRCLES AND OVALS ARE OUR FRIENDS HERE. THERE IS NOT A LOT OF DIFFERENCE BETWEEN THE CONSTRUCTION OF THE MALE AND FEMALE. THE MALE IS OBVIOUSLY TALLER AND LARGER SHAPES ARE USED WHEN DRAWING HIS UPPER TORSO. HIS ARMS AND LEGS ARE QUITE A BIT THICKER, TOO.

**Stage 1**

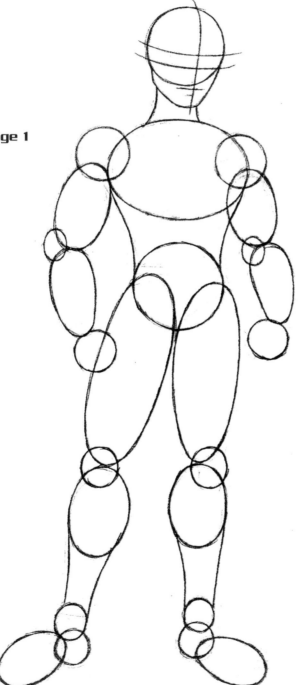

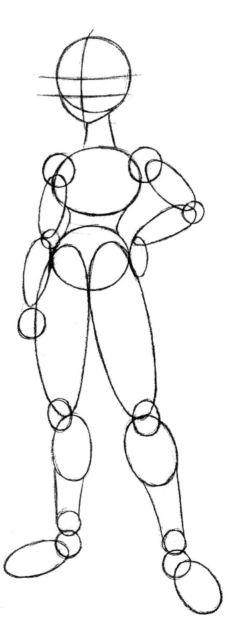

WHEN DOING THE DETAIL
PENCILLING, I ALWAYS START
WITH THE FACE, AND THEN ADD
HAIR TO GIVE MY CHARACTER A
MORE DISTINGUISHED LOOK.

NOW START TO DRESS THEM
(UNLESS YOU'RE DOING ADAM
AND EVE, IN WHICH CASE
PRACTICE DRAWING FIG LEAVES).

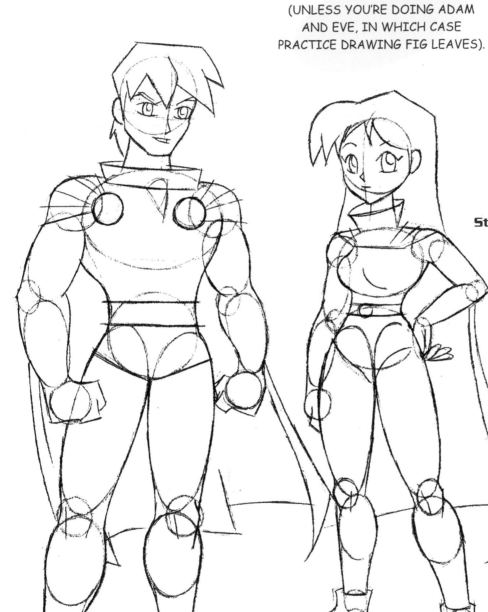

**Stage 2**

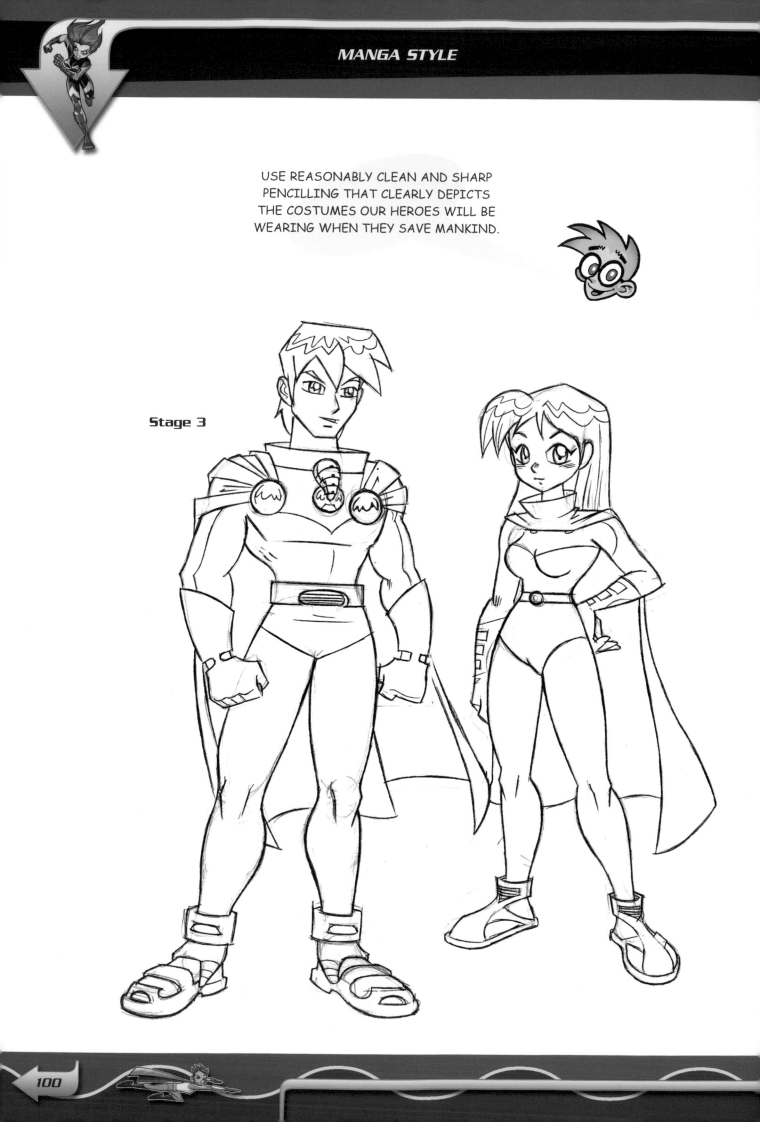

USE REASONABLY CLEAN AND SHARP
PENCILLING THAT CLEARLY DEPICTS
THE COSTUMES OUR HEROES WILL BE
WEARING WHEN THEY SAVE MANKIND.

**Stage 3**

VOILA! THE ILLUSTRATION IS COMPLETE, AND IT REALLY COMES TOGETHER ONCE COLOR IS ADDED.

Stage 4

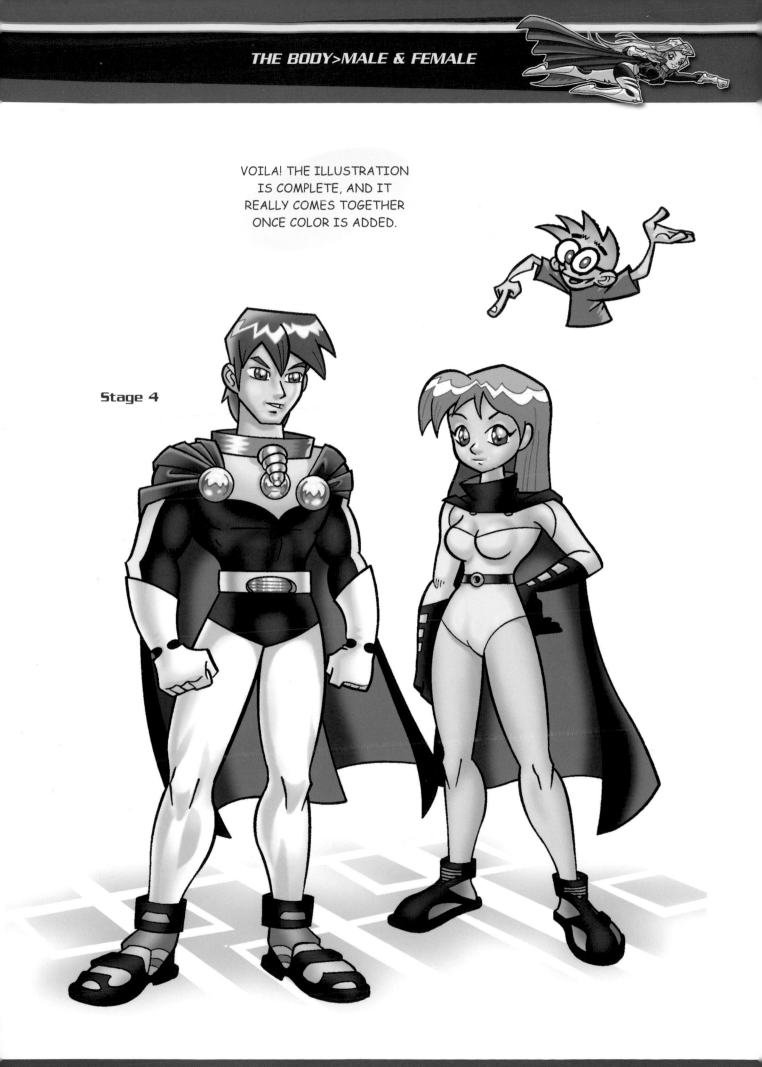

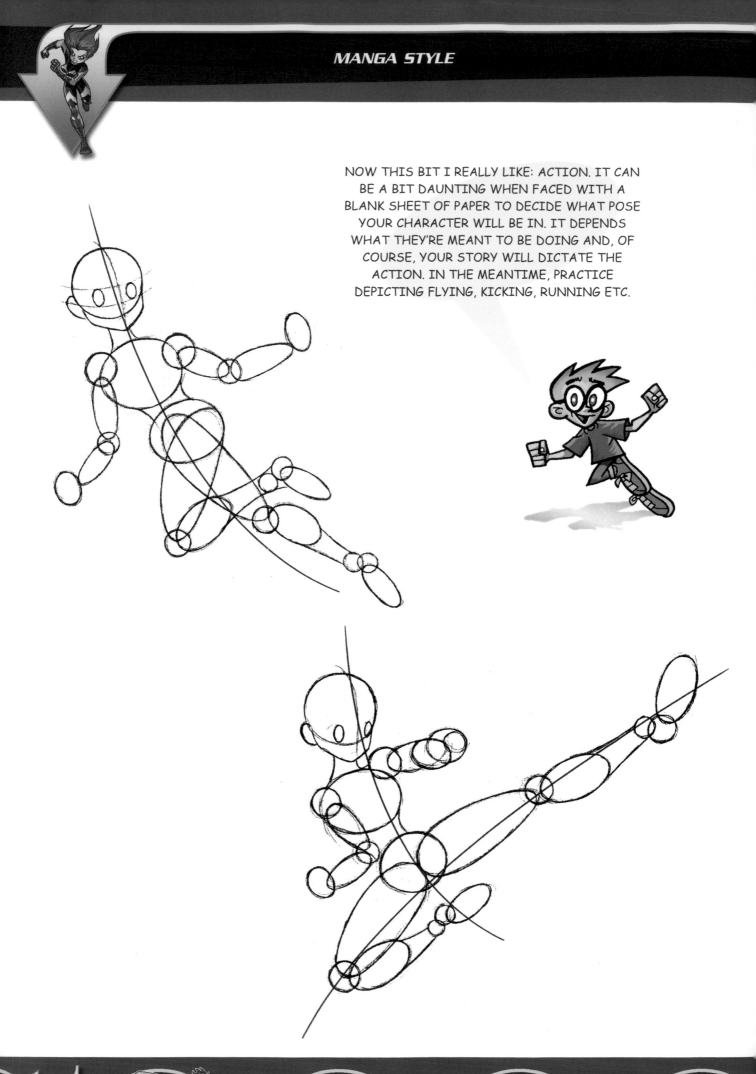

NOW THIS BIT I REALLY LIKE: ACTION. IT CAN BE A BIT DAUNTING WHEN FACED WITH A BLANK SHEET OF PAPER TO DECIDE WHAT POSE YOUR CHARACTER WILL BE IN. IT DEPENDS WHAT THEY'RE MEANT TO BE DOING AND, OF COURSE, YOUR STORY WILL DICTATE THE ACTION. IN THE MEANTIME, PRACTICE DEPICTING FLYING, KICKING, RUNNING ETC.

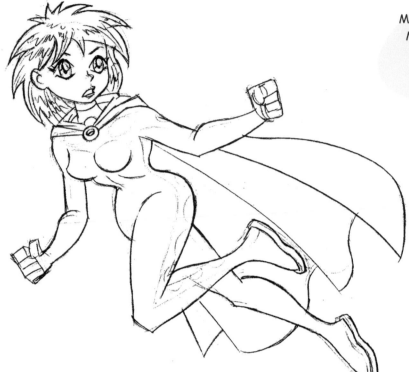

A GOOD POSE SHOULD CONVEY MOVEMENT WITHOUT THE HELP OF MOVEMENT LINES. JUST FROZEN IN TIME, YOUR CHARACTER SHOULD LOOK DRAMATIC.

SOMETIMES MORE SO THAN OTHERS...

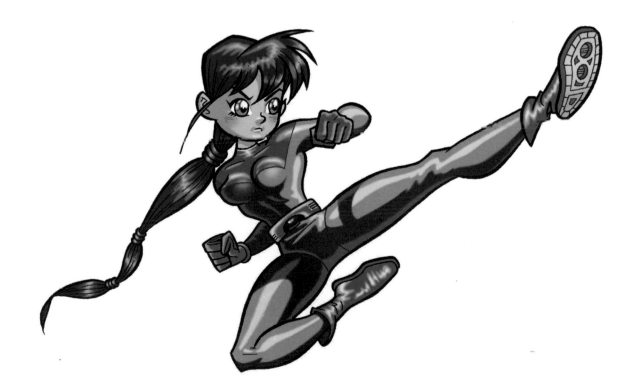

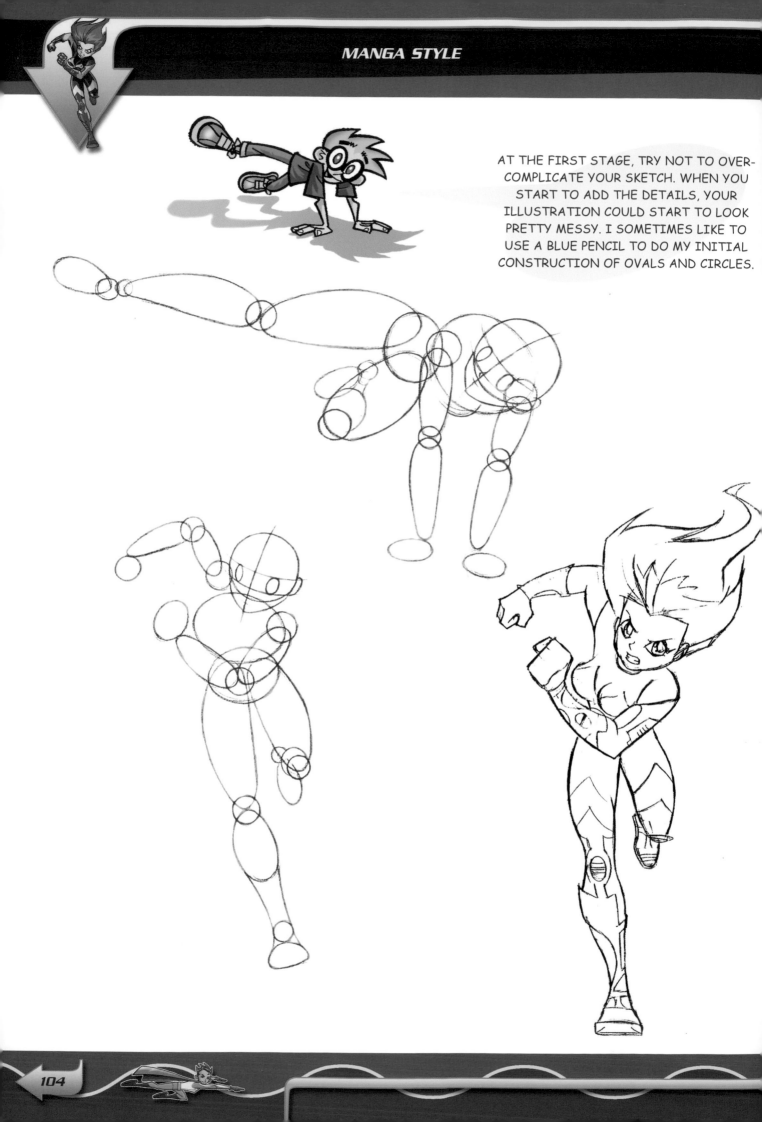

AT THE FIRST STAGE, TRY NOT TO OVER-COMPLICATE YOUR SKETCH. WHEN YOU START TO ADD THE DETAILS, YOUR ILLUSTRATION COULD START TO LOOK PRETTY MESSY. I SOMETIMES LIKE TO USE A BLUE PENCIL TO DO MY INITIAL CONSTRUCTION OF OVALS AND CIRCLES.

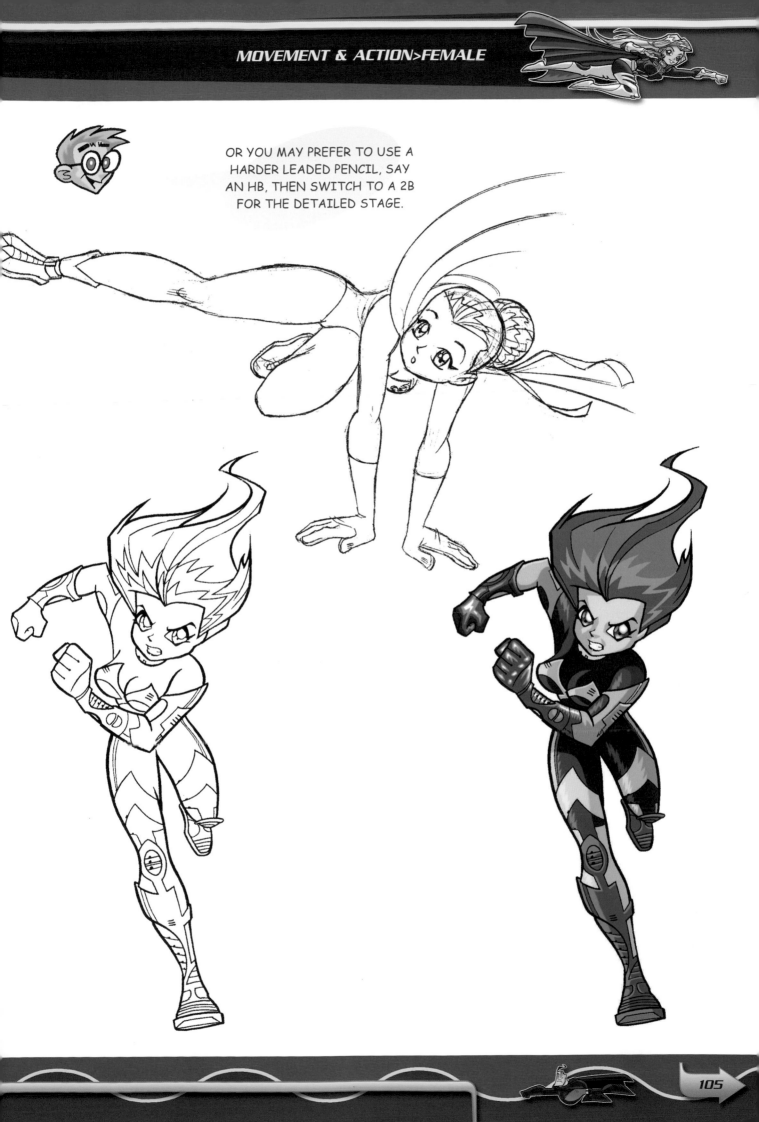

OR YOU MAY PREFER TO USE A
HARDER LEADED PENCIL, SAY
AN HB, THEN SWITCH TO A 2B
FOR THE DETAILED STAGE.

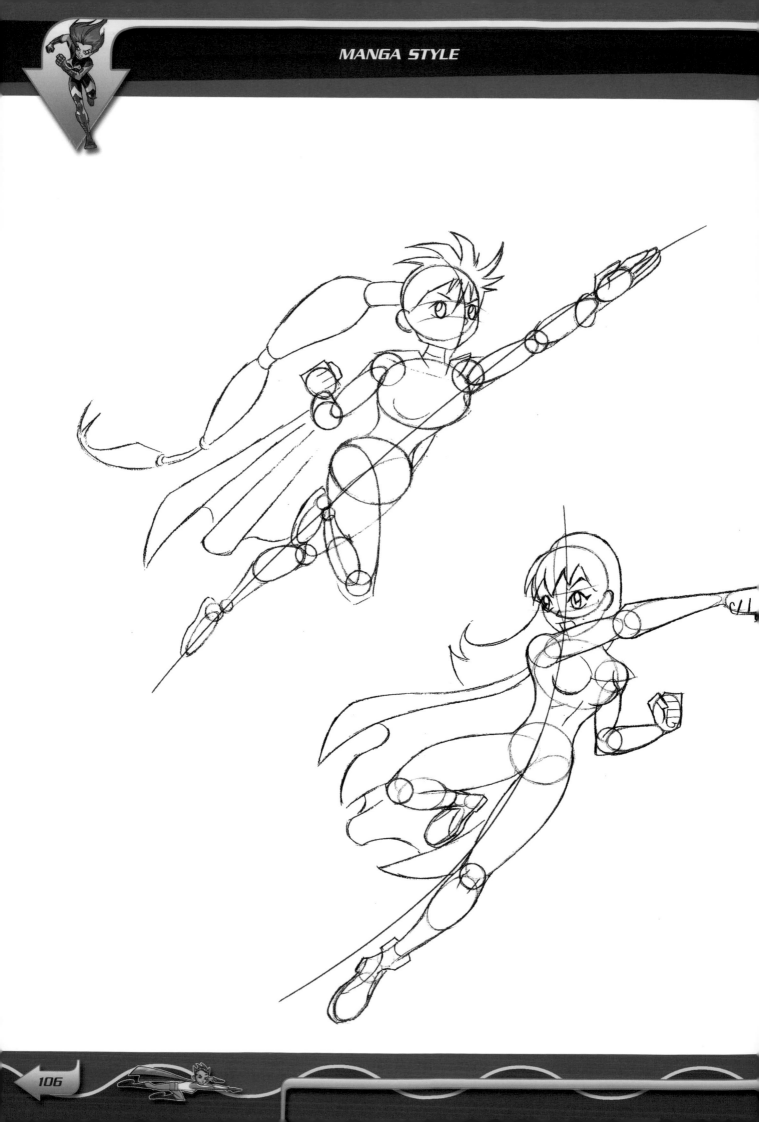

SO, ON TO THE 2B OR 3B AS THE "DRESSING" STAGE BEGINS. ADD LITTLE TOUCHES LIKE CREASES IN HER GLOVES AT THE WRISTS AND IN THE MATERIAL AT THE BACKS OF HER KNEES.

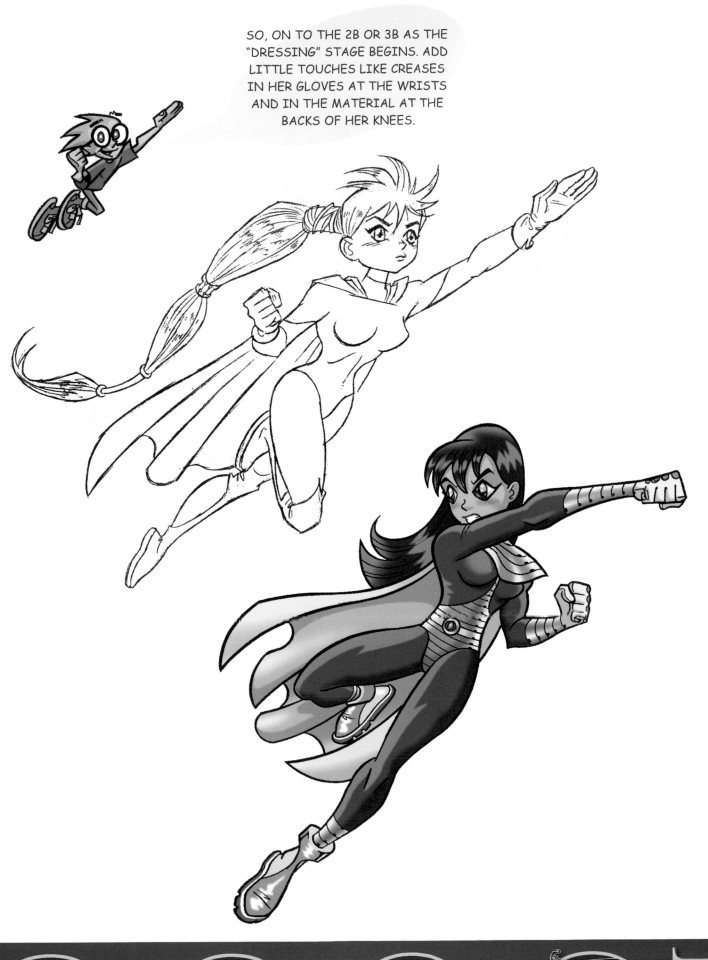

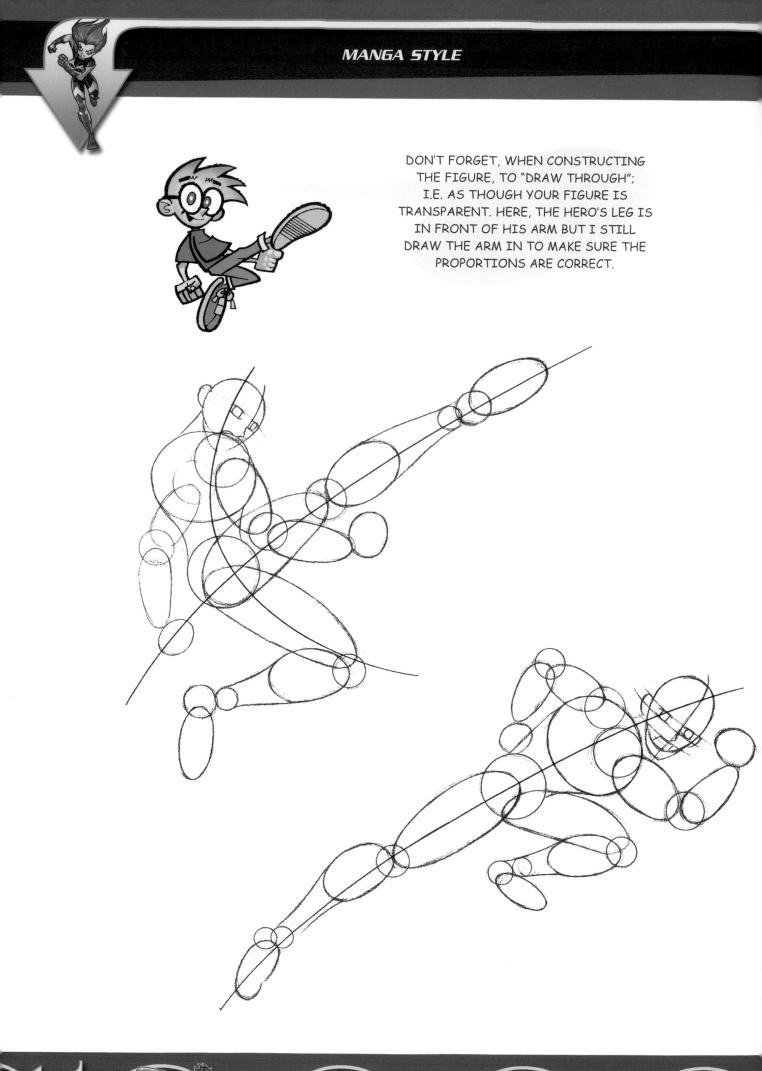

DON'T FORGET, WHEN CONSTRUCTING THE FIGURE, TO "DRAW THROUGH"; I.E. AS THOUGH YOUR FIGURE IS TRANSPARENT. HERE, THE HERO'S LEG IS IN FRONT OF HIS ARM BUT I STILL DRAW THE ARM IN TO MAKE SURE THE PROPORTIONS ARE CORRECT.

USE HIS HAIR AND ESPECIALLY HIS CLOTHING TO HELP IN CREATING THE FEELING OF MOVEMENT. EVEN ADDING A FEW BITS OF DIRT OR GRAVEL FROM HIS BOOT ADDS TO THE FEEL OF ENERGY AND ACTION.

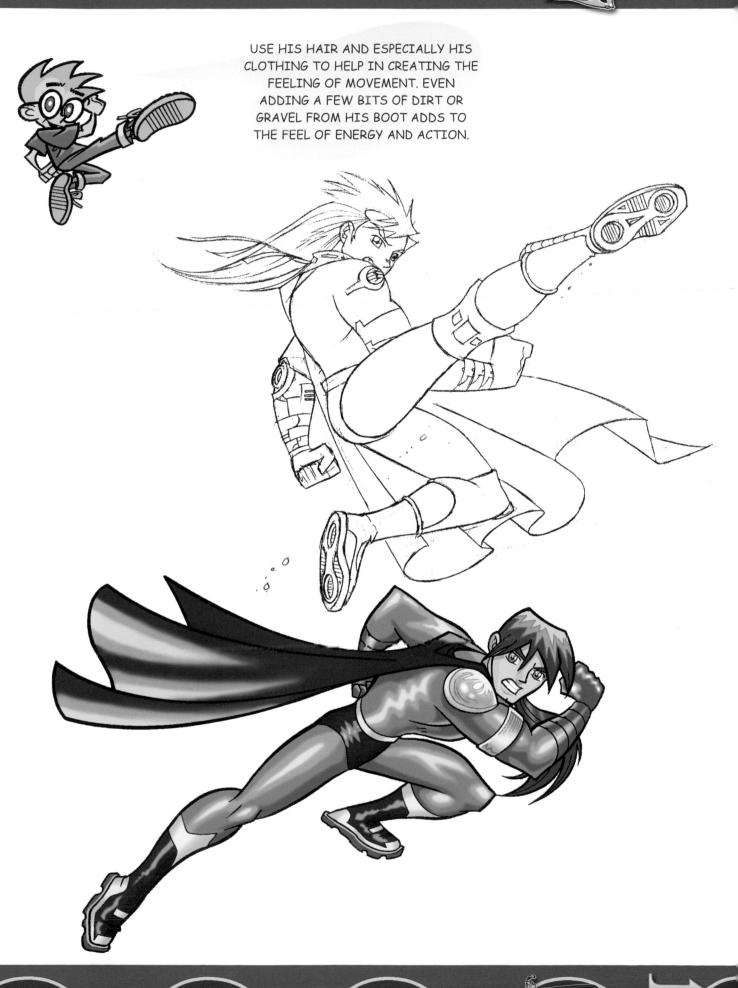

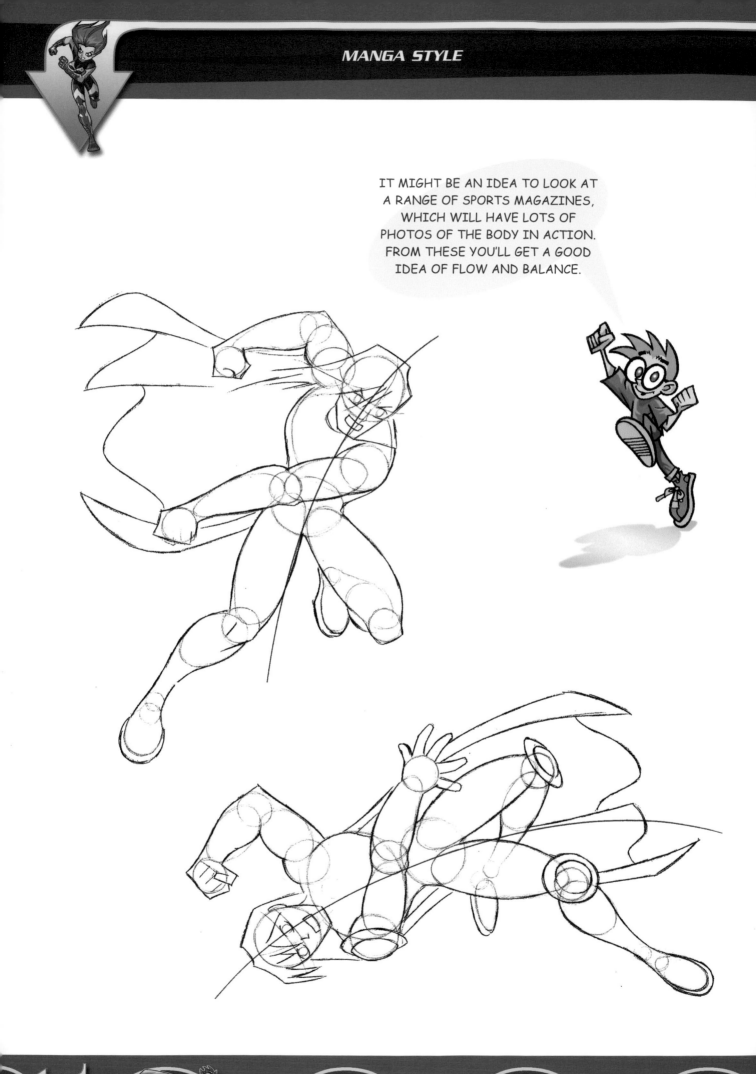

IT MIGHT BE AN IDEA TO LOOK AT A RANGE OF SPORTS MAGAZINES, WHICH WILL HAVE LOTS OF PHOTOS OF THE BODY IN ACTION. FROM THESE YOU'LL GET A GOOD IDEA OF FLOW AND BALANCE.

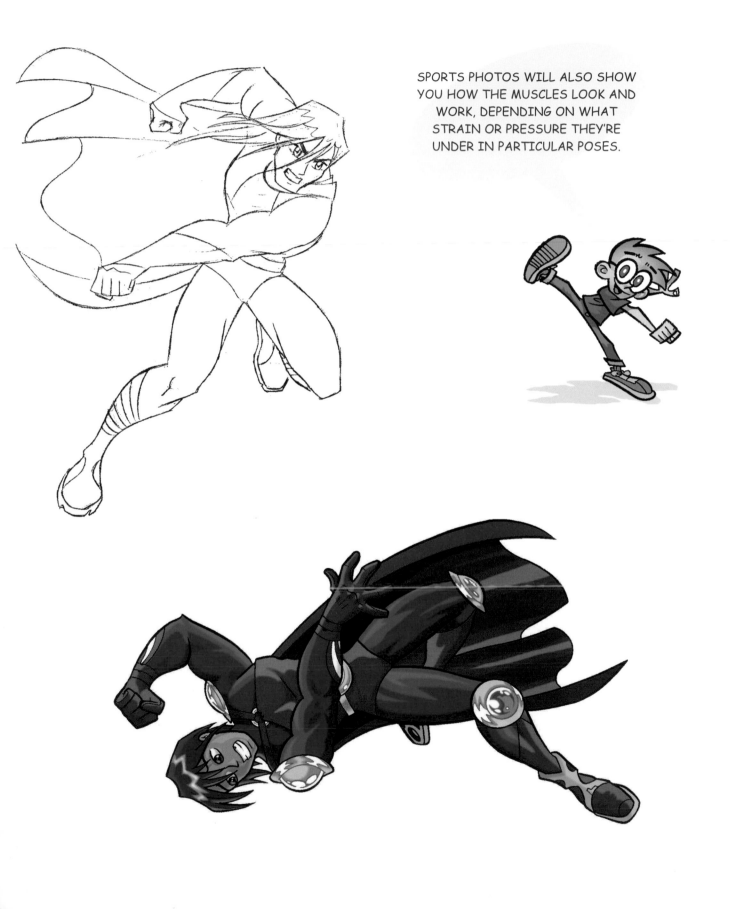

SPORTS PHOTOS WILL ALSO SHOW YOU HOW THE MUSCLES LOOK AND WORK, DEPENDING ON WHAT STRAIN OR PRESSURE THEY'RE UNDER IN PARTICULAR POSES.

THE FACE, OF COURSE, IS THE FOCUS OF ATTENTION ON THE HUMAN BODY. IT'S WHAT WE REACT TO MORE THAN BODY LANGUAGE. WITH THE EYES ESPECIALLY, WORDS ARE OFTEN UNNECESSARY AS THE FACE SAYS IT ALL. TRY THESE BELOW.

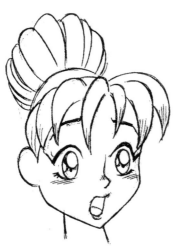

**Surprised**

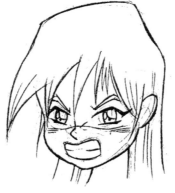

**Angry**

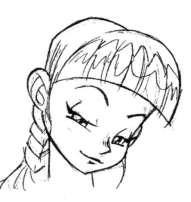

**Flirtatious**

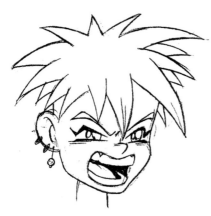

**Mega mad**

**Relaxed**

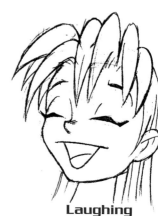

**Laughing**

**Bored**

**Sad**

**Scheming**

A FEW MORE TO SHOW THAT
THE BOYS CAN PULL FACES TOO.

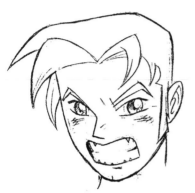

**Pretty steamed up**

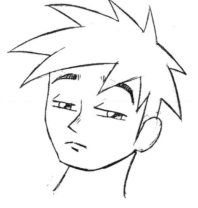

**Aloof**

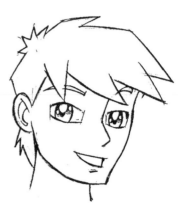

**Happy smile**

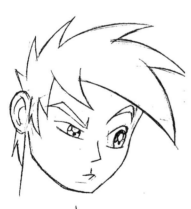

**Suspicious**

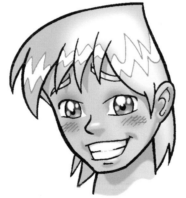

**Embarrassed**

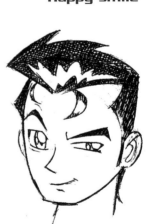

**Trying to be James Bond**

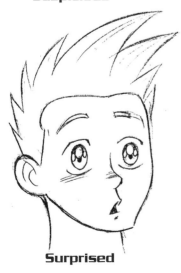

**Surprised**

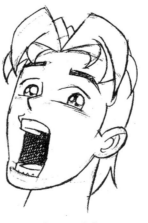

**Aaargh!**

**Shouting**

TO A CERTAIN DEGREE, YOU CAN DRAW
EYES HOW YOU LIKE, AS LONG AS THEY'RE
BIG WITH LOTS OF REFLECTED LIGHT.
HERE ARE A FEW OF MY FAVORITES.

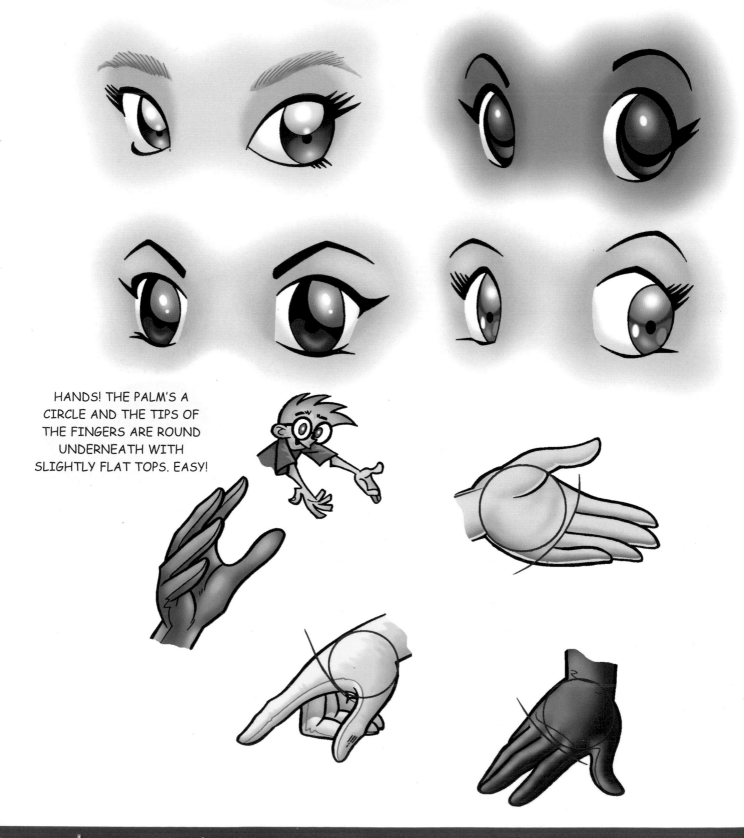

HANDS! THE PALM'S A
CIRCLE AND THE TIPS OF
THE FINGERS ARE ROUND
UNDERNEATH WITH
SLIGHTLY FLAT TOPS. EASY!

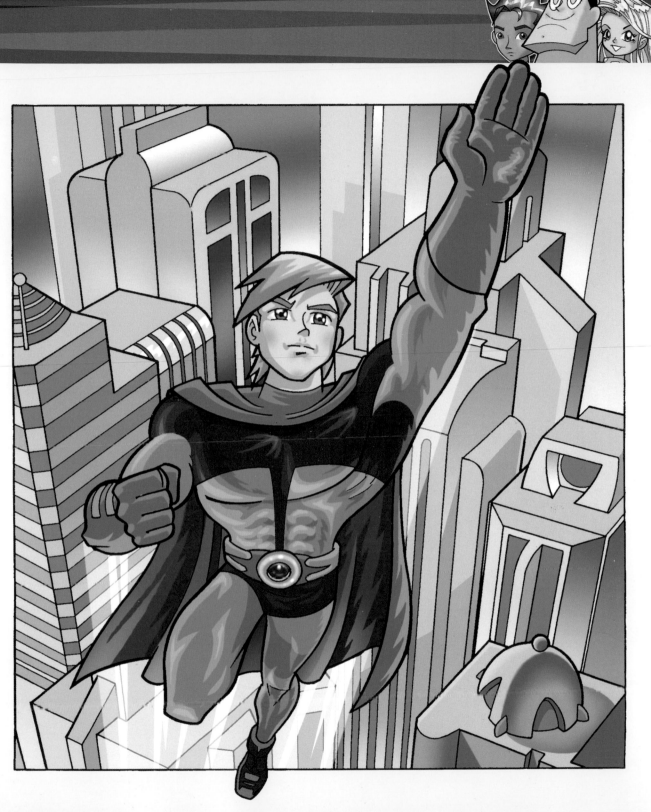

# TIPS & TECHNIQUES

Right, you've seen how all three styles are done, and by now you should be drawing and coloring with more confidence – and enjoying it! This last section just takes you over the techniques that will make your artwork look really professional.

Take your time to understand them as you go along, and don't be put off if they look tricky – once you understand them, they're not. These techniques are the blue-prints to making your artwork stand up from the page and holler "Look at me!"

IF YOU TAKE A CUBE AND TURN IT STRAIGHT ON TO YOURSELF, IT APPEARS THAT THE TWO SIDE LINES WOULD EVENTUALLY MEET IN THE DISTANCE.

WHERE THE TWO LINES MEET IS CALLED THE HORIZON LINE.

THIS IS CALLED "ONE-POINT" PERSPECTIVE.

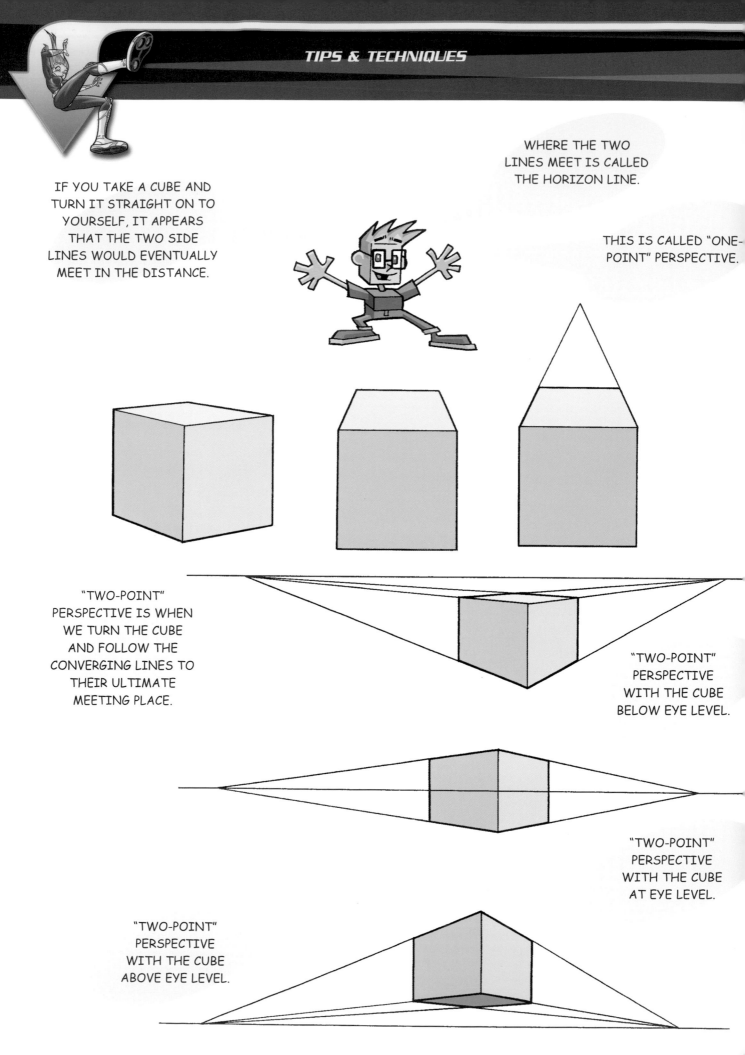

"TWO-POINT" PERSPECTIVE IS WHEN WE TURN THE CUBE AND FOLLOW THE CONVERGING LINES TO THEIR ULTIMATE MEETING PLACE.

"TWO-POINT" PERSPECTIVE WITH THE CUBE BELOW EYE LEVEL.

"TWO-POINT" PERSPECTIVE WITH THE CUBE AT EYE LEVEL.

"TWO-POINT" PERSPECTIVE WITH THE CUBE ABOVE EYE LEVEL.

PERSPECTIVE IS VITAL IF YOU WANT
YOUR DRAWING TO LOOK REALISTIC. AS
YOU GAZE OUT INTO THE DISTANCE,
WHERE THE LAND OR SEA MEETS THE
SKY, THAT IS THE HORIZON LINE.

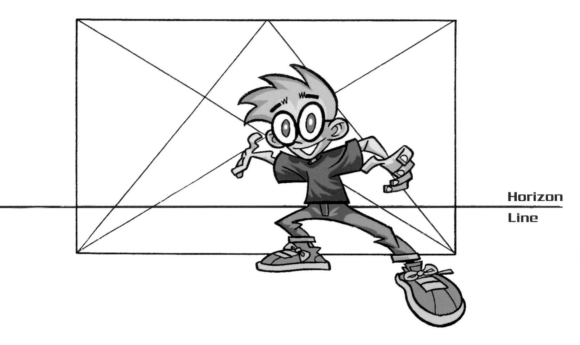

Horizon

Line

OF COURSE IT ISN'T A NEAT BLACK
LINE THAT YOU CAN ALWAYS SEE IN
THE DISTANCE. MOSTLY IT WILL BE
OBSCURED BY OBJECTS OR
DISTORTED BY HEAT OR LIGHT, BUT
IT'S ALWAYS THERE NONETHELESS.

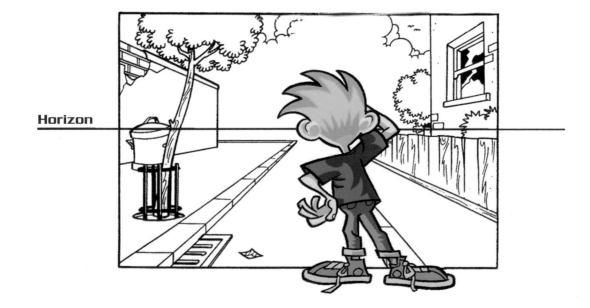

Horizon

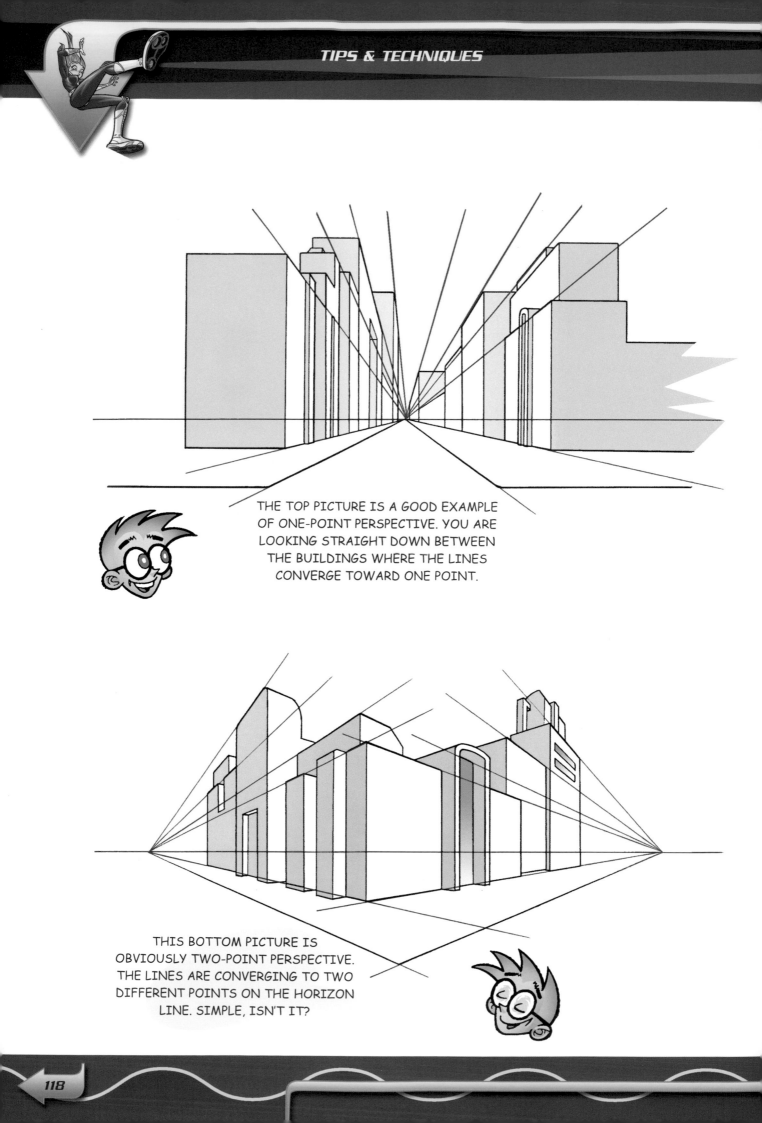

THE TOP PICTURE IS A GOOD EXAMPLE
OF ONE-POINT PERSPECTIVE. YOU ARE
LOOKING STRAIGHT DOWN BETWEEN
THE BUILDINGS WHERE THE LINES
CONVERGE TOWARD ONE POINT.

THIS BOTTOM PICTURE IS
OBVIOUSLY TWO-POINT PERSPECTIVE.
THE LINES ARE CONVERGING TO TWO
DIFFERENT POINTS ON THE HORIZON
LINE. SIMPLE, ISN'T IT?

HERE ARE TWO EXAMPLES CONTAINING THREE POINT PERSPECTIVE. IN THIS "BIRDS EYE VIEW" THE GREEN LINES ARE OUR 1ST AND 2ND POINT PERSPECTIVE WHILE THE 3RD IS REPRESENTED BY THE BLUE VERTICAL LINES. THE 1ST AND 2ND POINT LINES WILL OF COURSE EVENTUALLY COME TOGETHER AT A CERTAIN POINT ON THE HORIZON, THOUGH THE 3RD POINT LINES WILL JOIN AT A SPOT WELL BELOW THE HORIZON LINE.

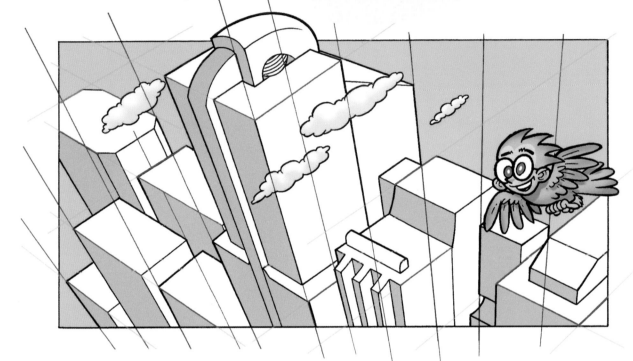

THE SAME PRINCIPLE APPLIES TO THIS "WORMS EYE VIEW" EXAMPLE, WITH THE RED VERTICAL LINES OF 3RD POINT PERSPECTIVE MEETING AT A POINT WELL ABOVE THE HORIZON LINE. THE POINT AT WHICH ANY ONE SET OF PERSPECTIVE LINES CONVERGE IS KNOWN AS THE VANISHING POINT.

NOW HERE'S A LITTLE ROOM—NOT MINE—THAT YOU'LL WANT TO LOOK NATURAL. THAT IS, ALL THE FURNITURE TO BE ON THE FLOOR AND NOT LOOKING AS THOUGH IT IS FLOATING AN INCH OR TWO ABOVE IT. JUST USE YOUR RULER, OBSERVE YOUR VANISHING POINTS AND ALL SHOULD BE FINE. NOTICE THOUGH, THE TV AND THE ARMCHAIR ARE ANGLED DIFFERENTLY. THIS GIVES YOU A THIRD AND A FOURTH VANISHING POINT.

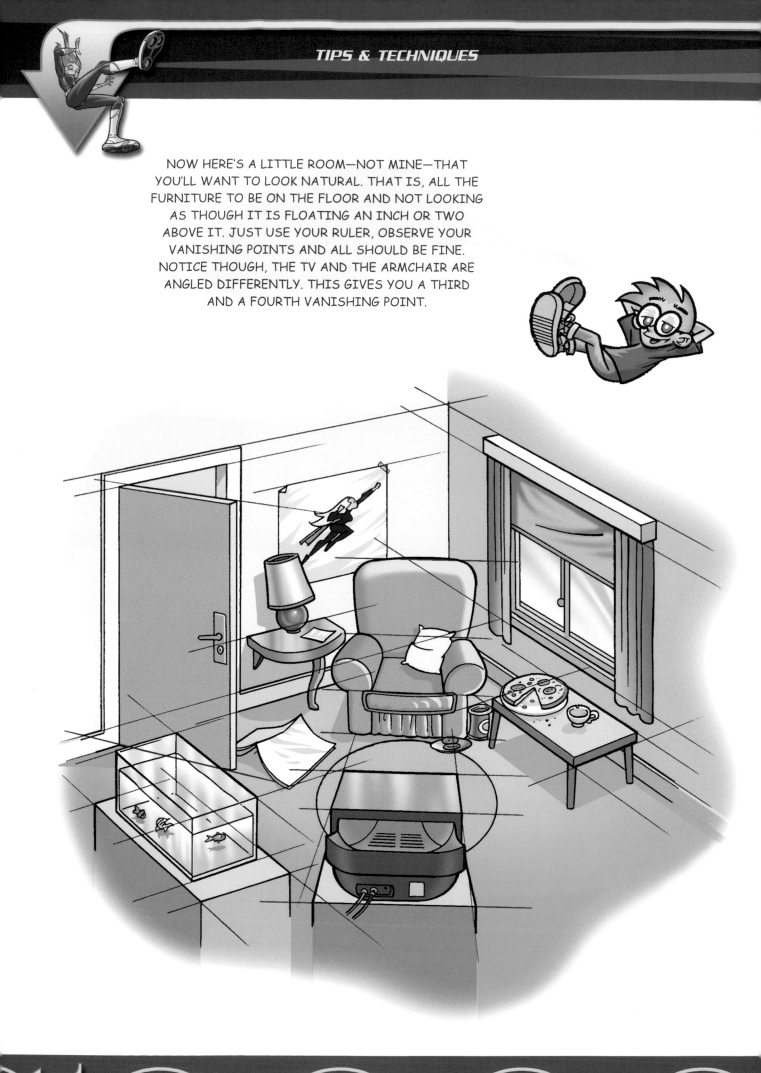

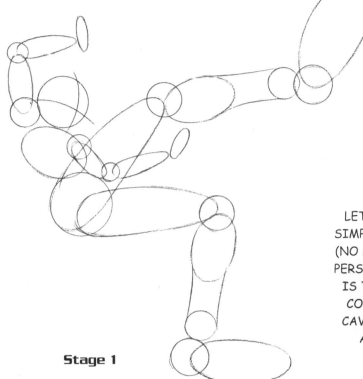

**Stage 1**

LET'S ADD A FIGURE TO THIS SIMPLE PERSPECTIVE. SHE FALLS (NO PUN INTENDED) INTO BODY PERSPECTIVE: FORESHORTENING IS THE TERM USED. YOUR ART COULD END UP AS FLAT AS A CAVE PAINTING IF YOU DON'T APPLY THIS TECHNIQUE.

**Stage 2**

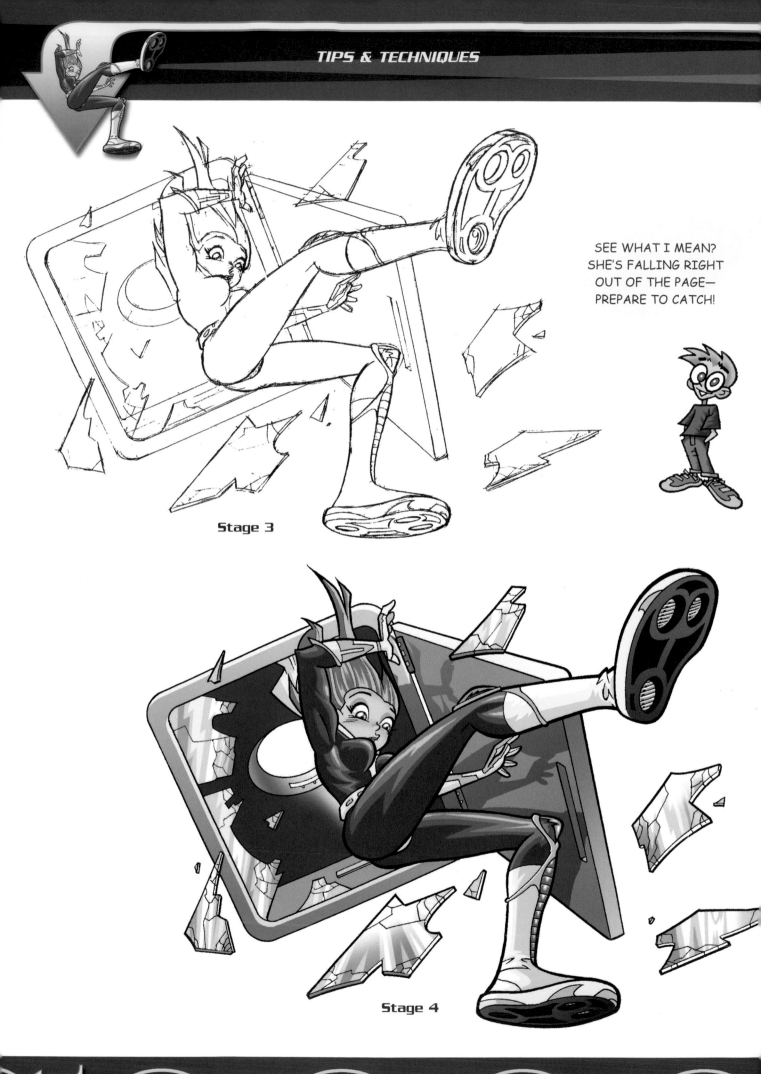

SEE WHAT I MEAN? SHE'S FALLING RIGHT OUT OF THE PAGE— PREPARE TO CATCH!

Stage 3

Stage 4

NOW YOU'VE HAD A LITTLE TASTER, LET'S EXPLORE A LITTLE MORE. WHAT YOU'RE AIMING FOR IS YOUR DRAWING TO LEAP OUT AT THE READER, ALMOST AS THOUGH IT'S 3D.

OBJECTS SHORTEN AND LOOK SMALLER AS THEY FALL AWAY FROM YOU. NEARER, THEY APPEAR BIGGER, AND THE NEAREST POINT TO YOU APPEARS THE BIGGEST. THE ARROW DOESN'T REMAIN THE SAME LENGTH AS IT CHANGES ANGLE—IT SHORTENS.

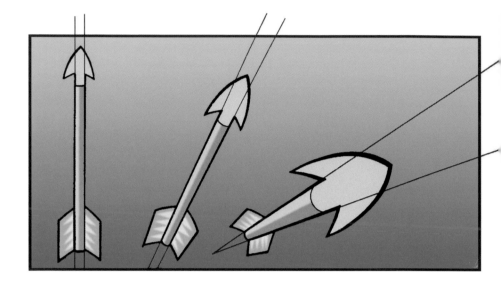

THIS RULE APPLIES TO THE BODY. THE BEST WAY TO FORESHORTEN IS, JUST FOR THE MOMENT, TO FORGET ABOUT CURVED LINES AND BRING IN A FEW SQUARES. COMPARE THESE "BLOCKED" EXAMPLES TO THE FINISHED EXAMPLE OF FORESHORTENING ON PAGE 123 TO GET AN IDEA HOW THIS TECHNIQUE WORKS.

HERE OUR CUTE HEROINE IS GLIDING GRACEFULLY THROUGH THE SKY. AS SHE IS HEADING MORE OR LESS TOWARD US, SO THE PART OF HER BODY NEAREST TO US APPEARS LARGER.

THE PART OF HER BODY THAT IS FARTHEST AWAY FROM US APPEARS SMALLER.

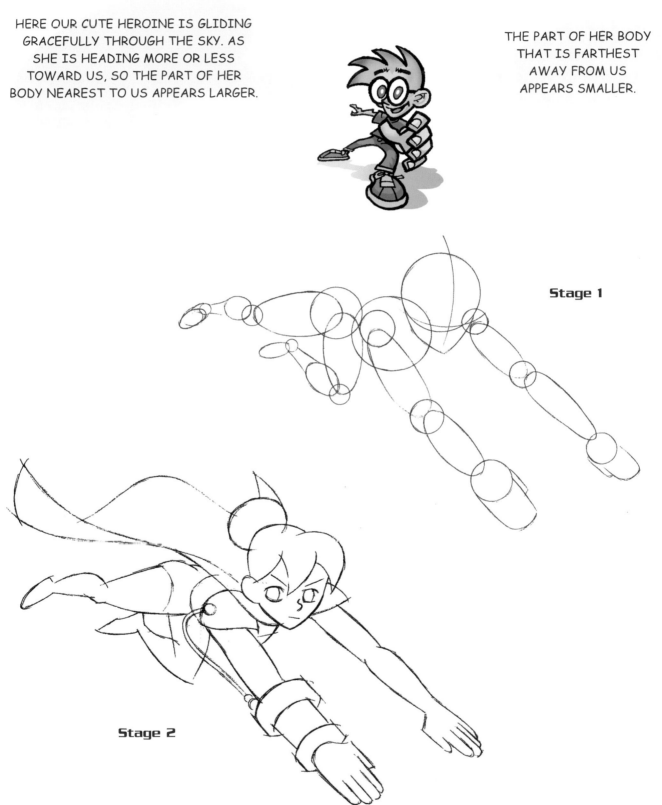

Stage 1

Stage 2

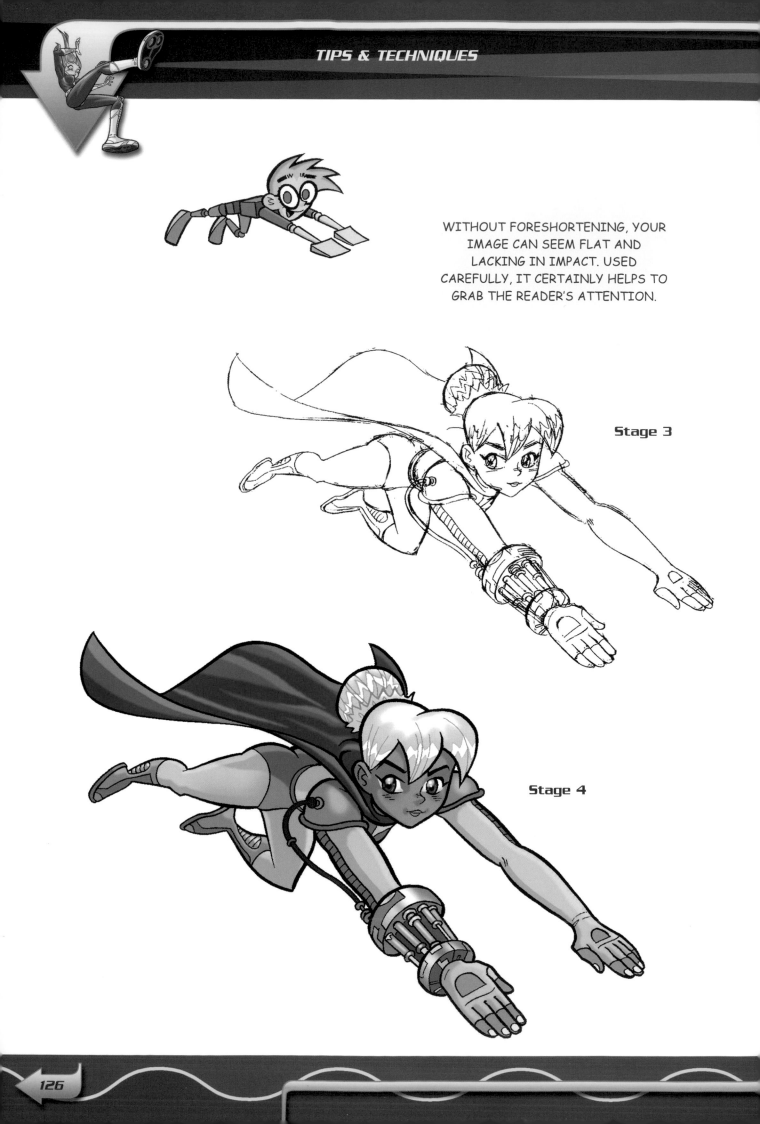

WITHOUT FORESHORTENING, YOUR
IMAGE CAN SEEM FLAT AND
LACKING IN IMPACT. USED
CAREFULLY, IT CERTAINLY HELPS TO
GRAB THE READER'S ATTENTION.

**Stage 3**

**Stage 4**

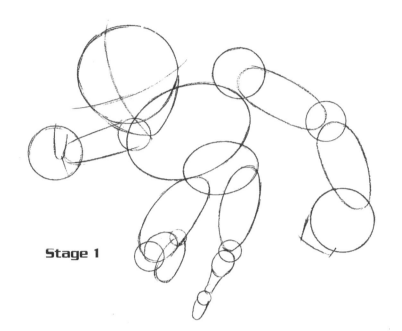

**Stage 1**

WHEN TAKEN TO EXTREMES, THE
DESIRED EFFECT OF FORESHORTENING
CAN BE LOST, BUT NOT IN THIS
EXAMPLE. HERE OUR HEROINE CONVEYS
JUST THE RIGHT AMOUNT OF ENERGY
AND POTENTIAL MOVEMENT.

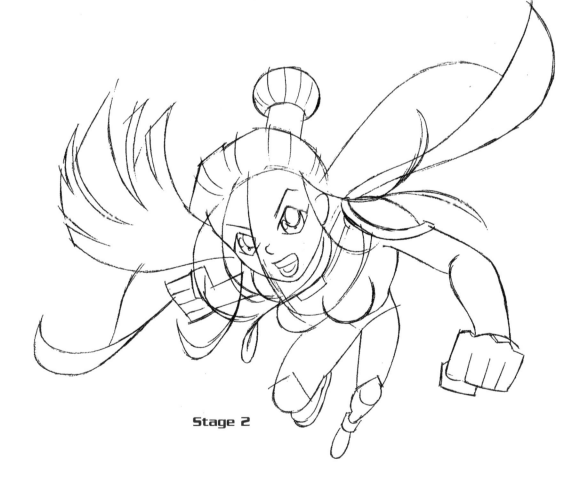

**Stage 2**

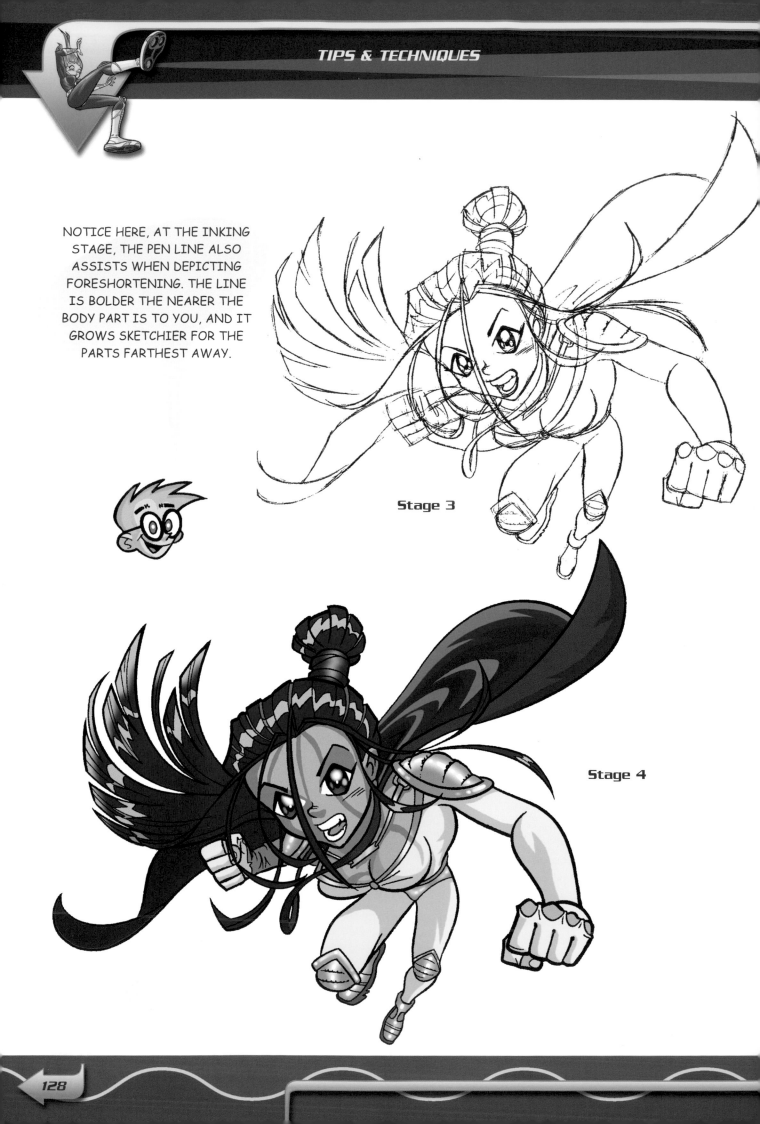

NOTICE HERE, AT THE INKING STAGE, THE PEN LINE ALSO ASSISTS WHEN DEPICTING FORESHORTENING. THE LINE IS BOLDER THE NEARER THE BODY PART IS TO YOU, AND IT GROWS SKETCHIER FOR THE PARTS FARTHEST AWAY.

Stage 3

Stage 4

HERE IS AN EXAMPLE OF EXTREME, OR MAXIMUM, FORESHORTENING. AS YOU CAN SEE, OUR LEAPING HERO'S FOOT IS COMING RIGHT OUT AT YOU. THIS CAN LOOK VERY EFFECTIVE, BUT DON'T OVER-DO IT AS YOUR PAGE CAN LOSE ITS IMPACT IF THIS IS OVER USED.

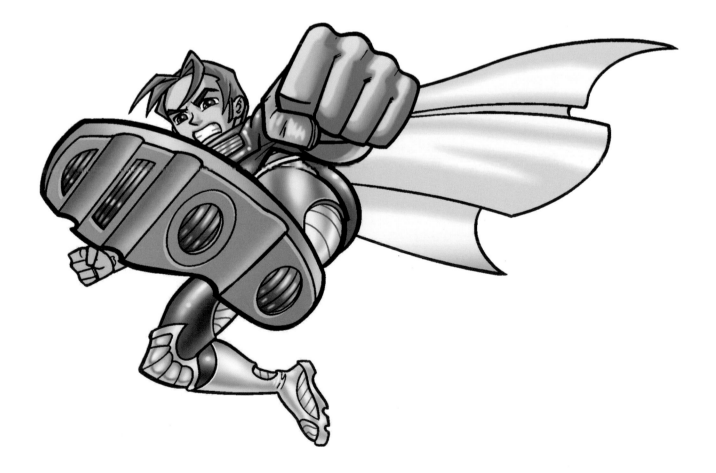

SPEED LINES ARE A PERSONAL CHOICE. SOME ILLUSTRATORS RELY ON THEM TOO MUCH; OTHERS, NOT A SINGLE STROKE ADORNS THEIR PAGE. IT ALL DEPENDS ON YOUR STYLE. HOWEVER, THEY EMPHASIZE SPEED, MOVEMENT, AND DRAMA, AND CAN BE USED TO VERY GOOD EFFECT IF EMPLOYED CORRECTLY. IN THE ILLUSTRATION BELOW, RADIAL SPEED LINES SUGGEST RAPID MOVEMENT AS OUR HEROINE SPEEDS TOWARD US.

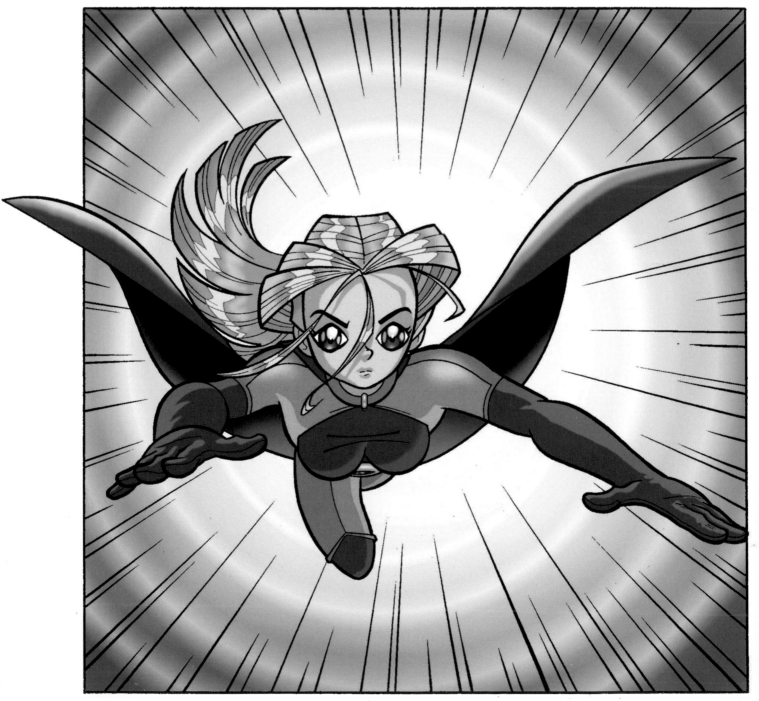

**Radial speed lines**

AGAIN, THE RADIAL
SPEED LINES CONVEY
PERFECTLY THE
INTENSITY AND
POWER OF THE BLOW.

THE THREE PANELS
BELOW DEPICT HOW YOU
SHOULD FOLLOW THE
FLOW OF ACTION WHEN
ADDING SPEED LINES.

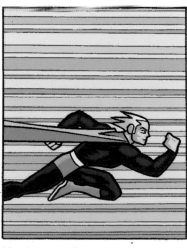

**Horizontal**

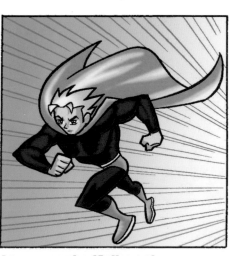

**At an angle (follow the lines of perspective)**

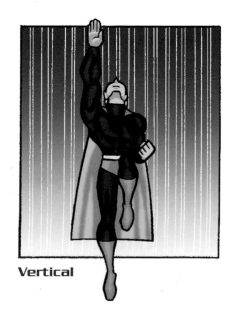

**Vertical**

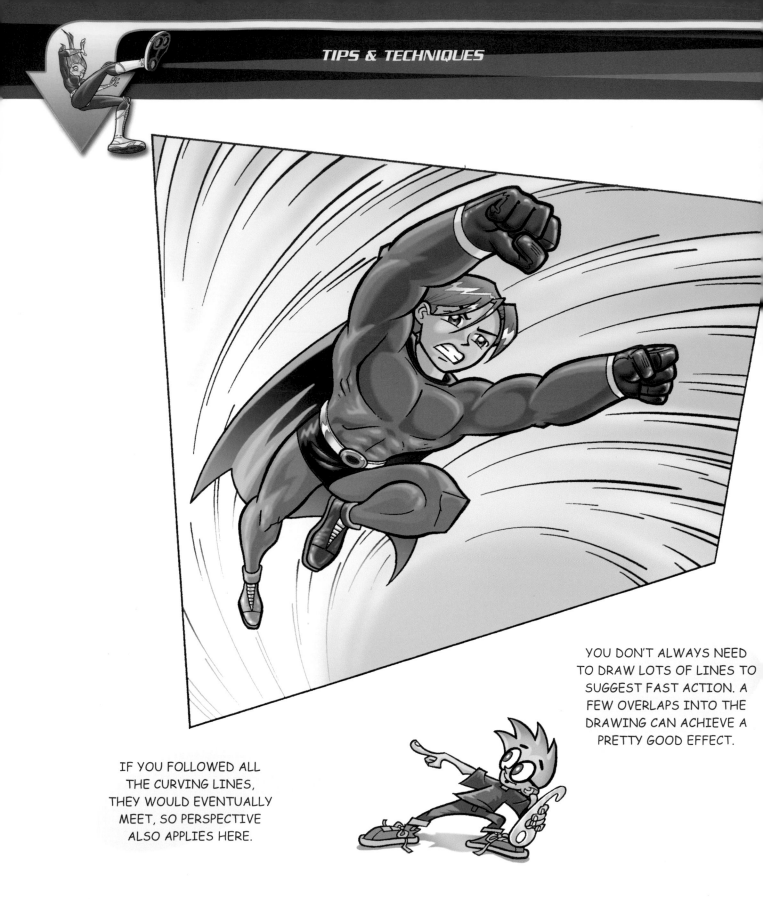

YOU DON'T ALWAYS NEED TO DRAW LOTS OF LINES TO SUGGEST FAST ACTION. A FEW OVERLAPS INTO THE DRAWING CAN ACHIEVE A PRETTY GOOD EFFECT.

IF YOU FOLLOWED ALL THE CURVING LINES, THEY WOULD EVENTUALLY MEET, SO PERSPECTIVE ALSO APPLIES HERE.

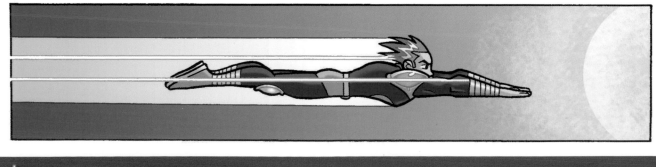

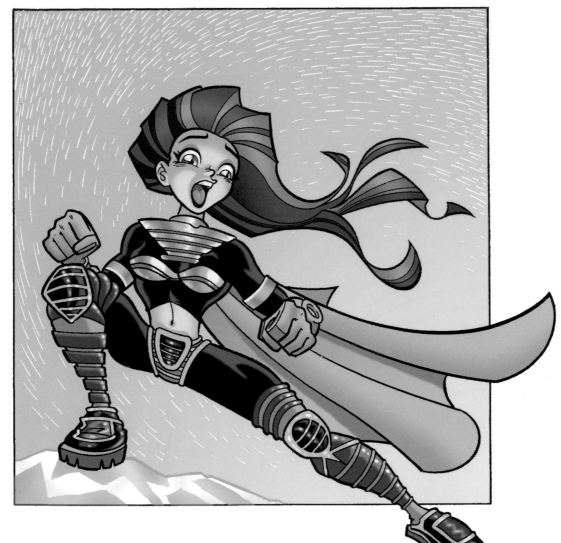

SPEED LINES CAN ALSO BE USED JUST FOR EFFECT, AND ADD BALANCE AND TONE TO AN ILLUSTRATION. ABOVE, SMALL BROKEN LINES COMPLEMENT THE FLOW OF THE POSE AND CAPE.

LEFT, OVERLAY SPEED LINES ARE USED JUST TO EMPHASIZE THE DIRECTION AND SPEED OF THE ARM.

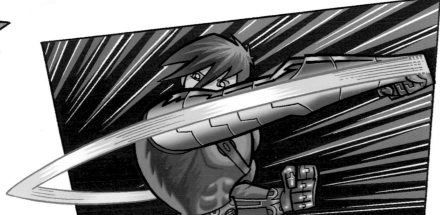

IT'S REALLY ONLY THE KICKING LEG THAT'S THE MAIN FOCUS HERE, PLUS THE CONNECTING EFFECT, WHICH EMPHASIZES WHERE THE HEROINE'S FOOT HAS STRUCK WHATEVER OBJECT SHE WAS AIMING AT.

WE'VE REALLY TRIED FOR POWER HERE. NOT ONLY ARE SPEED LINES USED TO DENOTE THE DIRECTION, POWER, AND SPEED OF THE DOUBLE-FISTED STRIKE— THEY ALSO EMPHASIZE THE EFFECT OF THE BLOW.

YOUR PAGE MUST BE PLEASING TO THE EYE—DYNAMIC AND EXCITING BUT ALSO ENJOYABLE TO READ. THE PANELS IN THE LAYOUT BELOW ARE SIMPLE ENOUGH, BUT THEY RESTRICT THE ACTION, AND THE CHARACTERS ARE MORE OR LESS VIEWED FROM THE SAME ANGLE AND DISTANCE FROM YOU, THE VIEWER. IN SHORT, THEY'RE INCREDIBLY BORING, WITH NO FEELING OF SUSPENSE LEADING UP TO THE FINAL ACTION.

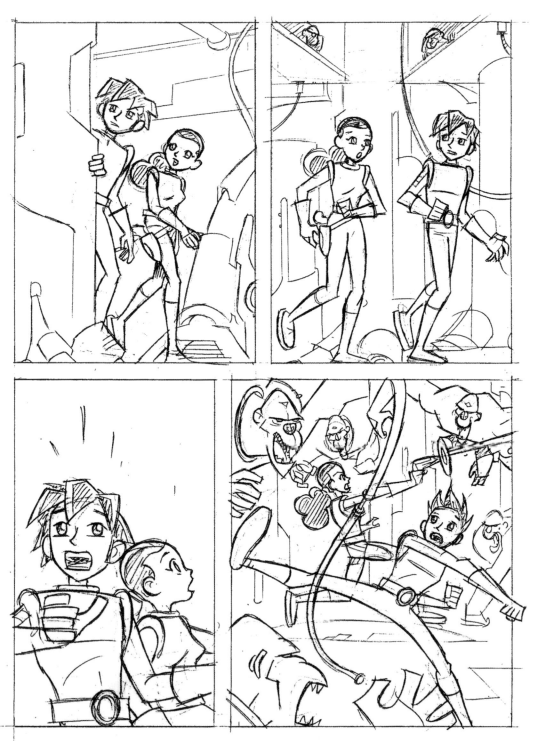

NOW THIS IS BETTER. WITHOUT GOING TOO MAD IN DESIGNING THE PAGE WITH MIXED UP DIFFERENTLY SIZED PANELS (WHICH CAN BE DISTRACTING), WE'VE USED "CAMERA" ANGLES SO THAT IT ALL LEADS NICELY UP TO THE FINAL "ACTION" PANEL.

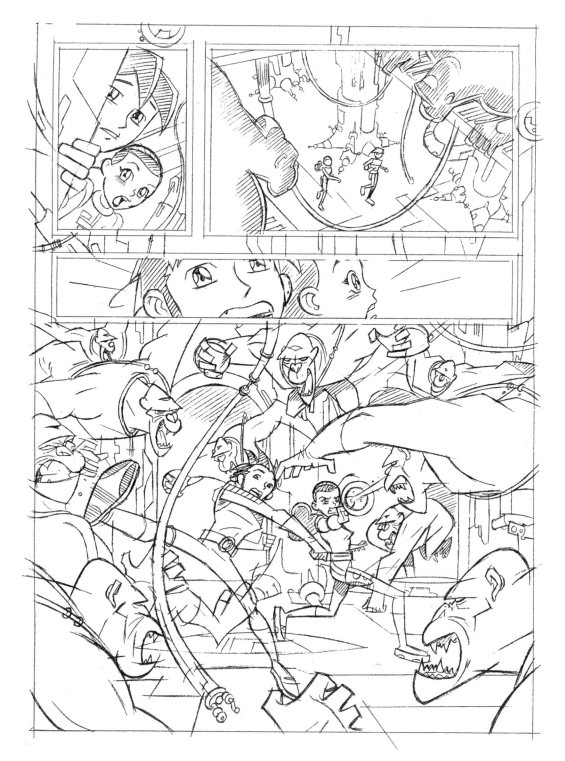

INKED AND CLEANED, NOW
FOR THE COLORING.

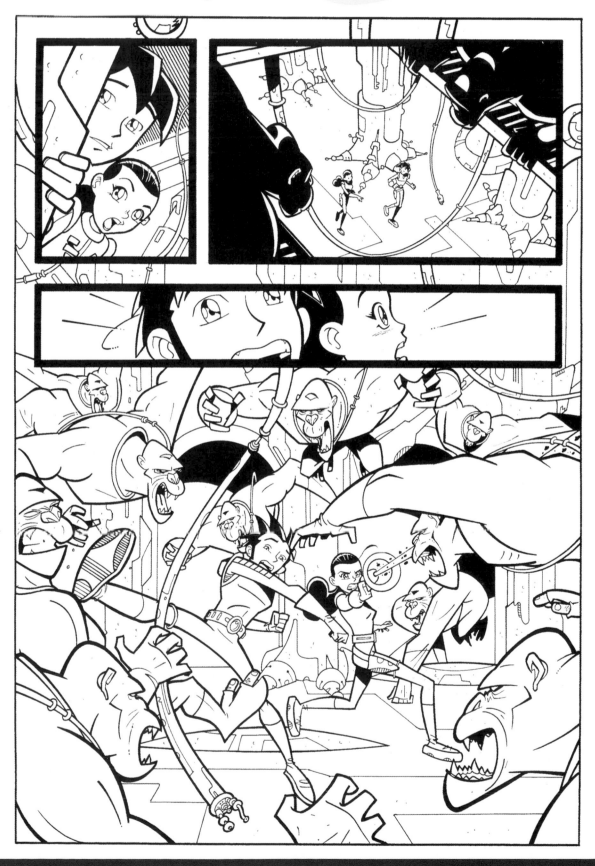

SO HERE'S THE FINISHED PAGE. LAYOUT AND DESIGN IS SOMETHING SOME ARTISTS SEEM TO HAVE A NATURAL EYE FOR, BUT YOU CAN TRAIN YOUR EYE TOO—JUST A LITTLE THOUGHT AND CARE ARE NEEDED.

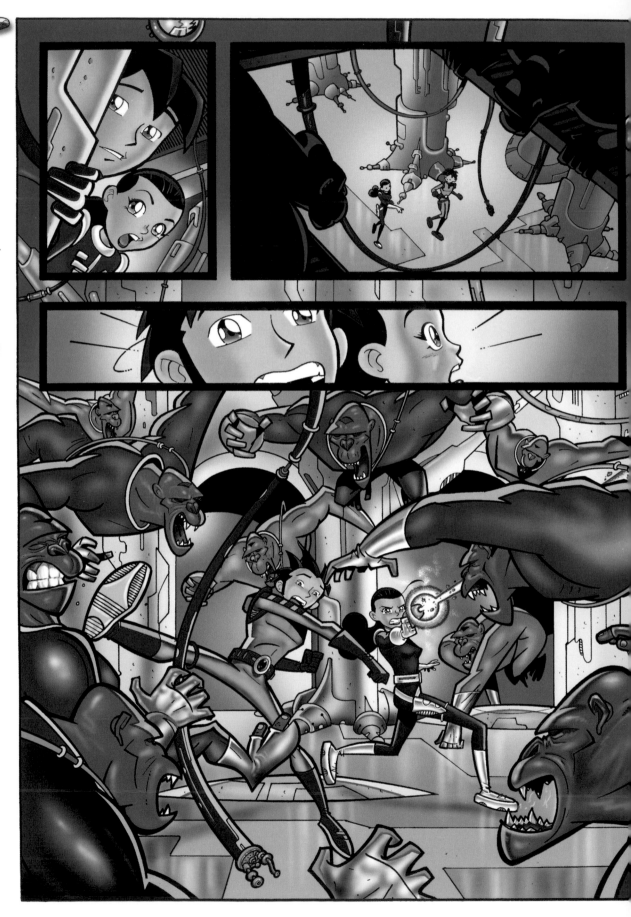

A GOOD INKER CAN DO WONDERS TO MEDIOCRE PENCIL LINES, WHILE A MEDIOCRE INKER CAN DULL WONDERFUL ONES. IT'S UP TO YOU TO DO YOUR BEAUTIFUL PENCILLING JUSTICE. HERE ARE THREE INKED PANELS—WHICH IS THE BEST?.

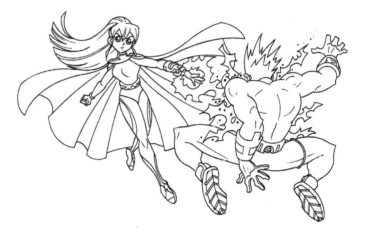

THIS WAS INKED WITH NO VARIATION IN THE LINE. CONSEQUENTLY NONE OF IT STANDS OUT.

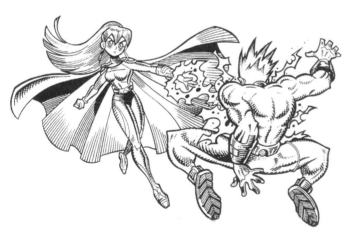

THIS INKER JUST DIDN'T KNOW WHEN TO STOP. IT IS COMPLETELY OVER-INKED, RESULTING IN THE FRAME LOOKING MESSY. SHARP AND CLEAN IS THE BALANCE TO AIM FOR. REMEMBER, WHAT YOU LEAVE OUT IS JUST AS IMPORTANT AS WHAT YOU LEAVE IN. (PS. DON'T FORGET YOUR OPAQUE WHITE.)

HERE THE INKING IS JUST RIGHT. THERE'S A PLEASING VARIETY OF THICK AND THIN LINES, BRINGING THE FIGURE NEAREST TO US TO THE FOREGROUND, AND PUSHING THE MORE DISTANT ONE FARTHER BACK. BY VARYING THE WIDTH OF YOUR LINE, YOU CAN MAKE YOUR ARTWORK FAR MORE INTERESTING.

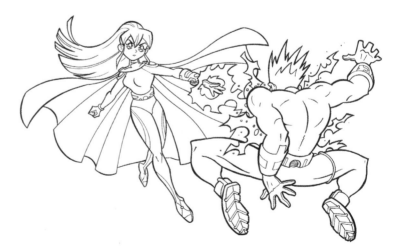

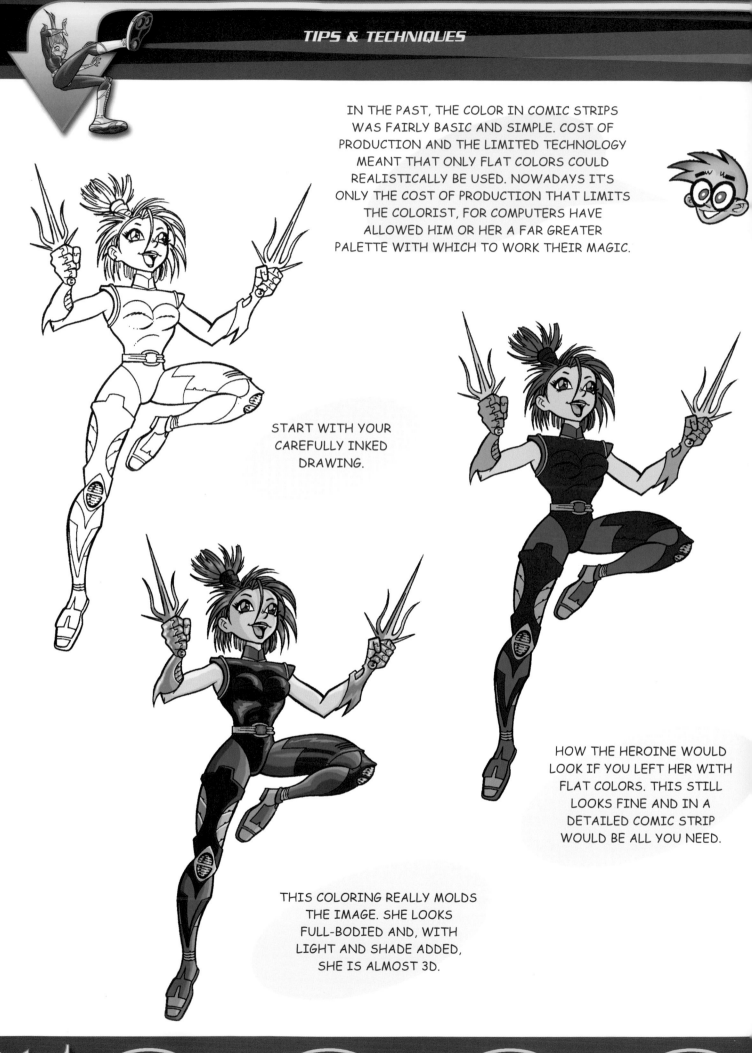

IN THE PAST, THE COLOR IN COMIC STRIPS WAS FAIRLY BASIC AND SIMPLE. COST OF PRODUCTION AND THE LIMITED TECHNOLOGY MEANT THAT ONLY FLAT COLORS COULD REALISTICALLY BE USED. NOWADAYS IT'S ONLY THE COST OF PRODUCTION THAT LIMITS THE COLORIST, FOR COMPUTERS HAVE ALLOWED HIM OR HER A FAR GREATER PALETTE WITH WHICH TO WORK THEIR MAGIC.

START WITH YOUR CAREFULLY INKED DRAWING.

HOW THE HEROINE WOULD LOOK IF YOU LEFT HER WITH FLAT COLORS. THIS STILL LOOKS FINE AND IN A DETAILED COMIC STRIP WOULD BE ALL YOU NEED.

THIS COLORING REALLY MOLDS THE IMAGE. SHE LOOKS FULL-BODIED AND, WITH LIGHT AND SHADE ADDED, SHE IS ALMOST 3D.

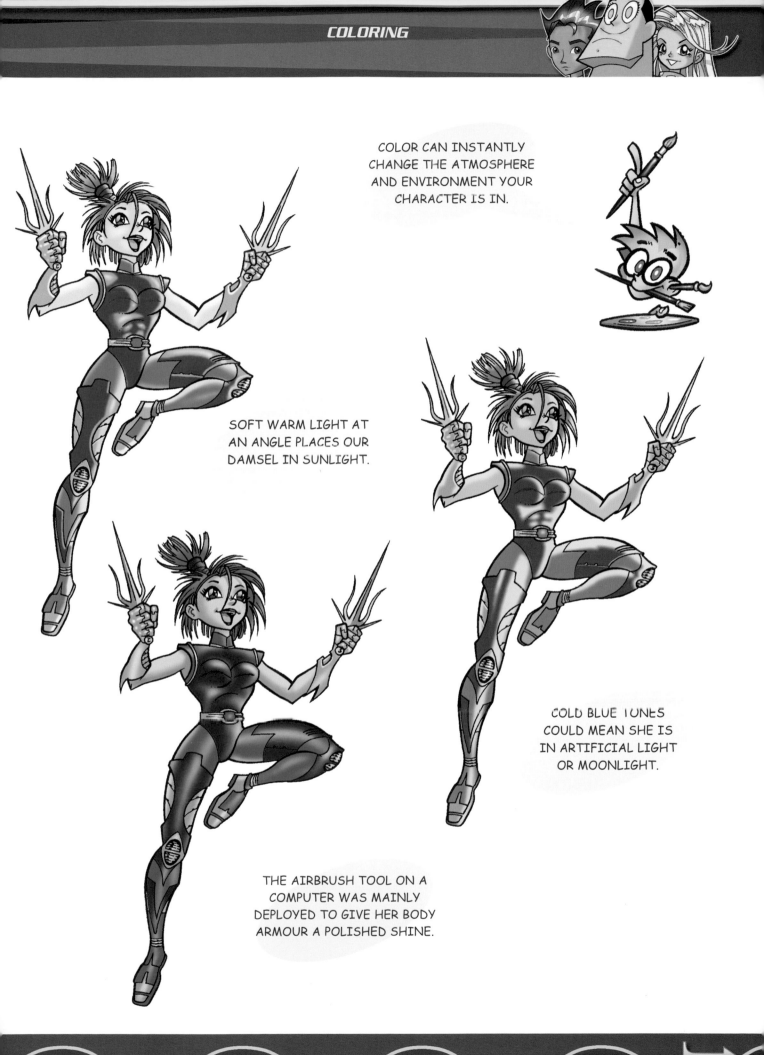

COLOR CAN INSTANTLY CHANGE THE ATMOSPHERE AND ENVIRONMENT YOUR CHARACTER IS IN.

SOFT WARM LIGHT AT AN ANGLE PLACES OUR DAMSEL IN SUNLIGHT.

COLD BLUE TONES COULD MEAN SHE IS IN ARTIFICIAL LIGHT OR MOONLIGHT.

THE AIRBRUSH TOOL ON A COMPUTER WAS MAINLY DEPLOYED TO GIVE HER BODY ARMOUR A POLISHED SHINE.

PHOTOSHOP ENABLES YOU TO
EXPERIMENT TILL YOUR HEART'S
CONTENT. YOU CAN SEE HOW MUCH
BRIGHT AND EFFICIENT COLORING CAN
REALLY ENHANCE AN ILLUSTRATION. SO
IF YOU WANT TO BE AN ALL-ROUND
COMIC ARTIST, KEEP PRACTICING—NOT
ONLY YOUR PENCILS AND INKS, BUT
DEFINITELY YOUR COLORING TOO.

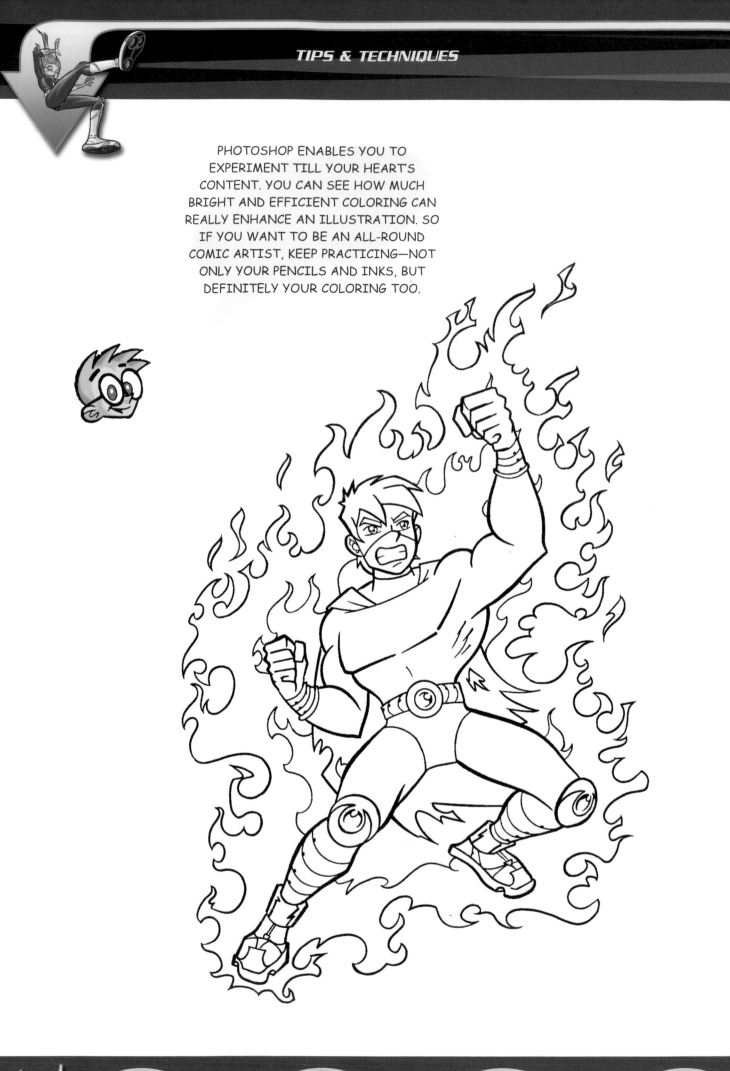

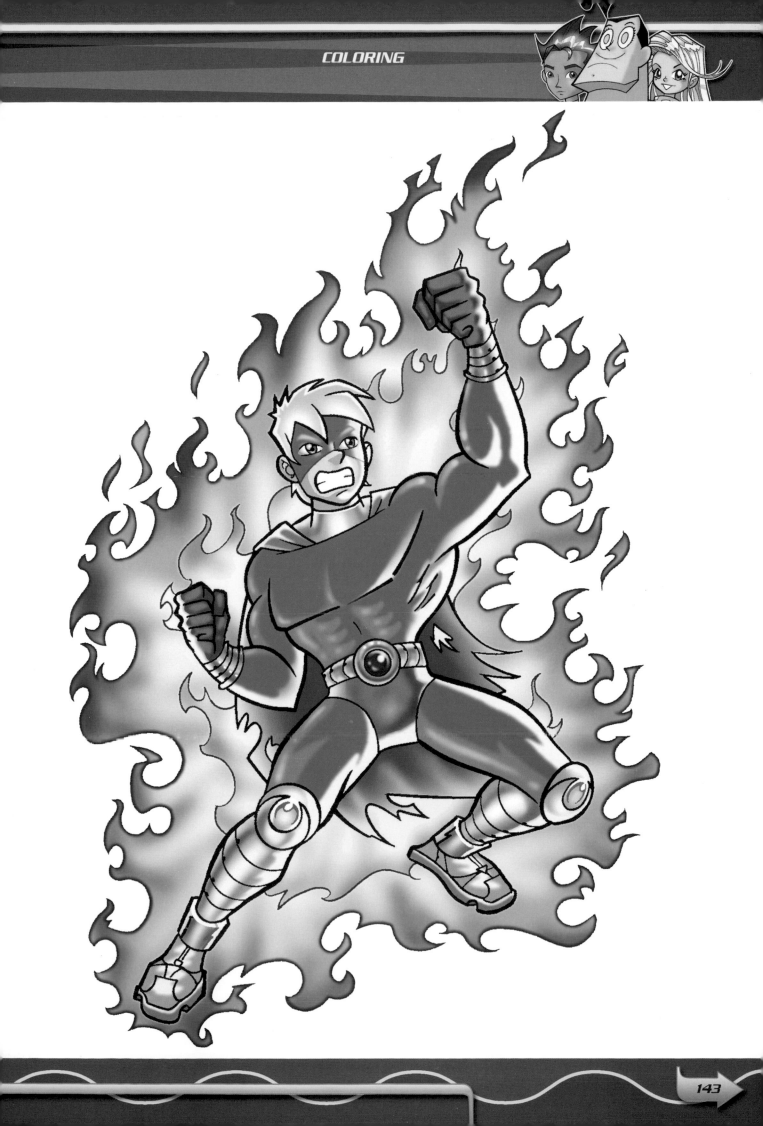

WELL, THAT'S IT FOR NOW. I HOPE THIS BOOK HAS HELPED YOU TO UNDERSTAND THE BASIC TECHNIQUES USED IN COMIC ART. WHATEVER YOUR PERSONAL FAVORITE, BE IT HUMOROUS OR REALISTIC, THE PRINCIPLES ARE MUCH THE SAME. SO, NO EXCUSES— SHARPEN THAT PENCIL, FLIP THE COVER ON YOUR SKETCH PAD, AND GET DRAWING...

AND DON'T FORGET—
HAVE FUN!

CLICK!